The Vine Pottery
Birks Rawlins & Co.

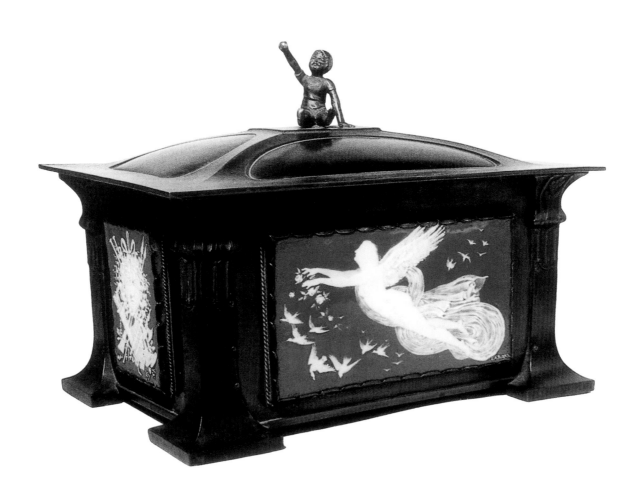

Frontispiece
Casket with four pâte-sur-pâte panels by Lawrence A. Birks depicting 'War' and 'Peace'.

The Vine Pottery
Birks Rawlins & Co.

Influences from Minton
and
Spode/Copeland
on
Lawrence Arthur Birks
and his sculptor/modeller relatives

Peter S. Goodfellow

ANTIQUE COLLECTORS' CLUB

ISBN 10: 1-85149-512-6
ISBN 13: 978-1-85149-512-2

British Library Cataloguing-in-Publication Data
A catalogue record for this book is available from the British Library

Printed in China
for the Antique Collectors' Club Ltd., Woodbridge, Suffolk

The Antique Collectors' Club

Formed in 1966, the Antique Collectors' Club is now a world-renowned publisher of top quality books for the collector. It also publishes the only independently-run monthly antiques magazine, *Antique Collecting*, which rose quickly from humble beginnings to a network of worldwide subscribers.

The magazine, whose motto is *For Collectors–By Collectors–About Collecting*, is aimed at collectors interested in widening their knowledge of antiques both by increasing their awareness of quality and by discussion of the factors influencing prices.

Subscription to *Antique Collecting* is open to anyone interested in antiques and subscribers receive ten issues a year. Well-illustrated articles deal with practical aspects of collecting and provide numerous tips on prices, features of value, investment potential, fakes and forgeries. Offers of related books at special reduced prices are also available only to subscribers.

In response to the enormous demand for information on 'what to pay', ACC introduced in 1968 the famous price guide series. The first title, *The Price Guide to Antique Furniture* (since renamed *British Antique Furniture: Price Guide and Reasons for Values*), is still in constant demand. Since those pioneering days, ACC has gone from strength to strength, publishing many of today's standard works of reference on all things antique and collectable, from *Tiaras* to *20th Century Ceramic Designers in Britain*.

Not only has ACC continued to cater strongly for its original audience, it has also branched out to produce excellent titles on many subjects including art reference, architecture, garden design, gardens, and textiles. All ACC's publications are available through bookshops worldwide and a catalogue is available free of charge from the addresses below.

For further information please contact:

ANTIQUE COLLECTORS' CLUB

www.antique-acc.com

Sandy Lane, Old Martlesham
Woodbridge, Suffolk IP12 4SD, UK
Tel: 01394 389950 Fax: 01394 389999
Email: info@antique-acc.com
or
Eastworks, 116 Pleasant Street - Suite 18,
Easthampton, MA 01027, USA
Tel: 413 529 0861 Fax: 413 529 0862
Email: info@antiquecc.com

Dedication

To Helen, my wife of forty years, an ever-loving person dedicated to her family, bringing into life two fine boys, Andrew and Ian, and supporting my enthusiasm and passion for sporting pursuits, family and ceramic research.

Latterly, after a teaching career cut short, Helen struggled for her last three and a half years so bravely against cancer, but remained cheerful to the very end in April 2001, sharing every little success in finding new pieces of bone china or porcelain made by the family's manufactory in Stoke upon Trent.

Helen will be sadly missed for her organisational capacity in our social life, organising her vast number of friends, hosting so many occasions of significance. A true bastion of education and the local community.

Contents

Acknowledgements

I should like to thank the following people who have contributed tremendously in many ways in enabling all the information in this book to bear fruition. They are:

Dave Bennet; Victoria Bergeson; Michael Berthoud; John A.R. Birks; John S. Birks; Margaret A. Birks; Harry F. Blackburn; Christine Boulton; Jim and Marjorie Bourne; David Brook; Bernard Bumpus; Helen Burton; Andrew Cheney; David Cherrett; Robert Copeland; Eric and Sheelagh Cox; Tony and Leslie Curnock; Michael Diggory; Roger and Helen Fellows; Cedric Garbett; Sharon Gater; Miranda Goodby; Gill and Bob Green; Leonard Griffin; Nigel Griffin; Eric Grindley; Eileen and Rodney Hampson; Len. H. Harris; Sue and Ron Holmes; Alan Hughes; Joan Jones; Helen and Keith Martin (Carlton Ware); Moorland Photographic Studios, Burslem; Kathy Niblett; Martin Phillips; Linda Pine; Tony and Joy Priestly; Paul Proctor; Arthur Puffett; Ravensdale Studios, Tunstall; Joe and Mavis Rawlins; Stuart Richards; Philip and Robin Riley; Gaye Blake-Roberts; Frank Joseph Salmon; John Salt; Gary Sirett; Deborah Skinner; Myra Skinner; Angela and Reg Slinn; David Taylor; Sue Taylor; Derek and Jayne Towns; Laurence Wolffe; Pam Wooliscroft; Mike and Margaret Younger.

I have a very special thank you to Bob Cumming, who is the President of the Board of Directors of the Cumming Research Foundation. The Foundation very kindly awarded me a grant in January 2001, to support my work researching the Vine Pottery, Birks Rawlins & Co. and the Birks family as modellers, sculptors and pottery artists within the Minton and Spode/Copeland manufactories and the North Staffordshire ceramic industry in general.

Introduction

Throughout my life before marriage, living with my parents on the outskirts of Stoke-on-Trent, known as the Potteries, I was brought up to be careful and not to be clumsy with the products of this famous area – pots. I have vague recollections from time to time, as a small child, of people of significant importance in the pottery industry visiting my parents on Sunday mornings for a drink of percolated coffee. Gradually, of course, as I progressed through the teenage years, I got to know who these people really were.

Grandfather, Charles Frederick Goodfellow, had been a potter's miller and miller's merchant supplying clay materials to various pottery manufactories in the late nineteenth century through to the mid-1920s. He had built a modest home in Northwood, Clayton, with the help of his one and only son, my father, and the designers and architects Barry Parker and Raymond Unwin of national acclaim. After twenty-six years, this dwelling known as Goodfellow House became the property of Colley Shorter and his first wife, Nancy Beech, with their two daughters Margaret and Joan. Colley was a pottery manufacturer at Middleport, Burslem, owning A.J. Wilkinson and Shorter & Sons in Stoke upon Trent. To this present day the house is known as Chetwynd House, the name of Colley's father's home in Wolstanton, near Newcastle under Lyme. Colley lived at Chetwynd for some thirty-seven years, latterly with his second wife Clarice Cliff. He passed away on 13 December 1963, but Clarice lived there for another nine years.

The socialising between the families seemed fairly regular with Colley and Clarice visiting my parents and the hospitality being reciprocated with visits to Chetwynd and its impressive cobblestone courtyard. Occasionally the pottery agent Emerson Nichols from London, Ontario, in Canada would be visiting Britain on a business trip, being based at the North Stafford Hotel in Stoke upon Trent, and he would be present too with Mrs. Nichols or his secretary. I have since found out that Emerson was the official representative for several pottery manufacturers, for example Enoch Wedgwood & Co. in Tunstall, George Jones & Sons at the Crescent Pottery in Stoke upon Trent and the Royal Staffordshire Pottery group of A.J. Wilkinson Ltd. and Newport Pottery Ltd., Middleport, Burslem.

Reggie Fielding, the owner of Crown Devon Pottery at the Railway Works in Stoke upon Trent, was another person friendly within this group, along with various members of the Birks family who were cousins. Uncle Ronald was a frequent visitor.

All these people lived within a mile radius of my home, what you could call an easy walking distance.

Apparently my grandfather had furnished his home with many interesting pieces from the Art Nouveau period and William Morris influence, alongside Oriental works of art and bone china from the factory he had been involved in whilst in part ownership with his brother-in-law, Lawrence Arthur Birks, during the late 1890s. There were signs also of an influence from the artist Cecil Aldin and the Swiss ceramic artist Edmond Reuter, who was the inspiration behind Birks' 'Persindo' porcelain. These influences were borne out in the June 1910 edition of *The Craftsman,* a New York monthly magazine, in which an article on modern country houses in England by Barry Parker illustrated 'building for light', naming Goodfellow House which he had designed with his partner Raymond Unwin.

This background of having such magnificent works of art around for my formative years as a child, student and young adult, lay dormant for many years, although some pieces came into my possession in my early married life. I became interested in these works of art, particularly as my father passed some objects on to me before he passed away. I then took over as the keeper and custodian and became aware of identification marks or backstamps on many pieces of ware, and also the lack of any evidence of origin.

I had the desire to enquire, particularly with all the differing wares that came under the description of pottery and porcelain. I think this seemed so attractive as my early retirement was imminent. Because my working life was spent within the mining industry and different aspects of education, I had never had any real contact with a pottery manufactory apart from a brief visit to Shorter & Sons with Colley when I was about twelve years of age. Neither had my father any involvement, apart from his late teenage days when he had worked with his father for a very short time at the mill before rebelling and leaving the country in the early 1900s to work as an electrical engineer in the United States of America. Ironically both my sons are now involved with the pottery industry.

My quest to understand the identification of many varied forms of pottery and porcelain led me to search for a variety of courses and subsequently to join the Northern Ceramics Society. The Society has proved invaluable, particularly in mixing continually with so many like-minded and friendly helpful people. There is much enjoyment and excitement when certain discoveries and revelations are made.

What I thought was going to be a gentle piece of research into my family involvement at the Vine Factory in Stoke upon Trent has now developed into a much wider brief – the Birks family in general.

Initially I relied heavily upon information published each month in the *Pottery Gazette* (later called the *Pottery Gazette and Glass Trades Review* but hereinafter referred to as the *Pottery Gazette)* for the period 1894 to 1934. More recently a variety of books have been most helpful, written by many learned people who have covered the subjects of sculptors and modellers, parian ware, the art of pâte-sur-pâte, and crested china, to name but a few skills of the industry that will be revealed in the following chapters.

Chapter 1.

The Beginnings

THE FAMILY BIRKS HAS FOR MANY YEARS BEEN INVOLVED IN THE ceramic industry around the North Staffordshire area, mainly in the town of Stoke upon Trent. However, it appears to originate from the marginally more northern area of the Staffordshire moorlands bordering Derbyshire.

The first indication of genius as a sculptor and modeller from rural stock was shown by Isaac Birks when at the age of ten in 1812 he modelled a black basalt creamer.[1] Impressed on the base is 'Isaac Birks No. 2. 1812. Aged 10 years' (Colour Plates 1 and 2). There is a probability that this piece of ware was classed as a test piece. A further indication of Isaac's skills is the extremely interesting glazed bust of a boy that he produced as a teenager in 1821 (Colour Plates 3 and 4). This pearlware bust is again clearly impressed on the base with 'Ic.Birks. Feby.22.1821'.

1. Now in a private collection.

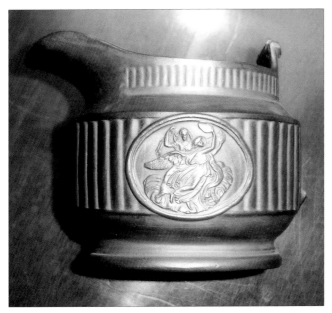

Colour Plate 1. Black basalt creamer, signed Isaac Birks and impressed No.2. 1812. Aged 10 years. 3in. (7.6cm) high.

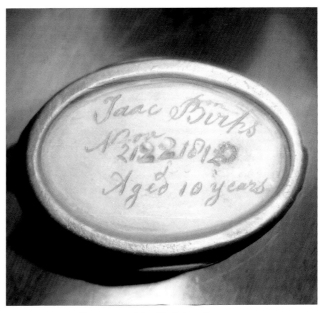

Colour Plate 2. Base view of the black basalt creamer.

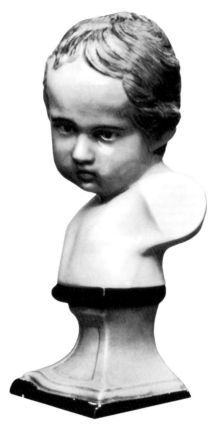

Colour Plate 3. Glazed pearlware bust impressed on the base 'Ic.Birks. Feby.22.1821'. 7¾in. (19.8cm) high. Photograph courtesy of Harry F. Blackburn, antiques lecturer in Melbourne, Australia.

The original source of the bust was a sculpture by François Duquesnoy (1597-1643), who worked in Rome for most of his working life. Duquesnoy was born in Brussels, Flanders, and was often referred to as Il Flamingo, the Fleming. He was a celebrated sculptor, specialising in sleeping babies.[2]

More recently another piece of Isaac's work came to light, a glazed red clay jug decorated with dynamic floral sprigging (Colour Plates 5-8). The outstanding feature is the base, which is impressed 'I.Birks. Foundation Clay. April ᵗʰ⁄. 1830'. Very little is recorded of Isaac's work, but he certainly appears to have been in the employment of Minton as several researchers of the Minton pottery quote 'active pre 1831'.[3] He was recorded in the 1851 census as a modeller, living in Temple Street, Fenton and he died in 1852 at the age of fifty.

The Minton records on staffing illustrate the extent to which the Birks family were involved at the factory, usually as modellers, in the middle to late nineteenth century. They were not all there together, but ten

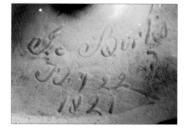

Colour Plate 4. Base view of the pearlware bust. Photograph courtesy of Harry F. Blackburn.

2. 'Ahead of his time', N.C.S. *Newsletter* No. 122, by Harry F. Blackburn.
3. *The Dictionary of Minton* by Paul Atterbury and Maureen Batkin.

Colour Plate 5. *Sprigged red clay jug, I. Birks 1830. 4¾in. (12cm) diameter, 6in. (15cm) high. Side view.*

Colour Plate 6. *Sprigged red clay jug, I. Birks 1830. Front view.*

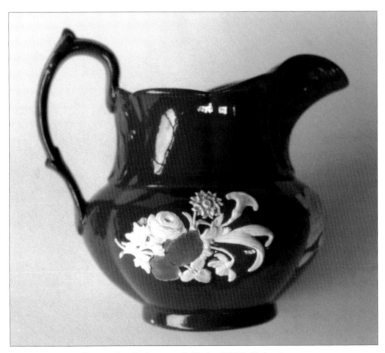

Colour Plate 7. *Sprigged red clay jug, I. Birks 1830. Side view.*

Colour Plate 8. *Inscription on base of sprigged red clay jug. 'I.Birks. Foundation Clay. April ᵗʰ₃ 1830'.*

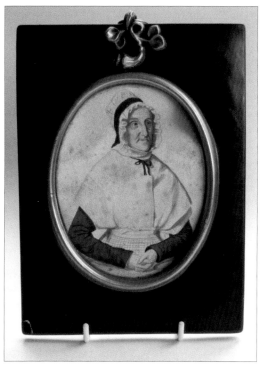

Colour Plate 9. *Portrait of Sarah Birks, Isaac's mother.* 5½in. x 7½in. (14cm x 19cm).

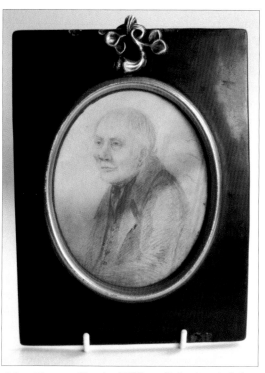

Colour Plate 10. *Sketch of William Birks, Isaac's father,* 10.7.1829. 5½in, x 7½in. (14cm x 19cm).

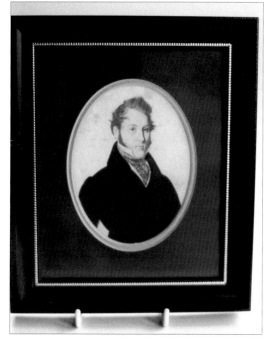

Colour Plate 11. *Portrait of Isaac Birks.* 6½in. x 7½in. (16.5cm x 19cm).

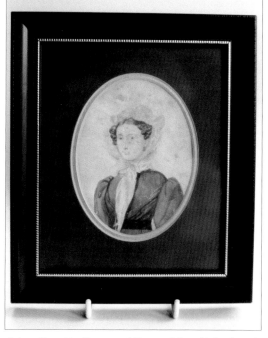

Colour Plate 12. *Portrait of Frances Mary Birks, Isaac's wife.* 6½in. x 7½in. (16,5cm x 19cm).

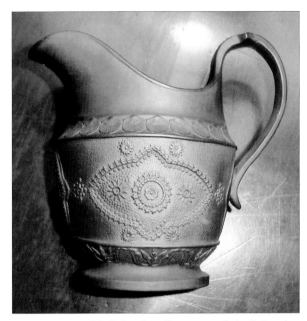

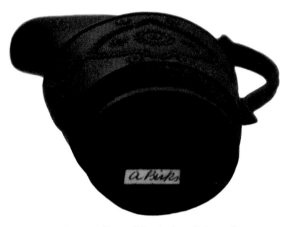

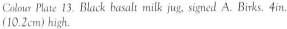

Colour Plate 13. Black basalt milk jug, signed A. Birks. 4in. (10.2cm) high.

Colour Plate 14. Base of the Arthur Birks milk jug.

members of the family covering at least three generations worked at some time at the factory – brothers, cousins, fathers, etc. Isaac had three brothers (Charles, Joseph and George) and he and his wife Frances Mary (née Viggars) had five children; their sons Arthur and Henry both entered the industry. Portraits of Isaac, his wife and his parents are illustrated in Colour Plates 9-12.

Arthur was the eldest son and is briefly mentioned in the Minton records, having worked at the Stoke upon Trent manufactory for a few years after leaving school in the first half of the nineteenth century. He left Minton after a very short time and became a modeller at the nearby Copeland manufactory in Stoke upon Trent (Colour Plates 13 and 14). Records show that he was an extremely gifted ceramic artist and he was the head modeller at Copeland, being responsible with his team of three to four fellow modellers for the entire output of wares between the years 1877 and 1898.[4] The other staff involved were Frederick W. Thorley, John Abraham and George Painter. The photograph[5] of the modelling room (Plate 1) shows the men at work, all looking at their colleague demonstrating his skill.

Arthur 'Spode' Birks, as he was known, retired in November 1898 from the Copeland manufactory to live on the shores of Rudyard Lake near Leek on the northern side of the Potteries (Plates 2 and 3). He had completed fifty-six years of service with Messrs. Copeland and the occasion was marked by his employers and fellow workmen presenting him with a magnificent vase (Plates 4 and 5). The handled vase, which measures 18in. (46cm) in height, exhibits fine workmanship with gilding

4. Daily work diaries of the modellers at the Copeland factory recently discovered and being recorded.
5. Photograph from the family archives.

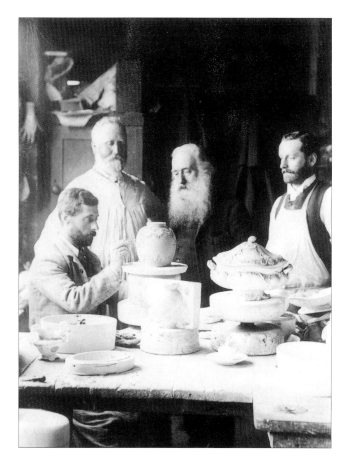

Plate 1. The modelling room at Copeland, c.1880, with John Abraham, Arthur Birks (head modeller), Francis Xavier Abraham (china manager) and George Painter.

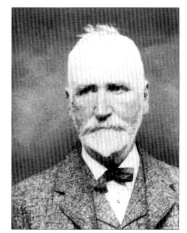

Plate 2. Arthur 'Spode' Birks.

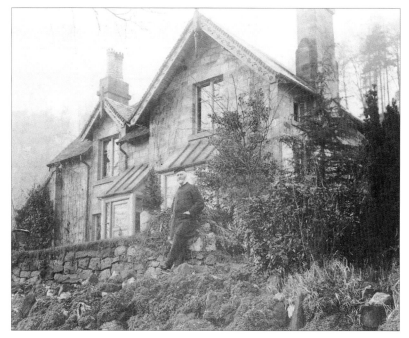

Plate 3. Arthur at his Rudyard house.

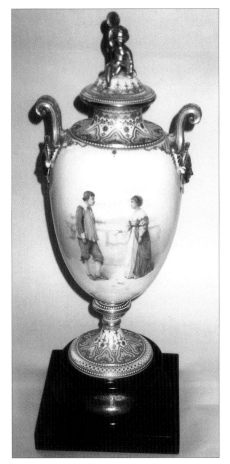
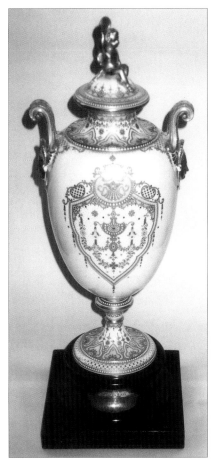

6. *The Dictionary of Minton.*
7. Census for 1891, Henry living at 111 Albert Road in Fenton.
8. *The Dictionary of Minton.*

Plate 4. The vase presented to Arthur Birks on his retirement in November 1898. 18in. (46cm) high, 22in. (56cm) high including the base. Plate 5. Reverse side of the presentation vase.

and different scenes on either side. There is an engraved plaque on the base (Plate 6).

Arthur's brother Henry, the second surviving son of Isaac, was one of the early pâte-sur-pâte (paste upon paste or body upon body) artists at Minton, active around the 1860s and 1870s.[6] Henry may be the artist named in the *Art Journal* who executed a pair of celadon vases decorated with embossed grasses, flowers, flies and birds shown at the International Exhibition of 1862. As well as being listed as a pâte-sur-pâte artist, he is also recorded working in the tile department on studio tiles in 1876. Henry went on to greater things after leaving the employ of Minton and became the manager of Pratt.[7]

George Birks senior, born c.1791 and brother to Isaac, was stated in the Minton archives[8] to be active pre 1835. He was mentioned as a modeller in the first available wages list for Minton, which commenced in 1831. He continued in the firm's employ until November 1835, but is not to be found in the 1841 census. His nephew George,

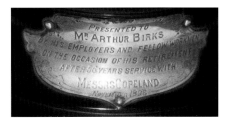

Plate 6. The inscription on the presentation vase reads 'Presented to Mr. Arthur Birks by his employers and fellow workmen on the occasion of his retirement after 56 years service with Messrs Copeland. November 1898.'

Plate 7. 'Literature' by George Birks junior. Shape 397. Modelled in the style of Carrier's series 'Art', 'Industry' and 'Science'.

born c.1819, joined the firm in 1832 and began his apprenticeship as a modeller under the direction of his uncle. George junior was employed at Minton for many years and it is thought that he definitely modelled a wine cooler, shape 582, and the parian figure entitled 'Literature'[9] shown at the 1862 International Exhibition.

Edward Birks, son of Joseph, was also apprenticed at Minton from 1876 to 1883.[10] However, before this Edward had joined Pinder Bourne in 1875 and he was regarded by John Slater, the Art Director from 1867 to 1914, as a flower painter of exceptional ability who executed many fine pieces in traditional style.[11] He had spent time at the Stoke School of Art as a pupil and later became a teacher there, before moving to the Doulton manufactory for six years between 1883 and 1889. His death at the early age of thirty-three cut short what had promised to be a brilliant career. Signed pieces by him are extremely rare.

Little is known of Frederick A. Birks,[12] who is recorded as being a designer around the last quarter of the nineteenth century. He created designs for decorative borders and ornamental wares and is identified in the census for 1861, when the family lived in Penkhull, as the stepson of George Birks, junior, and is described as a potter's figure worker.

Thomas Birks, who was active in the mid-1880s, was another pâte-sur-pâte artist, recorded by Atterbury and Batkin in *The Dictionary of Minton*. Signed work has not yet been found.

Alboin Birks (Plate 8) had a remarkable span of sixty years' working life at Minton. Born in Fenton in 1862, the second child of Henry and Elizabeth Birks, Alboin went straight to Minton on leaving Stoke St. Peters School to become an apprentice as a surface modeller (1876-1883). After completing his apprenticeship, he worked as a pâte-sur-pâte artist under the guidance of Louis Marc Emmanuel Solon, the grand master of this art, who had himself developed this form of ceramic decoration at the Sèvres factory in France. Alboin was the last of at least a dozen of Solon's pupils to be employed on this type of work. He worked on a series of fine portraits of John Campbell and other celebrities, also the famous Jubilee Vase presented to Queen Victoria, as well as other prestigious wares.

The *Pottery Gazette,* in its obituary,[13] paid tribute to one of his best works produced for the American market, the four-panel design depicting the seasons of the year on serving plates. The development of this change of technique took him two months to complete and many repetitions were ordered at high prices. The new technique (see Chapter 2, page 30), which was quicker than the famed method of pâte-sur-pâte decoration, involved an initial moulding being placed on the bone china body and then being completed with the original style of this art. Alboin will be remembered not only for his longevity at Minton, but also his clever draughtsmanship and for the successful execution of pâte-sur-pâte to a bone china body and not being confined to the historical and traditional parian body.[14]

9. Parian model, 'Literature' in *The Parian Phenomenon* by Paul Atterbury, p.110.
10. *The Dictionary of Minton.*
11. *The Doulton Burslem Wares* by Desmond Eyles.
12. *The Dictionary of Minton.*
13. *Pottery Gazette,* August 1941, p. 637 and *Evening Sentinel* newspaper, 28 June 1941.
14. *Pottery Gazette,* August 1941, p.638.

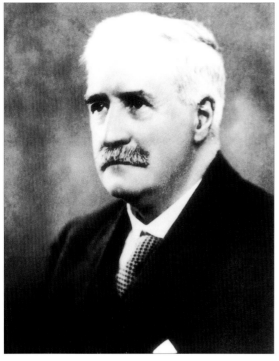

Plate 8. Alboin Birks.

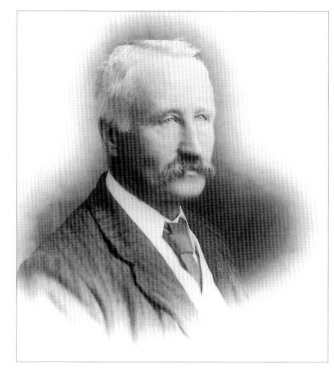

Plate 9. Lawrence Arthur Birks.

Tiffany's of New York, the biggest ceramic dealers in the world at that time, handled much of his work and the value they set on it was shown by their insistence that he should sign his pieces of ware boldly with 'A.Birks' instead of the modest 'A.B.' with which the artist himself was content.

Examples of Alboin's work appear in Chapter 2 which discusses the pâte-sur-pâte technique and products.

In addition to his work as a ceramic artist, Alboin did good pencil drawings and oil portraits.[15] He married (another Elizabeth) and lived in Ashford Street, Shelton, before moving to the 'White House' in Clayton, near Newcastle under Lyme, Staffordshire. Outside his domestic circle he had been captain of Fenton Cricket Club and later played for Trentham Club. He was keenly interested in music, being a regular concert-goer, and had a particular affection for Gilbert and Sullivan. He died in 1941, in his eightieth year, four years after his retirement, leaving a widow, two daughters and a son, Stanley, who was Assistant Director of Education to the county of Derbyshire.

Lawrence Arthur Birks (Plate 9) is the tenth to be highlighted as an employee at the Minton manufactory. Born in 1857, the eldest son of Arthur 'Spode' Birks and cousin of Alboin, Lawrence just had to be a potter's modeller and sculptor of considerable and outstanding talent; all the male members of the family were involved and had been working in the main manufactories of the area around the town of Stoke upon Trent.

15. *Evening Sentinel* newspaper, 28 June 1941.

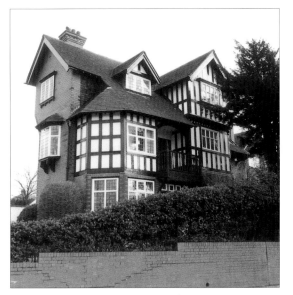

Plate 10. *'Highfield House', Hanford.*

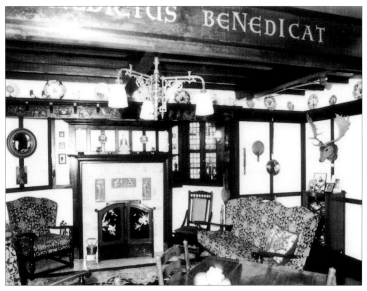

Plate 11. *Interior of 'Highfield House' showing pâte-sur-pâte tiles above a fireplace.*

Several generations of the family, as far as can be ascertained, were involved at either Copeland/Spode, Minton, Doulton or Pratt, and latterly Lawrence at his own factory in Summer Street, off Corporation Street, Stoke upon Trent, within three hundred yards of the Minton factory.

It is without doubt that he had the confidence as an artist to display his architectural achievement not only in designing the new Vine Pottery in 1899/1900, but also in the building of the family residence, Highfield House in Hanford, just two miles south of the town of Stoke upon Trent. This half-timbered building (Plate 10) shows Lawrence to have been a dedicated 'Arts and Crafts' follower, as it contains several features associated with the movement. Former colleague Edmond G. Reuter at Minton and brother-in-law Charles Frederick Goodfellow were both influential in the choice of styles of furnishing by the likes of William De Morgan, William Morris and Ernest Gimson. Goodfellow, a potter's miller supplying different clays to a group of manufacturers, also chose to build a house a mile and a half away using a similar William Morris theme for its style and furnishing. Goodfellow House, later renamed Chetwynd House, has recently achieved fame through Clarice Cliff living there in her final years.

Highfield House, referred to by the locals in the village as 'Birks Folly',[16] included two tiled fireplace surrounds created by Lawrence Birks himself (Plate 11), one with the motto 'Fire and Heat praise ye the Lord'. In the drawing room a dado of woven rushes must have been inspired by the rushes on the staircase at nearby Wightwick Manor, near Wolverhampton in old south Staffordshire, a house now noted for its William Morris influences.

16. Local history records.

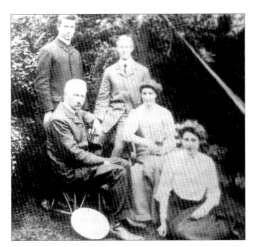

Plate 12. Lawrence Birks (seated) with family and friends at his home, Highfield House, Hanford, c.1908.

Plate 13. Lawrence Birks (right) and family and friends at Hanford. Alice Birks is sitting, with Ronald on her knee, and Sidney is at the back.

Atterbury and Batkin in *The Dictionary of Minton* state that Lawrence was active at the Minton factory between 1872 and 1894. He served his apprenticeship as a modeller between 1872 and 1878 and trained as a pâte-sur-pâte artist under Solon. Lawrence developed a style very similar to the master and was one of the few pâte-sur-pâte artists allowed to sign his own work (much more about this fine art is covered in Chapter 2).

Lawrence founded his own pottery, the Vine Pottery, in 1894 with his brother-in-law Charles Frederick Goodfellow. Operating on the site in Summer Street, Stoke upon Trent, they traded as Goodfellow Birks & Co. (G.B&Co.) but registered as the more popular Birks & Co. (B&Co.). The object of the manufactory from the outset was to produce fine bone china tableware. Lawrence designed a new factory five years later and he managed this operation for the next twenty-eight years as Birks Rawlins & Co. (B.R.& Co.) with fresh partners, brothers William Sidney Rawlins and Adolphus Joseph Rawlins,[17] who were grocers in the village of Hanford. Adolphus had already been involved in the financing of the firm from the formative partnership. Charles Goodfellow, meanwhile, withdrew to concentrate on supplying the relevant clay to his brother-in-law.

17. Stoke-on-Trent rate returns.

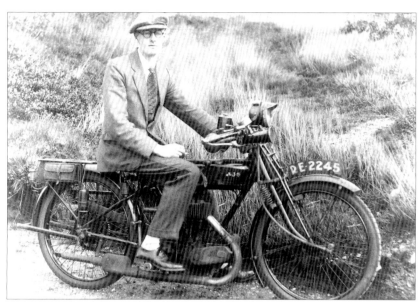

Plate 14. Ronald Birks on his motorbike in the 1920s.

Lawrence had two sons, Sidney (born in 1887) and Ronald (born in 1906). Sidney had considerable artistic talents, but little is known of his work at his father's factory. Ronald was the youngest of three children born at Highfield House to Lawrence Arthur and Alice Ann Birks (née Rhodes). On leaving school he completed several years at the local Art School within the North Staffordshire Technical College in Stoke-on-Trent and displayed quite an artistic talent, as can be seen on the plate depicting a sailing scene (Colour Plate 15). Following his older brother, Sidney, he was taken on by his father at the Vine Pottery in the early 1920s and appears in a photograph taken when Her Majesty Queen Mary was visiting the Birks Rawlins & Co. stand at the Potteries and Glass Exhibition within the British Industries Fair held at White City, London, from 28 April to 9 May 1924 (see page 73). He left to join the A.J. Wilkinson manufactory for a short spell, working under the works manager Austin Walker, before returning to his father's works again.

There are brief references to Ronald's work in *The Rich Designs of Clarice Cliff* by Richard Green and Des Jones. He is referred to as an industrial apprentice at the Newport Pottery, which had been taken over by Colley Shorter, Managing Director of the adjoining A.J. Wilkinson manufactory at Middleport, near Burslem. When the disaster of the National Strike in 1926 had taken its toll and the Vine Pottery had merged with Wiltshaw & Robinson, the makers of Carlton Ware, he returned to Colley Shorter's factory at the Newport site around 1928/29

He is said to have designed the 'Industry' ('Latona') design (Colour Plate 16) in the 1929-30 period, an industrial motif of symbols for water, electricity and power painted by Ronald at the Newport Pottery. The 'Latona' design was produced from 1929 to

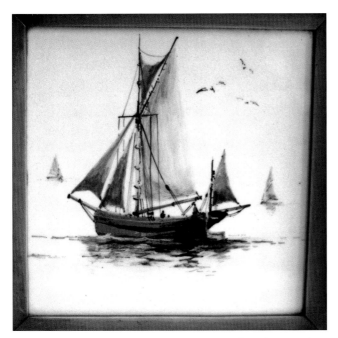

Colour Plate 15. Sailing boat plaque by Ronald Birks. No. 640.
5½in. x 5½in. (14cm x 14cm).

Colour Plate 16. The 'Industry' ('Latona') plate showing symbols for
water, electricity and power, designed by Ronald Birks.

1932; it had a milky coloured glaze with a matt surface and the designs were printed freehand. He also designed and modelled several 'grotesque' masks (Colour Plates 17 and 18), one of which is illustrated early in the Green and Jones book.

It is quoted that Ronald's work on the 'Latona' design and various grotesque masks was quite stunning in both colouring and design.[18] It had involved time in the so-called 'Bizarre' shop, where Clarice Cliff was establishing her work, and had led to some stylised industrial designs on 'Latona' glazed plates. It was in this environment that he modelled the large face masks. The features were inspired by a mixture of cubism and African tribal

18. *Clarice Cliff 'The art of bizarre'* by Leonard Griffin, pp.141-143. Leonard is the chairman of the Clarice Cliff Collectors' Club.

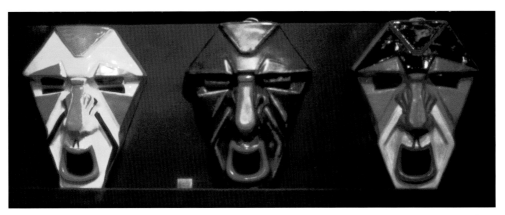

Colour Plate 17. Three coloured grotesque face masks modelled by Ronald Birks. Courtesy of Gaye Blake
Roberts at the Wedgwood Visitors Centre.

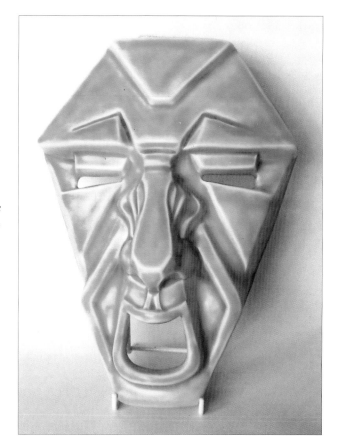

work, being 15in. (38cm) in height. The result, suitably called 'grotesque', was initially issued in 'Inspiration' glazes. Whilst at least one of these masks was to be located in just a pale green, the masks were mainly decorated in brighter colours, quite eye-catching as can be seen in the illustrations. They had rather a limited commercial appeal, but were seen regularly at exhibitions and remained in production in various designs until at least 1937. The three coloured masks were to be seen at the fairly recent Clarice Cliff exhibition at the Wedgwood Visitors Centre in 1999.

Ron Birks signed the few plates that he decorated on the front. The early masks have an impressed R.B. on the side, but this is omitted from later examples, although he was still at A.J. Wilkinson until the Second World War broke out.

Although initially an artist and modeller, like all his family before him, Ronald became A.J. Wilkinson's chief sales manager on the home market.[19] He later graduated to being in charge of the export and shipping department of the firm, before being called up to the armed forces for the Second World War (Plate 15).

Having spent time as a corporal in R.E.M.E. during the war, he was in 1945, like many other men, without employment. When he joined Wengers' marketing department in Stoke-on-Trent (Wengers supplied colours to the pottery industry and also owned Grindley Hotel Ware), so ended a family involvement in the ceramic industry, of modellers and sculptors, for some one hundred and twenty years.

Sidney Birks (Plate 17), older brother to Ronald by some eighteen years, showed a certain artistic flair early in his involvement at the Vine Pottery, but appears not to have signed any of his work. They were extremely bad times in the mid-1920s and sadly his wife

19. Information gained from Eric Grindley, another former employee at the A.J. Wilkinson Pottery, who took on Ronald Birks' responsibilities when he left the firm.

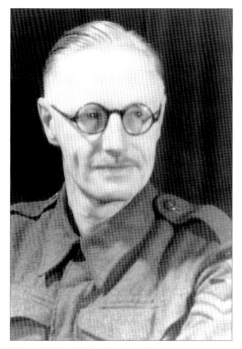

Plate 15. Ronald Birks in uniform.

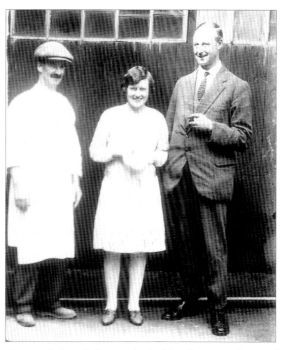

Plate 17. Sidney Birks outside the Vine Pottery with two of the workforce.

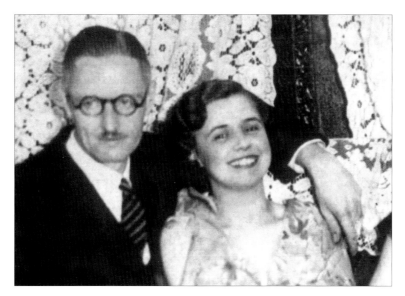

Plate 16. Ronald Birks and his wife, Vera.

died quite young, bringing tremendous grief to himself and his daughter, Marjorie.[20] The collapse of the factory by a merger in 1928 and then the Wall Street crash in the United States of America in 1929 resulted in a decline in his health. Sidney had taken on certain responsibilities in the sales area which really suffered in this period, due to lack of finance generally and also because the majority of wares produced by the Vine Pottery had been for export. His was sadly a fairly brief career in extremely difficult times for the economy across the whole country. He died in 1941, aged fifty-four.

20. Family information.

Chapter 2.

The Pâte-sur-pâte Influence at Minton

LOUIS MARC EMMANUEL SOLON CAME TO ENGLAND IN SEPTEMBER 1870,[1] following the evacuation of Sèvres in France in the face of the Prussian army advancing into the country, and the consequent forced closure of the Imperial Manufactory at Sèvres. He was immediately engaged by Colin Minton Campbell, managing director of the Minton pottery in Stoke upon Trent, the heart of the English Potteries. His work at Minton established him as the most celebrated pâte-sur-pâte artist in the world. He was a true master.

Soon after establishing himself at the manufactory, Solon began to attract apprentices to his style of work and Lawrence Arthur Birks appears to have joined him in March 1872.[2]

The production and demand for pâte-sur-pâte had so increased[3] after the 1871 London International Exhibition that Lawrence Birks had his own 'L.B.' monogram on a pair of small bottles.[4] There were three apprentices at the time, the others being Frederick Alfred Rhead and Henry Saunders (or Sanders), and they were required to produce works of their own to supply swiftly the needs of those people who could not afford the high prices charged for Solon's work. The designs for these wares were basically simple in that they usually consisted of flowers, foliage, insects and birds, and sometimes cupids.

Greater demand for the extremely slow and painstaking pâte-sur-pâte necessitated an increase of apprentices from three in 1872 to six in 1873/74 and again to nine in 1877. Lawrence Birks' cousin Alboin[5] was now one of the team of nine apprentices. Shortly after this boost, Henry Saunders and Frederick Rhead left Minton for new pastures.

Plaques/tiles made in 1877 illustrating Solon's work at his home for Minton were many years later adapted by Alboin Birks for tableware. The pieces were called 'Papillons' (butterflies) and 'Abeilles' (bees).

A vase by Lawrence Birks proved an outstanding success for Minton in 1878 at the Paris Universal Exhibition,[6] so much so, indeed, that it was purchased by the Musée des Arts Décoratifs in Paris where it still remains in their reserve collection.

The large Jubilee vase presented by Minton to H.M. Queen Victoria in 1887 on the occasion of her Golden Jubilee illustrates the amount of time spent on the pâte-sur-pâte

1. *Pâte-sur-pâte. The Art of Ceramic Relief Decoration 1849 to 1992* by Bernard Bumpus, p.100.
2. Ibid., p.102.
3. Ibid., p.107.
4. Ibid., p.107.
5. Ibid., p.114.
6. Ibid., p.116.

process of decoration. Solon was reputed to have spent seventy-eight days and Alboin Birks ninety-three days on this one piece of ware. Minton stated that the vase was the greatest triumph of the potter's art ever achieved. It can be seen in Osborne House and stands 31in. (78.8cm) high. Not many other pieces of pâte-sur-pâte were made or recorded in the Minton estimate book for that year.

Alboin Birks' contribution to this vase seems to have been omitted from Minton's and Solon's records,[7] but the fact that he had been selected to work on such an important piece of ware rather suggests that he was likely to succeed the great master of pâte-sur-pâte when he retired.

Although marked with his monogram, a small vase by Lawrence Birks in 1878 showing Venus teaching Cupid to shoot does not appear under his name in Solon's estimate book, even after he had been working as an apprentice for nearly twenty years. It could be felt that this lengthy term of apprenticeship would be rather tiresome. In fact another similar vase was shaped by cousin Alboin and is illustrated in G.A. Godden's book *Victorian Porcelain*. Although all these designs evolved from Solon, not all were marked by monograms identifying the various apprentices employed at Minton; consequently it is difficult to say who did certain pieces.

The 1889 Paris Universal Exhibition saw contributions from the Birks cousins. They were named as the artists who had produced a pair of vases,[8] but they were not identified in the Minton records. However, there was a double inkstand that was marked with the monogram of 'A.L.'[9] which could be interpreted as Alboin's and Lawrence's work. Solon's estimate book does in fact show that Lawrence Birks had decorated another inkstand of very similar design, so this lends support to the belief that he was involved in the decoration of this 1889 piece. It is also thought that another vase (Colour Plate 19)[10] by Lawrence Birks was on display at this Paris Exhibition.

Difficulties appeared to arise in the few years after this exhibition and various pieces of pâte-sur-pâte failed to sell. With these financial problems several of the apprentices were laid off in the early 1890s, but Lawrence Birks decorated a large vase entitled 'Winter'[11] in two versions (Colour Plate 20), the second being completed in June 1894. It was considered that the work on this piece was worthy of Solon himself, a

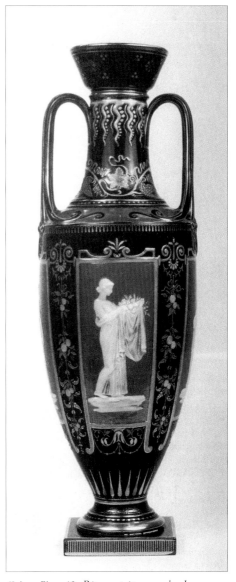

Colour Plate 19. Pâte-sur-pâte vase by Lawrence Birks, 1885, Minton, 17½in. (44.5cm) high. Bumpus, p.132.

7. Ibid., p.129.
8. Ibid., p.130
9. Ibid., p.131.
10. Ibid., p.132.
11. Ibid., pp.138, 139, 141.

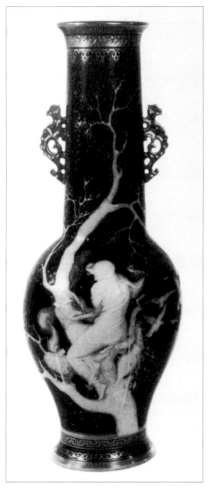

Colour Plate 20. Pâte-sur-pâte vase, 'Winter', by Lawrence Birks, 1894, Minton, 19¼in. (49cm) high. Bumpus, p.141.

compliment to the skills Lawrence had developed during his twenty-two years working with the great master.

When he left Minton later in 1894, Lawrence established his own pottery manufactory in Stoke upon Trent, some three to four hundred yards away from the Minton factory. The Vine Pottery spasmodically produced quite exciting pieces of pâte-sur-pâte for approximately the next twenty-five years.

Alboin Birks was now the sole surviving apprentice[12] to Solon and from this time there is evidence of his name being recorded in the estimate book for Minton. Alboin was now thirty-five years of age and had been with the Minton manufactory for nineteen years. He had been born in Fenton, where his father, Henry, later became the manager of Pratt.

A selling exhibition in May 1894 held at the Imperial Institute in London showed many pâte-sur-pâte pieces,[13] but only the work of M. Solon was identified in the catalogue. It was probably thought that potential buyers would only be attracted to Solon's work and not that of the apprentices. Despite the pruning of the staff Minton continued to make losses and this was probably a reason for not participating in the 1900 Paris Universal Exhibition. The manufactory nearly went out of business, but despite this Solon and Alboin Birks continued an output of the ware during the 1890s and into the 1900s. Over a period of two years, around 1894, Alboin had produced five garnitures[14] with identical designs but different coloured backgrounds, namely pink, cream, white and yellow (one garniture could be, and was, produced in different coloured backgrounds). Bernard Bumpus illustrates Alboin's work of this period in his book *Pâte-sur-pâte* with figures 108 and 110, where there are a pair of Pembroke ewers and a matching vase illustrated firstly, and secondly a Minton vase (Colour Plates 21 and 22).

After the retirement of Solon in March 1904 the only artist employed at Minton was Alboin Birks who continued to work in the style of the master, decorating plaques, vases and a large volume of high class wares.[15] He used his full name to mark pieces, not his usual AB monogram, a change perhaps insisted on by the retailer, Tiffany, in New York. Tall slender vases appear to have been a favourite with Alboin, where panels of the work were produced on the front and reverse, showing nymph and cupid theme variations.[16]

Another example of Alboin's work around the turn of the century was the cache-pot illustrated in Colour Plate 23. Nymphs and two cupids feature in a similar vase which suggests Solon's influence. Obviously many Solon designs were adapted by Alboin in the next few years – for example 'Le Collier',[17] 'Learning to shoot', 'Abeilles' and 'Papillons' – as decoration on many differently shaped vases and for the central design of plates.

12. Ibid., p.139.
13. Ibid., p.140.
14. Ibid., p.144, Figure 108.
15. Ibid., p.142.
16. Ibid., pp.45-46, Figures 110 and 111.
17. Ibid., p.143.

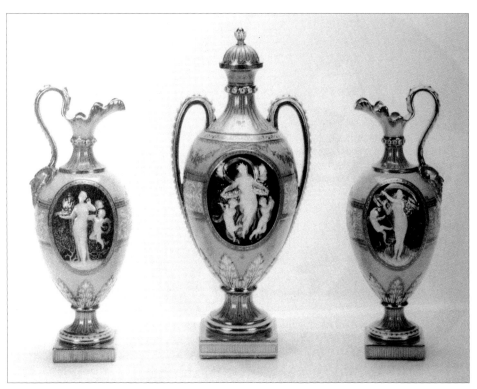

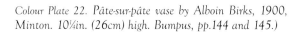

Colour Plate 21. Pâte-sur-pâte Pembroke ewers and vase by Alboin Birks, 1894, Minton.

Colour Plate 22. Pâte-sur-pâte vase by Alboin Birks, 1900, Minton. 10¼in. (26cm) high. Bumpus, pp.144 and 145.)

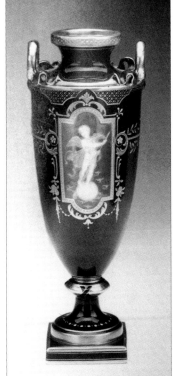

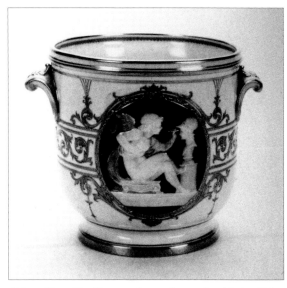

Colour Plate 23. Pâte-sur-pâte cache-pot by Alboin Birks, c.1900, Minton.6⅞in. (17.5cm) diameter.

The North American market was creating a demand for pâte-sur-pâte decorated tableware,[18] and money talks. Consequently a quicker method was required to produce the fine art and Alboin Birks developed what is now known as the moulding process, which overcame certain difficulties. This had been tried to a certain degree by George Jones at the Crescent Pottery (next door to Minton off South Wolfe Street in Stoke upon Trent, founded in 1861) and others some twenty years before. Pâte-sur-pâte had up until that time been applied to a parian body, which was acceptable for decorative dessert plates, but unsuitable for tableware. The application of pâte-sur-pâte to bone china had shown a proven chemical reaction, where the oxides of the parian body were attacked by the phosphate of lime contained within the china body. Alboin Birks worked the pâte-sur-pâte on to parian panels to overcome this problem and the panels in turn were then applied to the bone china body. A method was also devised whereby preliminary work on the pâte-sur-pâte decoration was carried out by means of the moulding process. The ware would then have its finishing touches applied by the accepted and proven pâte-sur-pâte techniques, thus enabling identical designs to be applied to table services of twelve with a relatively low cost compared with the old technique (Colour Plate 24).[19]

Alboin Birks developed an extension of the new technique with an interesting range around 1909. Boxes with patterns called 'Tug of war' and 'Fir branches'[20] were marketed along with buttons, having designs that were called 'Vine', 'Trophies', 'Rose', 'Poppy', 'Fir cones' and 'Cameos'. Some teapot stands were produced around this period with classical scenes in a variety of colours, whilst the 'Tug of war' mould was used in the production of peacock blue plaques that were framed and exported to the United States of America.

Some of Alboin Birks' tableware and several vases by Solon were shown at the Brussels Exhibition in 1910[21] and the Turin International Exhibition in 1911. Apparently pâte-sur-pâte work did catch the eye and special mention was made of that produced by the relative newcomers on the scene from the Birks Rawlins factory in Stoke upon Trent (see page 128).

Alboin Birks remained at Minton until his retirement in 1937 and over these next twenty-six years he introduced many different designs for his pâte-sur-pâte tableware (Colour Plates 25-54). Typically he featured nymphs and cupids, female figures in classical dress, all clearly influenced by Solon. A considerable

18. Ibid., p.144.
19. Ibid., p.148, Figure 113.
20. Ibid., p.144.
21. Ibid., p.146.

Colour Plate 24. Pâte-sur-pâte plate by Alboin Birks with decoration by John Wadsworth. 10¼in. (26cm) diameter. Bumpus, p.148.

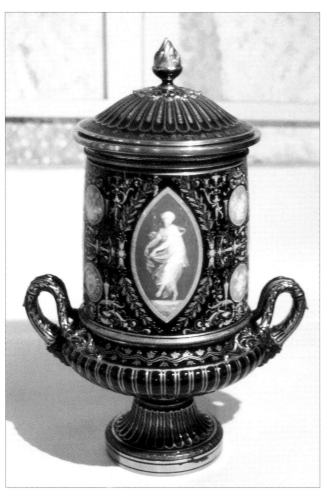

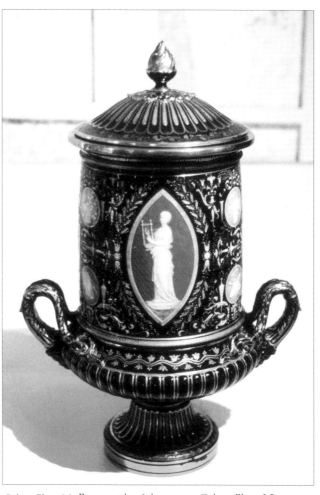

Colour Plate 25. Pâte-sur-pâte vase with lid, signed 'A.B.', shape 2108, Minton. 20in. (50.8cm) high, 7½in. (19.05cm) diameter.

Colour Plate 26. Reverse side of the vase in Colour Plate 25.

amount of pâte-sur-pâte tableware was included in the Minton exhibit at the 1925 Exposition Internationale des Arts décoratifs et industrials de Paris.[22] The demand for Minton tableware in the United States and Canada was so great that they employed an extra hand in the technique; Richard Bradbury became Birks' assistant around 1927. Despite the massive international financial crisis of 1929, when all orders from the United States were cancelled, Minton kept pâte-sur-pâte in production, after a short stoppage, when most other staff at the factory were laid off.[23] This must have been done for purely prestigious reasons.

Despite all the setbacks to the pottery industry caused by the 'Great Strike' in 1926, affecting quality directly, and then this financial slump, the fine art work continued to be produced with Bradbury and Birks each complementing each other with exciting designs on tableware at the Minton manufactory.

22. Ibid., p.146.
23. Ibid., p.147.

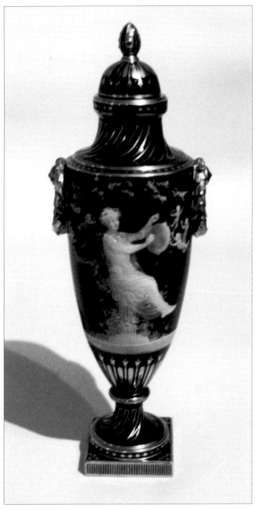

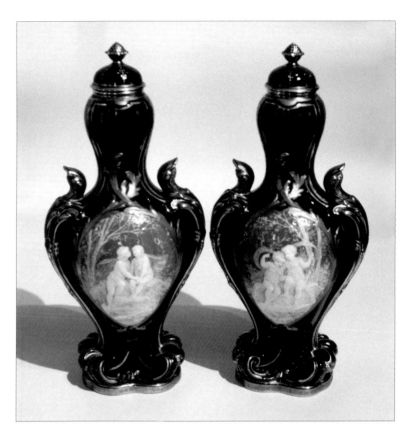

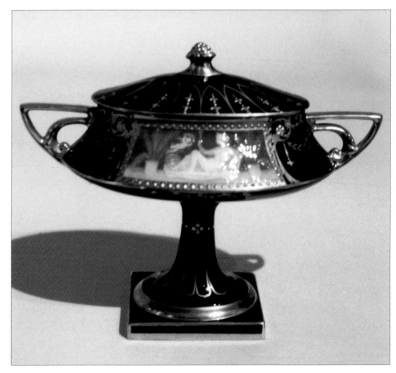

Colour Plate 27. Pâte-sur-pâte vase with lid, signed 'A.B.', Minton. 14in. (35.56cm) high.

Colour Plate 28. Two pâte-sur-pâte vases with lids, signed 'A. Birks', Minton. 13½in. (34.29cm) high.

Colour Plate 29. Pâte-sur-pâte two-handled vase, green background, signed 'A/B.', Minton. 7in. (17.78cm) high.

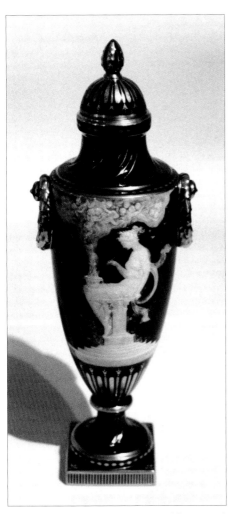

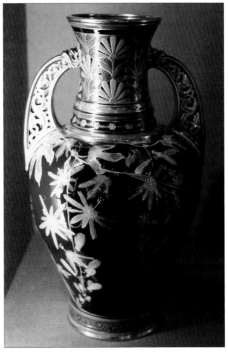

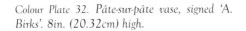

Colour Plate 31. Pâte-sur-pâte vase, signed 'A.B.'.
7½ x 13½in. (19.05 x 34.29cm).

Colour Plate 32. Pâte-sur-pâte vase, signed 'A.
Birks'. 8in. (20.32cm) high.

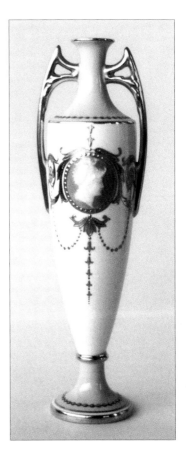

Colour Plate 30. Pâte-sur-pâte vase, blue, signed
'A.B.', Minton. 13¾in. (34.93cm) high.

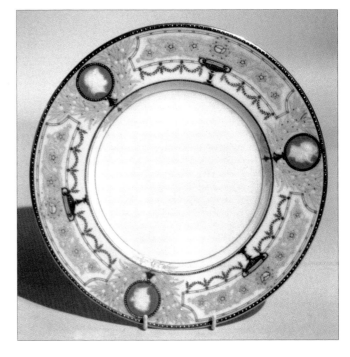

Colour Plate 33. Pâte-sur-pâte plate, signed 'A.B.', Minton.
10¼in. (26.04cm) diameter.

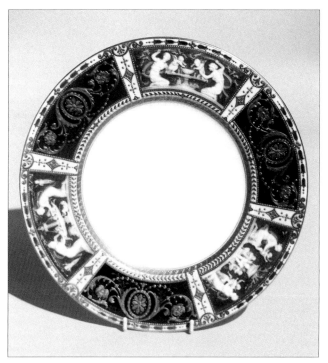

Colour Plate 34. Pâte-sur-pâte plate, by A. Birks, 10¼in. (26.04cm) diameter.

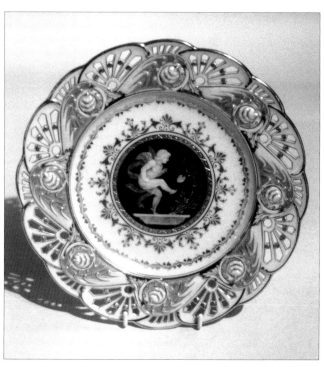

Colour Plate 35. Pâte-sur-pâte pierced plate, signed 'A. Birks', Minton. 9½in. (24.13cm) diameter.

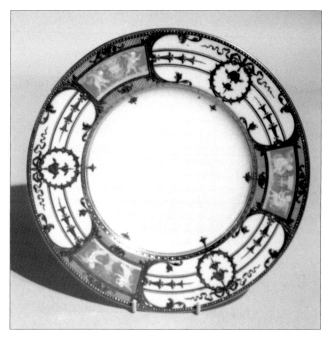

Colour Plate 36. Pâte-sur-pâte plate, signed 'A. Birks', Minton. 10¼in. (26.04cm) diameter.

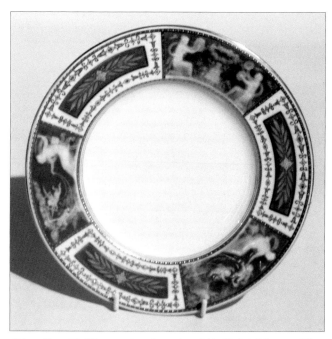

Colour Plate 37. Pâte-sur-pâte plate, signed 'A. Birks', Minton. 7¾in. (19.69cm) diameter

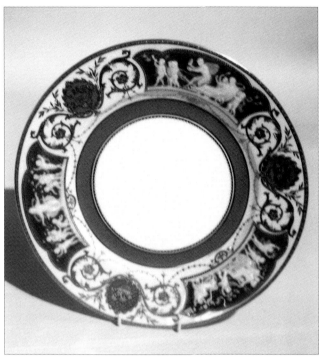

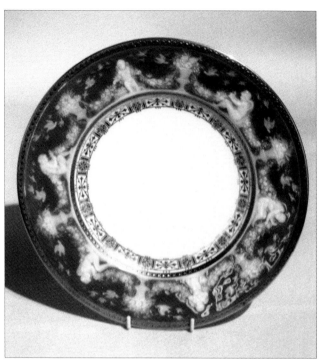

Colour Plate 38. Pâte-sur-pâte plate, signed 'A. Birks', Minton. 11½in. (29.21cm) diameter.

Colour Plate 39. Pâte-sur-pâte plate, signed 'A. Birks', Minton. 10½in. (26.67cm) diameter.

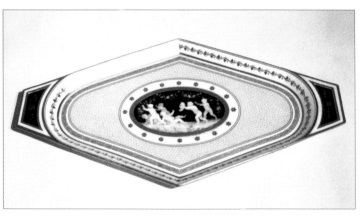

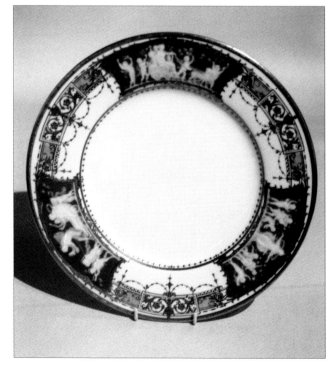

Colour Plate 40. Pâte-sur-pâte plate, signed 'A.B.', Minton. 20½ x 11in. (52.07 x 27.94cm).

Colour Plate 41. Pâte-sur-pâte plate, signed 'A.B.', Minton. 11¼in. (28.58cm) diameter.

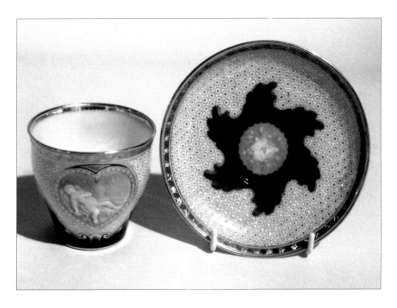

Colour Plate 42. Pâte-sur-pâte cup and saucer, signed 'A.B.', Minton. 2¾in. (6.99cm) high.

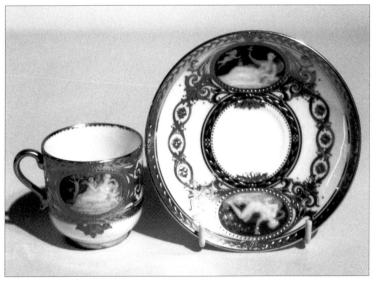

Colour Plate 43. Pâte-sur-pâte cup and saucer, signed 'A. Birks'. Cup 2¼in. (5.72cm) high, saucer 4¾in. (12.07cm) diameter.

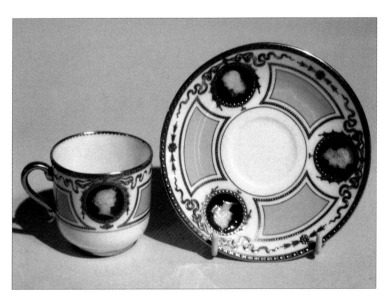

Colour Plate 44. Pâte-sur-pâte cup and saucer, signed 'A. Birks'. Cup 2¼in. (5.72cm) high, saucer 4¾in. (12.07cm) diameter.

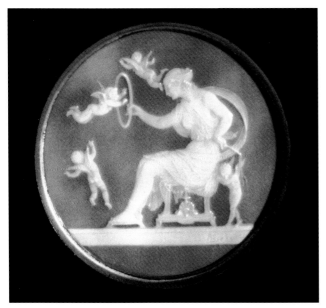

Colour Plate 45. Pâte-sur-pâte circular plaque by Alboin Birks. 3¾in. (9.53cm) diameter.

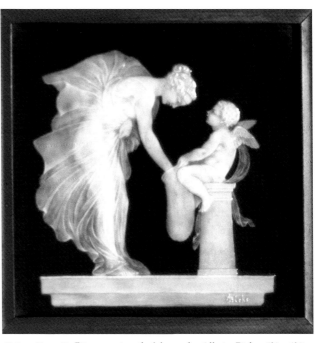

Colour Plate 47. Pâte-sur-pâte tile/plaque by Alboin Birks. 4¾ x 4¾in. (12.07 x 12.07cm).

Colour Plate 46. Alboin Birks' signature on the plaque in Colour Plate 45.

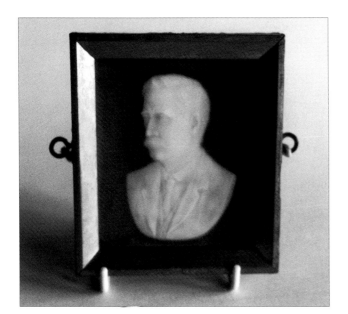

Colour Plate 48. Pâte-sur-pâte plaque with a self-portrait of Alboin Birks. 3½ x 2⅞in. (8.89cm x 7.3cm).

Colour Plate 49. Pâte-sur-pâte slab/tile signed 'A.B.'. Minton. 5⁵⁄₁₆in. (13.5cm).

Colour Plate 50. Pâte-sur-pâte vase by Alboin Birks. 6¼in. (15.9cm) high, 5in. (12.7cm) diameter.

Colour Plate 51. Reverse of the vase in Colour Plate 50.

Colour Plate 52. Pâte-sur-pâte vase signed 'A.B.', Minton. 7in. high.

Colour Plate 53. Reverse of the vase in Colour Plate 52.

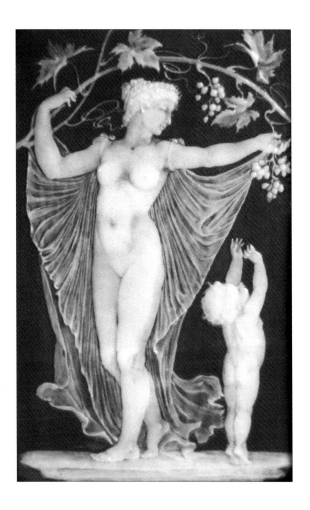

The Lawrence Birks phenomenon

Lawrence Arthur Birks, as already stated, had already worked twenty-two years for the Minton Pottery, serving a long apprenticeship to the famous pâte-sur-pâte artist Louis Marc Emmanuel Solon. He left the company some time in 1894, when the factory was having grave financial problems, with the conscious decision to set up his manufactory within a few hundred yards of Minton in the same town of Stoke upon Trent. He commenced trading as L.A. Birks & Co. in 1894, but in 1900 the firm became known as Birks Rawlins & Co. More details of the firm and its various partnerships are explored in later chapters.

Lawrence Birks was a most highly skilled pâte-sur-pâte artist and continued to work patiently on many individual pieces. An account was reported by the *Pottery Gazette* when giving publicity to the Vine Pottery in the monthly magazine.[24] Apparently the journalist was so impressed with the ceramic wares that he reported they were beautiful examples of the most difficult class of fine art ceramics and could be compared with

24. *Pottery Gazette*, July 1902, p.685; Bumpus, p.163.

Colour Plate 54. Pâte-sur-pâte plaque by Lawrence Birks, 7⅞ x 4½in. (20 x 11.43cm). From the Pottery Gazette.

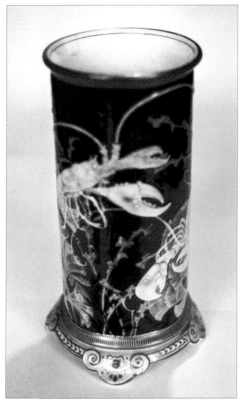 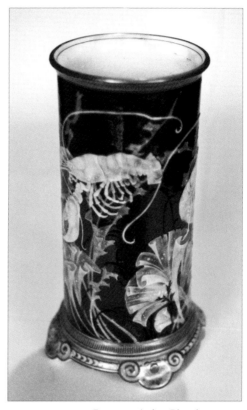

Colour Plate 55. Pâte-sur-pâte vase, 'Marine Animals', signed F.A. Rhead. 12in. (30.48cm) high, 5½in. (13.97cm) diameter.

Colour Plate 56. Reverse of the Rhead vase in Colour Plate 55.

the work of Solon. The tour of the factory revealed that the plaques in question were not to be seen in any of the rooms as a form of 'commercial' art ware and it was only at the pleading of the magazine's staff that Lawrence Birks consented to exhibit the three plaques in the group of wares appearing on 1 July 1902. Lawrence was careful to indicate that he could devote to this work only such time as he could spare from the control of a busy factory. The three plaques[25] illustrated appear as two on the top row and one in the centre of the second row, the one in Colour Plate 54 being called 'Offering bunches of grapes to Cupid'. Cupid is depicted as wingless.

There is little written in any of the trade magazines about the art of pâte-sur-pâte for the factory until 1911 when Birks Rawlins & Co. exhibited at the International Turin Exhibition. Vine Pottery had attracted many fine artists during the early 1900s; Frederick A. Rhead and his two daughters Charlotte (Lotty) and Dolly brought some extremely exciting designs to the manufactory. Amongst the display at Turin were some outstanding decorative wares that caught the eye and the *Pottery Gazette* reporter was equal to the occasion with deserved praise when commenting on the work of Frederick and Charlotte Rhead, William Leak and Lawrence Birks. Obviously Lawrence used this exhibition[26] as a launching pad for Birks Rawlins & Co. to make its mark on the international scene by

25. Bumpus, Figure XXV.
26. Ibid., p.164.

displaying a magnificent range of the factory's products and the official British catalogue contained a long entry for the firm. A collection of vases[27] executed in the pâte-sur-pâte process gave a cameo effect; it was a sculptured decoration, generally in white on dark grounds of varying colours. There were new effects in this process, coloured pastes having been used more than hitherto. Among the wares were the cylinder vases of 'Marine Animals' (Colour Plates 55 and 56) and a vase with a snake design by Frederick Rhead. Lawrence Birks' own exhibits included a dessert plate with the scene called 'School of Acrobats'[28] (Colour Plate 57), a vase 'Sowing' and a pair of vases 'Morning' and 'Night', titles suggesting the continued influence of Solon on his designs.

There was also a pair of bowls, 'Ships', by Charlotte Rhead (later to become famous for tube-lined wares), a unique reference to her pâte-sur-pâte work. So accomplished was this display and so impressive with its variety of wares that the Turin organisation awarded the Diploma of Honour to Birks Rawlins & Co.[29]

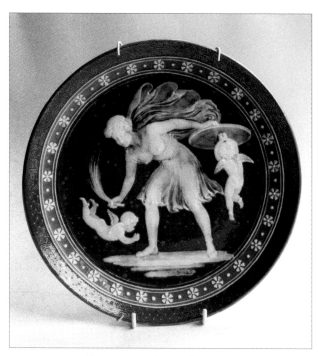

Colour Plate 57. Pâte-sur-pâte dessert plate, 'School of Acrobats', signed L.A. Birks. 9½in. (24.13cm) diameter.

The famous Pottery Exhibition two years later at the King's Hall, Stoke upon Trent in April 1913 had on view a beautiful collection of Birks Rawlins' fine bone china and porcelain of 'interesting diversity for the inspection of their Majesties King George V and Queen Mary upon their visit to the Potteries' (see illustrations from the Child report, page 42).

Many of the wares were admired by the Queen again in May at the Harrods store in Brompton Road, London, where there was a selection of the exhibition items. Later in the same year at the Ghent Exhibition in Belgium the factory were awarded the Diploma of Honour for their wares.[30] Among the many pieces exhibited were conspicuous pâte-sur-pâte plaques and vases, one or two Frederick Rhead designs being worthy of note. Most impressive was a design representing giant lobsters and seaweed, accompanied by another vase illustrating a quatrain from the *Rubaiyat of Omar Khayyam*, with a draped female figure appropriately posing in the foreground and an Oriental city behind. The *British Architect* magazine was particularly enthusiastic about the lobsters and seaweed vase, commenting: 'Nothing finer of its kind has surely ever been done than the beautiful translucency obtained in the vase with lobsters and seaweed, so charmingly designed by Mr Rhead'.[31] The same journal also illustrated his Omar Khayyam vase, observing that the modelling of the figure seen through the drapery was a 'triumph of the process.'[32] It would appear, without any record of employ-

27. *Pottery Gazette*, July 1911, p. 781; Bumpus, p.164.
28. Bumpus, p.164.
29. *Pottery Gazette*, July 1911, p.781; Bumpus, p.165.
30. *Pottery Gazette*, November 1913, p.1278.
31. Bumpus. p.165.
32. Bumpus. p. 165; *The British Architect*, 12 September 1913. pp.183-195.

Illustrations from the Illustrated Souvenir of the Royal Visit in 1913 compiled and edited by J. Child.

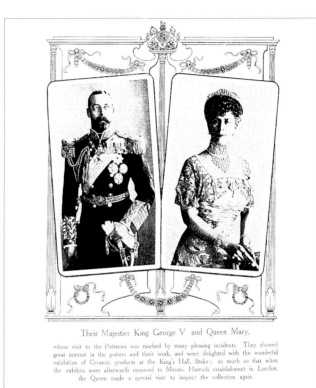

— THE —

Staffordshire Potteries

AS AN EMPIRE ASSET

— AND —

Illustrated Souvenir of the Royal Visit.

COMPILED AND EDITED BY J. CHILD.

Printed and Published by
The Manchester Courier Ltd., at their Offices, 22, Cannon Street, Manchester, England.

Their Majesties King George V and Queen Mary,

whose visit to the Potteries was marked by many pleasing incidents. They showed great interest in the potters and their work, and were delighted with the wonderful exhibition of Ceramic products at the King's Hall, Stoke ; so much so that when the exhibits were afterwards removed to Messrs. Harrods establishment in London, the Queen made a special visit to inspect the collection again.

kind of domestic and table ware in porcelain, as well as vases and other objects d'art which may be termed luxuries. Tea, breakfast, and dessert sets are the staple productions, and these are decorated in a variety of ways to suit every purse. The simplest decorations, however, are as carefully designed as the more elaborate, and the ablest designers, including Mr. E. G. Reuter, have been engaged in their production. Mr. Reuter, perhaps the finest ceramic designer of the day, was a collaborateur of William Morris.

Messrs. Birks, Rawlins & Company have taken into account the modern trend towards the reproduction of historic and antique types, and have examples of reproductions of Old Chelsea, Bow, Derby, Worcester, Sèvres, as well as replicas of famous Oriental models. A most

Mushrooms
slip decoration
by Birks Rawlins & Co.

SOME FINE MOULDINGS

BIRKS, RAWLINS & CO.

Messrs. Birks, Rawlins & Co., Vine Pottery, Stoke-on-Trent, are perhaps unique among china manufacturers as regards originality and a certain distinctive character, both of material and treatment. The firm makes every

successful reproduction is the Bristol dish, now in the Stoke-on-Trent Museum from the well-known Trapnel collection, for which the sum of £60 was paid. Another is from the service executed for Queen Charlotte by the Old Chelsea Factory. The quality of their porcelain is well known, and every effort is made to apply decorations which accentuate but do not conceal the inherent beauty of the material itself. While Messrs. Birks, Rawlins & Company do not ignore the popular taste for reproductions, their efforts are mainly directed towards types of decorations of which they may claim the origin and introduction. These are too numerous to be recapitulated. A notable example in the decoration of vases is the " Persindo " decoration which, as its name suggests, is a revival of the Persian style of ornament applied in a similar way to the well-known Rhodian wares. The

Persian trick or talent for the harmonious combination of gay primary colours without a suspicion of garishness is exemplified here. There are many graceful forms of vases decorated with " Persindo."

Another feature of the firm's products is the Heraldic ware. These are so well known as to preclude the necessity for description, and it is enough to say that Messrs. Birks, Rawlins and Company have an unsurpassed range of shape quaint, graceful, historic, or humorous. They are also celebrated for their views. In the higher branches of the ceramic art the firm has received the appreciation of the ceramic experts of Europe in the form of two Awards of the Grand Diploma of Honour at the

A very beautiful revival of trellis baskets, decorated with modelled and painted flowers of the fashion of Old Bow, is one of the most recent productions of the firm. The baskets are woven and built from clay, rolled strips, exactly as wicker baskets are made piece by piece. Her Majesty the Queen admired and purchased examples of this beautiful ware at the recent exhibition at Messrs. Harrods. The Porcelaine à la Copenhagen executed by this firm was admired by King George, who declared at the King's Hall that it was the most like the original that he had seen.

In their exhibit at the King's Hall the domestic element was leavened with an admixture of purely ornamental pieces—a natural corollary of the fact that

Surprise
by T. A. Elliot

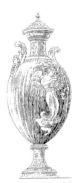

Music
by L. A. Birks

Shooting Stars
plaque in Pâte-sur-Pâte. L. A. Birks

Ceramics at the Ghent Exhibition
derived from exhibit by Birks, Rawlins & Co.
Stoke-on-Trent

International Expositions of Turin and Ghent. There, as also at the King's Hall, Stoke, were seen examples of the famous and exquisite pâte-sur-pâte wares in a variety of treatments, including classic designs, animals, birds, and essays in polychromatic pastes, unique of their kind.

Mr. Lawrence Birks, who by the way was a pupil of the famous Marc Solon, had some charming examples of plaques and vases, decorated with classic figures. Mr. Ridgway has also quite a different and original method of applying coloured pastes in porcelain, and his quaint marine and Dutch landscapes, treatments of birds in the Japanese manner, as well as decorative little Japanese figures, are quite distinctive in colour and method.

A series of pierrots on black grounds are noteworthy.

Mr. A. L. Birks, the senior partner of the firm, was for twenty years in the atelier of M. Solon, the well-known ceramic artist. Hence some good specimens of pâte-sur-pâte decoration applied on plaques were shown. The domestic services are largely decorated in cobalt, though other colours are not absent, and display a wide repertoire of various styles, such as Oriental, Moustiers, and Delph. Some of the services elaborately gilt and with enamelled painted panels are extremely rich in their effect. The firm also show a number of tasteful specimens of iron porcelain, decorated with heraldic devices and in Rhodian and Persian style, and a number of porcelain pots delicately painted in blue-grey monochrome in the manner of Copenhagen ware.

ment of the staff at the factory, that this was the last occasion on which Frederick Rhead had his work displayed by the Birks Rawlins Company, as he had taken another important step in his life, becoming the art director of Wood and Sons. He had been working for his friend Lawrence Birks for something like three years, having returned from the United States of America in 1910 and experiencing a short period of unemployment. Presumably his two daughters accompanied him in the two moves.[33]

Meanwhile it was also reported that the pottery owner Lawrence Birks' own pâte-sur-pâte work was extremely 'graceful and refined'. The designs of the figures on vases and plaques were praised by the *British Architect,* for example, 'Shooting stars'[34] on a plaque (Colour Plate 58) as well as a vase depicting the offering of a bunch of grapes to Cupid and a winged female figure playing a mandolin, allegorical of music. The scene 'Offering bunches of grapes to Cupid' was really a repeat of the plaque seen in the display as early as 1900. Also in the fine art at the 1913 Exhibition were a pair of pilgrim bottles by Lawrence, designs called 'Cupids building a house of cards' (Colour Plate 59) and 'Cupid blowing down the cards'.

All this fine work produced by Rhead and Birks must have inspired one of the other Birks Rawlins

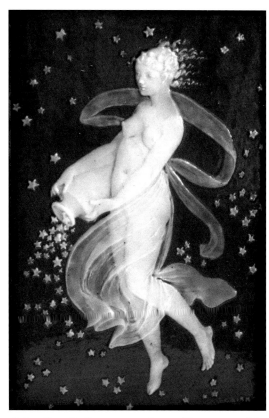

Colour Plate 58. Pâte-sur-pâte plaque, 'Shooting stars', by Lawrence Birks. 7¼ x 4½in. (18.42 x 11.43cm).

Colour Plate 59. Pâte-sur-pâte plaque, 'Cupids building a house of cards', by Lawrence Birks. 7½ x 4¾in. (19.05 x 12.07cm).

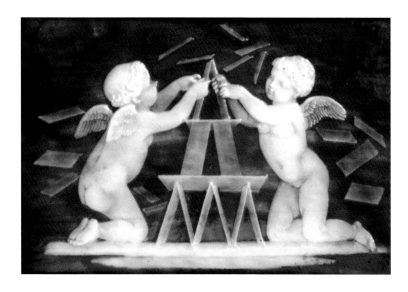

33. Ibid., p.175.
34. Ibid., p.165, Figure XXVI.

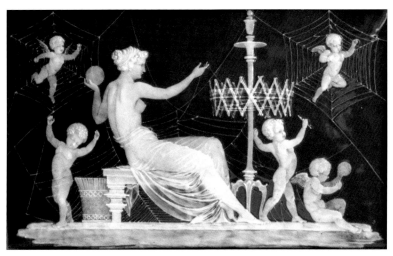

Colour Plate 61. Pâte-sur-pâte plaque, 'Spinning the spider's web', by Lawrence Birks, BR&Co. 10¾ x 6¾in. (27.31 x 17.15cm).

decorators, as the work of Fred Ridgway[35] with his coloured pastes caught the eye for the first time. A fine cylindrical vase decorated by Ridgway, entitled 'Peacock and flowers', was an outstanding example for its colour scheme, as was a vase showing fish swimming through aquatic plants, having a refreshingly naturalistic appearance.

Inspired by the success and the encouraging press reports of the Ghent exhibition, which was so important in the history of Birks Rawlins & Co., a decision was made to exhibit over the water in San Francisco in 1915. Among many of the Vine Factory's wares was the Ridgway fish and aquatic plant vase. The firm won the medal of Honour for their overall display.

The manufactory became a regular participant at all the subsequent British Industries Fairs held annually in London and received royal patronage on each occasion, as the King and Queen sought out the company stand.

Glowing reports were documented for the 1917 display, when the window space was claimed by the firm's pâte-sur-pâte ware.[36] The general opinion was that the decorations were essentially of an exhibition character and their classical themes showed with good effect on several of the pieces. Notably there was an electric lamp and two candlesticks mounted in silver with plaques entitled 'The Valentine' and

Colour Plate 60. Pâte-sur-pâte candlesticks by Lawrence Birks. 5¼ and 6¼in. (13.34 and 15.88cm) high.

35. *Pottery Gazette,* July 1913, p.807.
36. Ibid., April 1917, p.371; Bumpus, p.166.

'Spinning the spider's web' (Colour Plates 60 and 61) and a handsome presentation casket in oxidised silver and copper with panels of pâte-sur-pâte representing 'War and Peace' (Colour Plates 62-65), These panels were extremely high quality pâte-sur-pâte. The 'Peace'[37] panel showed a flying angel accompanied by doves, while on the reverse side 'War' wore a flaming headdress and carried two burning torches. The use of metal-work in conjunction with this process was unique and it was, of course, the work of Lawrence Birks, the pottery owner. Subsequently Lawrence used this magnificent casket to display excellence as a front cover illustration for Vine Pottery catalogues.

Lawrence Birks should be given the credit for making true pâte-sur-pâte for a very long time, some fifty years from 1872 to 1922. Frederick Rhead did write in his book that Lawrence's work was extremely impressive, but only occasional up to that time (c.1906).

37. Bumpus, p.166.

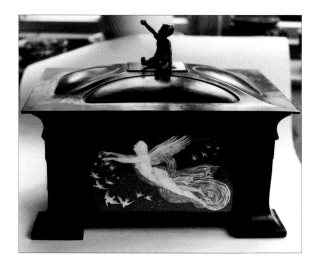
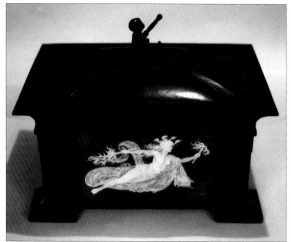
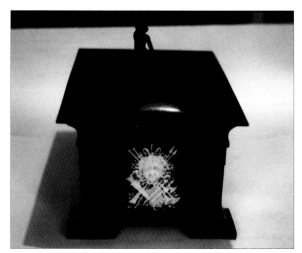
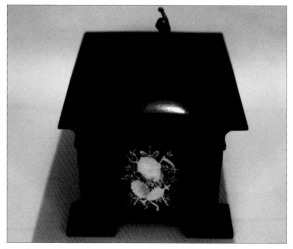

Colour Plates 62-65. Four views of the 'War and Peace' casket in oxidised silver and copper with four pâte-sur-pâte panels by Lawrence Birks. 15½ x 11in. (39.37 x 27.94cm), 7¾in. (19.69cm) high.

Colour Plate 66. Pâte-sur-pâte plaque signed by Arthur Morgan. 5 x 7¾in. (12.7cm x 19.69cm).

It has been thought that, as Arthur Morgan (who had worked with Solon) was a very close friend of Lawrence Birks and Frederick Rhead, all three having been at school together, he may have produced the occasional plaque (Colour Plate 66) in one or the other's home workshop in the early 1900s.

The 1917 casket was perhaps the last major work Lawrence attempted, but several pieces were still prepared from time to time in the early 1920s at his Ashley home, causing a little concern in the family by their presence in such a fragile state, before being fired.[38]

The only other pâte-sur-pâte made in England had been made by less expensive methods of production at Minton by cousin Alboin and his old fellow apprentice Frederick Rhead at Woods in Middleport. The remark Lawrence had made many years earlier, that to manage a busy factory he would have very little time for such a time-consuming process of decoration, no doubt had come true and become a reality. But, surely true pâte-sur-pâte was a sufficient reason for the firm to be remembered in ceramic history.

38. Family records.

46

Colour Plate 68. Pâte-sur-pâte plaque signed L.A. Birks. 8½ x 4¾in. (21.59 x 12.97cm).

Colour Plate 67. Pâte-sur-pâte plaque by Lawrence Birks. 7¼ x 4¾in. (18.42 x 12.97cm).

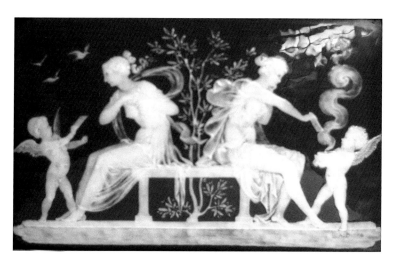

Colour Plate 69. Pâte-sur-pâte plaque signed L.A. Birks. 10¾ x 6¾in. (27.31 x 17.15cm).

Colour Plate 70. Pâte-sur-pâte plaque. 3½ x 5¼in. (8.89 x 13.34cm).

Colour Plate 71. *Pâte-sur-pâte plaque signed L.A. Birks. 10¼ x 6¾in. (27.31 x 17.15cm).*

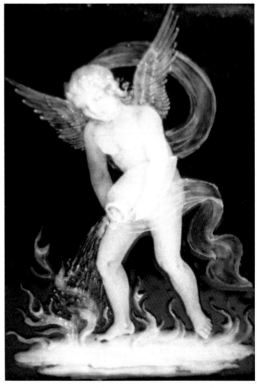

Colour Plate 72. *Pâte-sur-pâte plaque. 3¾ x 5½in. (9.53 x 13.97cm).*

Colour Plate 73. *Pâte-sur-pâte plaque. 3¾ x 5½in. (9.53 x 13.97cm).*

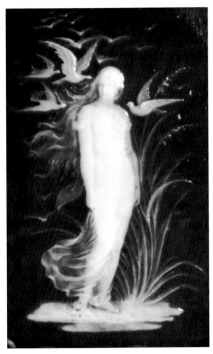

Colour Plate 74. Pâte-sur-pâte plaque. 4¼ x 7¼in. (10.8 x 18.42cm).

Colour Plate 75. Pâte-sur-pâte plaque signed L.A. Birks. 4¾ x 7¼in. (12.07 x 18.42cm)

Colour Plate 76. Pâte-sur-pâte plaque. 6½ x 10½in. (16.51 x 26.67cm).

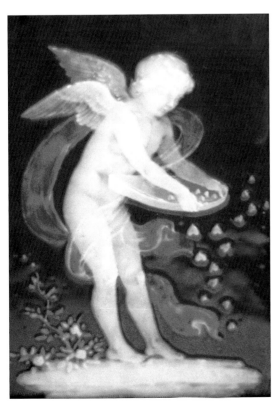

Colour Plate 77. Pâte-sur-pâte plaque. 5½ x 3½in. (13.97 x 8.89cm).

Colour Plate 78. Pâte-sur-pâte plaque by L.A. Birks. 7¼ x 4½in. (18.42 x 11.43cm).

Colour Plate 79. Pair of pâte-sur-pâte plaques by L.A. Birks, No. 555. 3¼ x 4¾in. (8.26 x 12.07cm).

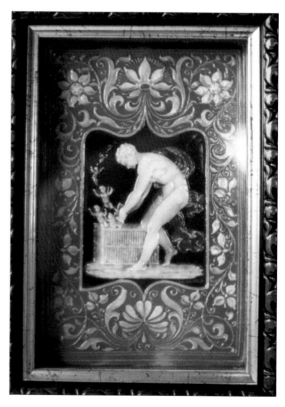

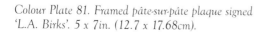

Colour Plate 80. Pâte-sur-pâte plaque signed 'L.B.'. Diameter 5in. (12.7cm).

Colour Plate 81. Framed pâte-sur-pâte plaque signed 'L.A. Birks'. 5 x 7in. (12.7 x 17.68cm).

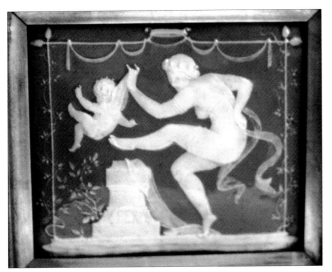

Colour Plate 82. Pâte-sur-pâte plaque by L.A. Birks. 6½ x 5¼in. (16.51 x 13.34cm).

Colour Plate 83. Pâte-sur-pâte plaque by L.A. Birks. 8in. (20.32cm) diameter.

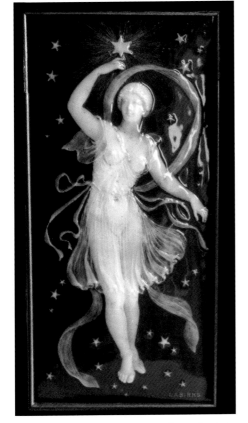

Colour Plate 84. Pâte-sur-pâte plaque by L.A. Birks, Birks Rawlins & Co. 10¼ x 5in. (26.04 x 12.7cm).

Colour Plate 85. Pâte-sur-pâte plaque (panel for casque). 6¾ x 10¼in. (17.15 x 26.04cm).

Colour Plate 86. Miniature pâte-sur-pâte plaque signed 'L.B.'. 5 x 5in. (12.7 x 12.7cm).

Colour Plate 87. Pâte-sur-pâte vase signed 'L.A. Birks', Birks Rawlins & Co. 12in. (30.48cm) high, 5½in. (13.97cm) diameter.

Colour Plate 88. Pâte-sur-pâte vase signed 'L.A. Birks', Birks Rawlins & Co. 12in. (30.48cm) high, 5½in. (13.97cm) diameter.

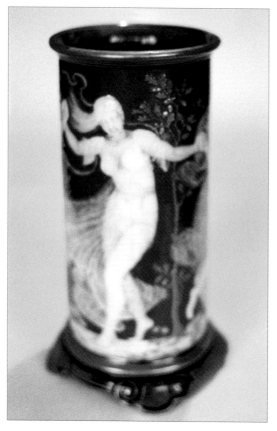

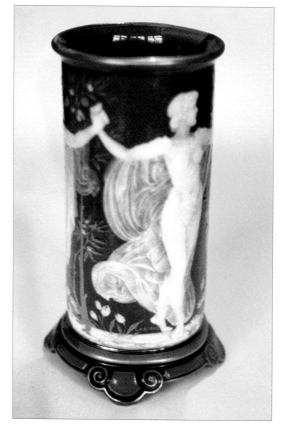

Colour Plate 89. Pâte-sur-pâte vase signed 'L.B.', tinted and glazed parian and enamelled gilding. 7in. (17.78cm) high.

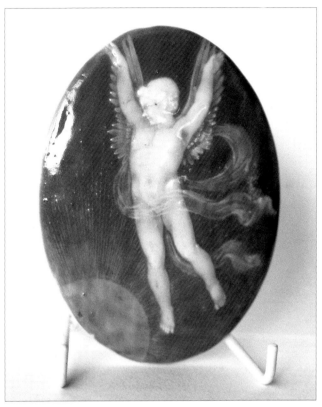

Colour Plate 90. Pâte-sur-pâte plaque, by L.A. Birks, not signed, Birks Rawlins & Co. 4¾ x 3⅝in. (12.07 x 9.21cm).

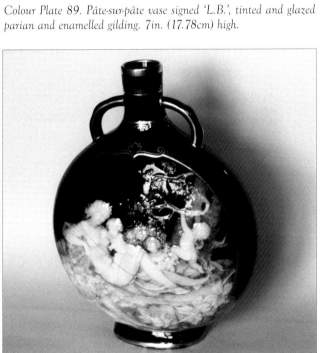

Colour Plate 91. Pâte-sur-pâte flask signed 'L.B.' 8¼in. (21cm) high.

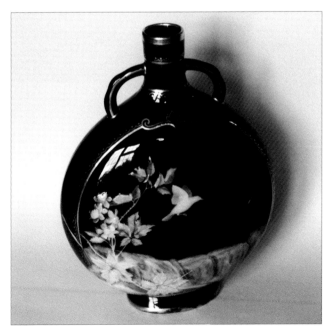

Colour Plate 92. Reverse of the flask in Colour Plate 91.

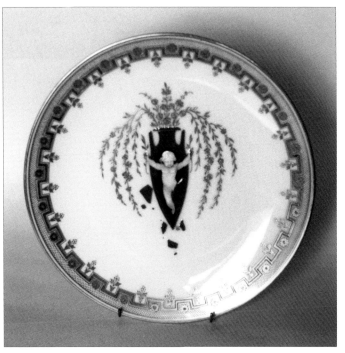

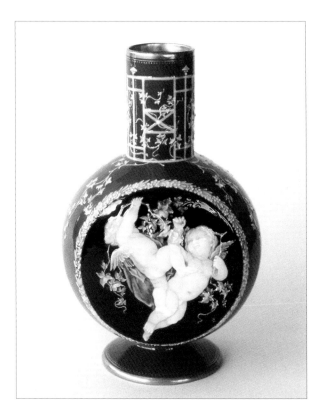

Colour Plate 93. Pâte-sur-pâte plate signed 'L.B.'. 9½in. (24.13cm) diameter.

Colour Plate 94. Pâte-sur-pâte vase signed 'L.B.', Minton. (7½in 19.05cm) high.

Colour Plate 96. Reverse of the vase in Colour Plate 94.

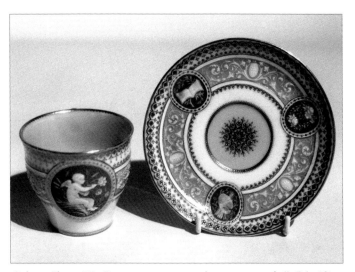

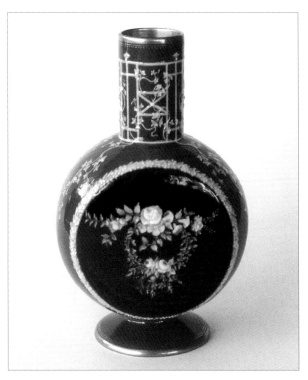

Colour Plate 95. Pâte-sur-pâte cup and saucer signed 'L.B.'. 2⅝in. (6.67cm) high, 5¼in. (13.34cm) diameter.

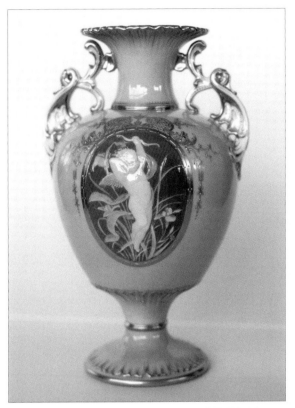
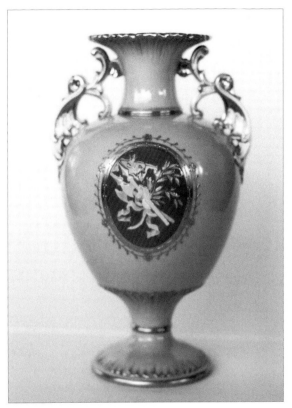

Colour Plate 97. Pâte-sur-pâte vase signed 'L.B.', Minton. (8in 20.32cm) high.

Colour Plate 98. Reverse of the vase in Colour Plate 97.

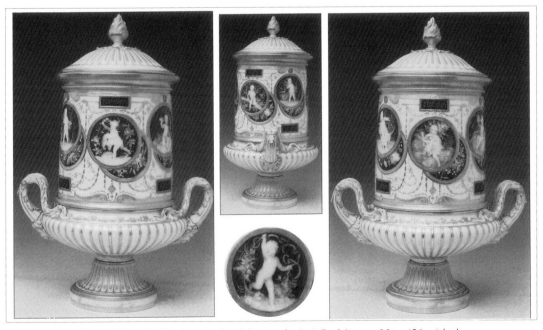

Colour Plate 99. Twelve months of the year by L.A.B., Minton. 22in. (56cm) high.

Chapter 3.

The Vine Pottery in Stoke upon Trent

THE TWENTY-TWO YEARS SPENT BY LAWRENCE BIRKS AT MINTON AS an apprentice to Louis Solon, working as a pâte-sur-pâte artist, had probably frustrated him and led to his desire to become independent. He formulated plans to build a new family home in Hanford, within two miles of Stoke upon Trent, and go it alone and set up a business as a ceramic manufacturer.

Lawrence was born in 1857 in Temple Street, Fenton, two miles from Stoke upon Trent, the son of Arthur and Mary. He had one sister, Gertrude, who was three years younger. Unfortunately his mother died the year that Gertrude was born, so Lawrence, from the age of three, was brought up by his widowed grandmother, Frances, who had lost her husband, Isaac, in his fifties. It must not have been very easy for father Arthur to bring up a son and daughter when Frances died. Other members of this close family, cousins, took over the role of housekeeper, when the family moved from Temple Street to West Parade in Fenton between 1861 and 1871 (see Appendix 2, Census Returns 1841 to 1891).

Meanwhile Arthur[1] had become the Head Modeller at Copeland in Stoke upon Trent. Lawrence became apprenticed at the age of fourteen in 1872 to Louis Solon at Minton and worked for many years with his schoolfriends Frederick Rhead, Arthur Morgan and his cousin Alboin. Lawrence married Alice Ann Rhodes in 1884 at St. Mary's and All Saints Church, Trentham, and became friendly with Charles Frederick Goodfellow, his sister-in-law Marion's husband. Goodfellow was in the business of supplying potter's clay and various porcelain materials to the pottery industry, as a miller's merchant. The two families lived close to each other in the small village of Hanford and together planned the future of their respective families and also the world of work. In the mid-1890s they both purchased land for new houses, Lawrence at Hanford and Charles at nearby Northwood, Clayton. They were to be within three-quarters of a mile of each other, across the River Trent meadows.

The year 1894 saw the dawn of the joint business venture. Lawrence Birks left Minton and along with Goodfellow set up business at the Vine Factory, off London Road in Stoke, with a third partner, Adolphus Joseph Rawlins, a former schoolfriend of Goodfellow's in the village of Hanford. The Vine was situated a quarter of a mile from

1. Bernard Bumpus. 'Lawrence Birks and the Vine Pottery', in Ars Ceramica, p.43.

56

the Minton manufactory. During these formative years various registration or trademarks were used – apart from the obvious use of surname letters,[2] there were grapes dangling from the vine.

BIRKS.

BIRKS *China.*

G. B. & CO.

L. A. BIRKS & CO.
1894-1900.

B & CO.

This latter trademark was almost certainly taken from the influential watering hole 'The Vine Inn', which is still standing today next to the Bilton manufactory. The Newcastle Canal separated the Birks & Co. business from the main Hanford to Stoke road (known as London Road) and the Bilton site. Years later the canal lost its popularity to the rail networks and road haulage and was filled in during the 1950s, although there is still evidence of its former existence with a bridge wall left on Corporation Street. The two sites of the Vine Pottery and Bilton's earthenware are now joined as one, with Bilton acquiring the Vine site in the 1950s. Bilton survived until the late 1990s, when they became bankrupt. Portmeirion Potteries recently acquired the whole site for their ambitious development. The aerial photograph and the street plans for the town of Stoke upon Trent illustrate the line of the canal through the site and the subsequent development of the Vine manufactory, through 1905, 1924 and 1937.

2. *Pottery Gazette Diary.* Trademarks. 1905 p.144 and 1907 p.150.

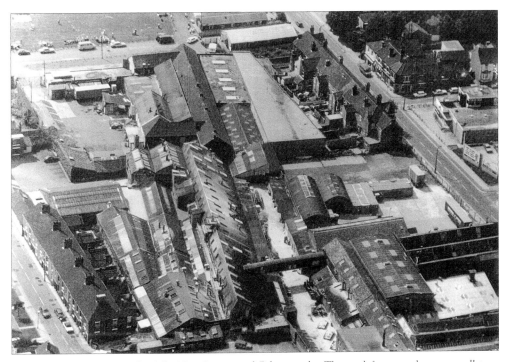

Plate 18. Aerial photograph of the Vine Pottery and Bilton works. The top left corner shows a small part of Birks' old factory built in 1899. Note the line of the canal running through the middle.

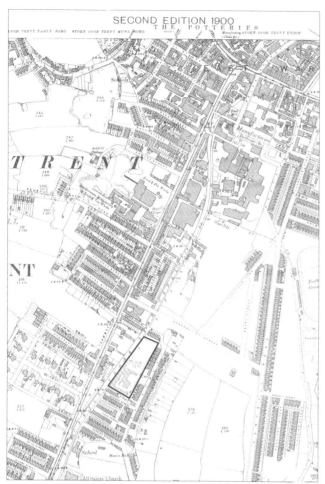

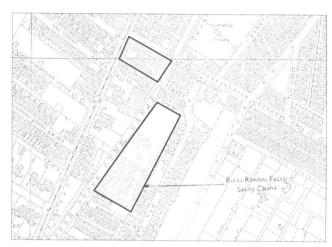

Plate 20. Stoke-on-Trent, 1924.

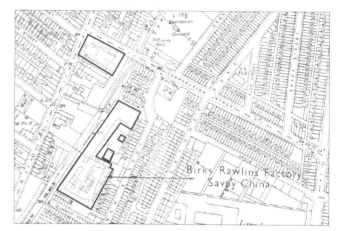

Plate 19. Stoke-on-Trent, 1905.

Plate 21. Stoke-on-Trent, 1937.

Plate 22. Photographs illustrating the dark, almost black, roofing of the Vine Pottery c.2000 (one hundred years old).

The initial partnership of the two brothers-in-law was dissolved in 1898 on 25 March after just over three years together.[3] Goodfellow was paid off to pursue his career in the amalgamation of some eight potter's mills in the Longton, Fenton and Stoke upon Trent neighbourhood. Potters Mills Ltd. was launched on 12 January 1899 with a capital of £120,000 in £10 shares.[4] However the Stoke upon Trent rate books reveal that Goodfellow continued to be in the partnership for the year 1898-1899, when the rates were £130 for the Summer Street site. He proved to be the main supplier of clay and bone materials for the various mixtures required for the fine bone china and porcelain that came out of this factory for the next twenty-six years.

Adolphus Joseph Rawlins was from a large family of several generations farming at the Hanford Hall Farm, although he personally was working as a grocer in Main Street, Hanford, with his older brother, William Sidney. It has been assumed that Rawlins provided more capital for this little known business, but it has recently been revealed through the rate books for the town that William Sidney Rawlins was also a partner in this manufactory. This can be evidenced by the purchase of more land adjacent to the original site for Birks & Co. bordered by Summer Street and New Street.

The factory had set out to produce porcelain and fine bone china tableware only and the beginnings were quite modest. The main emphasis was table and useful wares, with a few pâte-sur-pâte items made by Lawrence Birks himself.

It was company policy early on to exhibit at trades exhibitions. The April 1901 *Pottery Gazette* noted that Birks Rawlins & Co. were showing 'useful and ornamental china' at the fifth annual Trades Exhibition and Market that was being viewed at the Agricultural Hall in Islington between 25 March and 4 April.[5] These exhibitions were mainly for the trade, as the public were not invited; indeed the general public may be said to have been excluded, since no money was taken at the doors and admission was by complimentary ticket accompanied by a trade card. The firm's trademark had been adapted to Birks Rawlins & Co. around 1900 at the birth of the new factory, although some wares were still circulating with other marks, for example Birks & Co.[6]

BIRKS, RAWLINS, & CO.,
The Vine Pottery,

Porcelain.

The main purpose of the exhibition was to foster trade between manufacturers, wholesale dealers and traders. The task of interesting the general public in specialities was left to the dealers. The *Pottery Gazette* magazine was produced monthly and it is noted as early as 1904 that the sole agent for Birks Rawlins & Co. ware was J.W. Walton in London,[7] who championed the factory's ware each month for many years in the *Gazette*, emphasising the tea and breakfast sets and general china made in Stoke upon Trent. (See sketch plan of the City of London on page 60.)

3. *Pottery Gazette*, 1 June 1898, pp.741/742. Further research in the surviving rate books for Stoke-upon-Trent town has revealed that Charles Frederick Goodfellow was still a rate payer in the partnership for the next two years, to the end of 1899. In the new partnership in 1900 Lawrence Birks was joined by Adolphus Joseph Rawlins, as before, but new money was brought in by the addition of William Sidney Rawlins, brother of Adolphus. They all lived in Hanford. The very occasional trademark, G.B.& Co., would acknowledge Goodfellow's involvement in the trading at the Pottery.
4. *Pottery Gazette*, 1 February 1899, p.184.
5 Ibid., 1 April 1901, p.402.
6. *Pottery Gazette Diary*, 1905, p.7.
7. *Pottery Gazette*, J.W. Walton advertisements, 1 November 1904. p.1157 and *Diary* p.7.

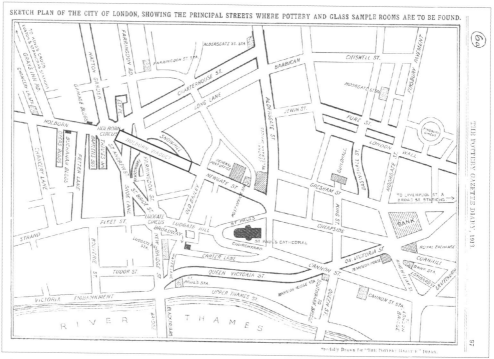

Plate 23. Sketch plan of the City of London.

New premises at the Vine Factory in the early 1900s (see Plate 19)[8] necessitated a slight increase in the workforce and there was subsequent improvement in quality and output. Lawrence had undertaken the design and supervised the construction of the new premises, as he explained to the *Pottery Gazette* reporter who visited the manufactory in 1902. The magazine had been familiar with the wares from the Vine Factory, but this visit in 1902 was a first, and Lawrence took the opportunity to conduct a tour of the entire premises. It was reported that the layout was the most conveniently arranged works that had been seen to date. Lawrence explained[9] that they had the advantage of a vacant piece of ground conveniently situated and were thus able to construct premises exactly suited to their requirements. Those who have had to reconstruct and make additions to old premises know the inconvenience that course

8. Hanley
Library Archives,
Map of Stoke
upon Trent
(South), 1898.
15in. to 1 mile.
9. *Pottery Gazette*,
1 July 1902,
p.685.

entails and would therefore appreciate beginning with what Lord Rosebery would have called a 'clean slate'. Many pottery manufacturers' premises had been structurally altered to admit everything from the raw materials at one point to the packed crates at another passing in one direction right through the works. So too the Vine Pottery had been built with that purpose in mind, in order that both time and labour were saved. Not only the plant and necessary fittings but the building itself seemed to have had a more substantial appearance than other potteries. The benches and tables at which the operatives worked appeared more solid than most and were of a simpler character. Lawrence Birks had had many years' experience in potting at Minton and knew exactly what he needed to facilitate production. It could be seen that this firm had the most approved labour and time saving arrangements, and in every department the health and comfort of the workers had had careful attention.

The comprehensive report in the *Pottery Gazette* gave an illustration of a group of samples selected from the showrooms which basically explained the specialist features of some of the wares and indicated the great variety of china teasets made at the works. Lawrence Birks had gathered a group of artists around him who collectively produced a tremendous variety in both design and ornamentation.

A large number of printed patterns for the tea and breakfast sets were shown, and there was not a vulgar one amongst them, according to the reporter. All designs exhibited the strong artistic feeling of the staff at the factory; there was an evidence of refinement, even in the utility articles.

10. Ibid.

The display exhibited the magnificent varied character of all the firm's ware. There was no sameness; each shape and each decoration had individuality. The pair of china vases in the top row of the *Pottery Gazette* photograph[10] (Plate 24) were decorated in Persian style – dark blue, red and gold. In the centre of the top row there is a graceful china vase, mazarine blue and gold, printed in the 'Moustiers' style. Next to this on the left is a teacup and saucer, 'Sutherland' shape, with blue band, turquoise ribbon, groups of flowers and gold tracing. The gold in any of the patterns was always referred to as 'best gold' in the two very large pattern books housed at the Potteries Museum in Hanley, Stoke-on-Trent. The cup and saucer at the extreme left of the second row is the very fine 'Chaucer' shape, with festoons of flowers – roses and forget-me-nots tied up with turquoise ribbons and finished with a gilt edge.

Two strictly artistic pieces, very different in

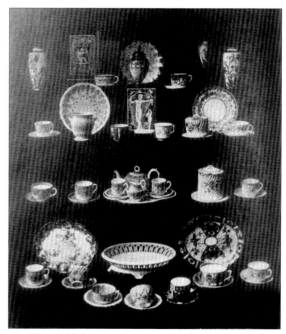

Plate 24. Display of Birks Rawlins & Co. productions from the Pottery Gazette, 1902. 'Offering bunches of grapes to Cupid' can be seen in the middle of the second row. There are two pâte-sur-pâte plaques on the top row.

character, are placed next to each other towards the bottom of the group. One is the beautiful oval pierced china centrepiece on feet (see page 140); the other is the oval dish with the conventional ornamentation in blue, brown and red which is now, for convenience, called 'Crown Derby' or 'Imari' style. This latter piece has exceedingly rich decoration and the pattern was produced for the next twenty-five years, as evidenced by the varying trademarks that have been recorded. The decoration of the cups and saucers at the foot of this group illustrate the variety of styles adopted by the factory. A very characteristic one is the second from the right, which is a breakfast cup and saucer in the dark blue Chinese 'Aster' pattern.

Some very fine examples of pâte-sur-pâte are to be seen, for example the decorative tiles on the top two rows. These plaques were the work of Lawrence Birks and were not to be seen around the factory as commercial 'art ware'; they were in his office/studio. Much has already been said about the work of the pâte-sur-pâte artist in the previous chapter. Lawrence could only devote such time that he had to spare from the control of a busy factory, but he did, in fact, work on his pâte-sur-pâte at home, much like Solon did when he retired.

Obviously the *Pottery Gazette* was extremely impressed with everything that they saw because a whole page within the 'Buyers' Notes' section was devoted to the Vine Pottery in July 1902.

Many pottery manufacturers closed over the years and it was reported that when Brownfields Pottery closed in Cobridge[11] their copper plates were sold by auction in October 1900. Patterns purchased by Birks Rawlins & Co. were called 'Baden', 'Key Border No. A.7' and 'Smyrna Bead'. This sort of occurrence explains why certain designs crop up regularly with different manufacturers.

Evidence of J.W. Walton's influence in being the sole agent in London for Birks Rawlins & Co. ware was regularly featured by the *Pottery Gazette* each month and in November 1906 they announced that a new showroom had opened at Bath House, 57 Holborn Viaduct, London E.1.[12] Walton stated that there was a full line of entirely new samples that he was agent for, from the various pottery and china manufacturers.

11. Ibid., Brownfield Patterns sale, 1 February 1902, p.293.
12. Ibid. New showrooms, 1 November 1906, p.1289.

Chapter 4.

Tableware

THE MAIN OBJECT AND PRINCIPLE OF THE VINE MANUFACTORY SET out by the partnership in 1894 was to produce porcelain and fine bone china tableware in the style of Minton, where most of the staff had worked over the previous decade. The productions went unnoticed in the formative years and it was only after the second partnership was created at the new premises that the *Pottery Gazette* reporter gave publicity to the large number of printed patterns on tea and breakfast sets.

Whilst the patterns were most numerous in the pattern books, only a selection were taken up by the partnership. Most graceful designs and ornamentation were devised by the talented ceramic artists, several of whom had been former Minton employees. Much skill was required in designing a pattern, but once designed the printing was no more difficult than a few sprigs would be.

Pattern names illustrated the strong artistic feeling which predominated in the factory, for example, 'Hogarth', 'Chaucer', 'Berrani', 'Wordsworth'. These were names for breakfast and tea sets of cups and saucers etc.

The photograph (Plate 24) that appeared in the *Pottery Gazette* for 1902[1] illustrated a teacup and saucer in the 'Sutherland' and another in the the taller 'Chaucer' shape. The grouping showed the Imari pattern in its splendour on an oval dish and teacup and saucer. The 'Aster' design was illustrated at the front and foot of the photograph on a breakfast cup and saucer amongst some six other different designs at that level.

The emergence of an extra and the latest trade mark, namely 'Savoy China', for tea and breakfast ware came to the attention of fellow manufacturers, agents and the public by courtesy of the *Pottery Gazette*[2] in 1910.

1. *Pottery Gazette*, 1 July 1902, p.685.
2. Ibid., 1 November 1910, p.1247. Also *The Encyclopaedia of British Pottery and Porcelain Marks* by Geoffrey A. Godden, p.76.

Porcelain.

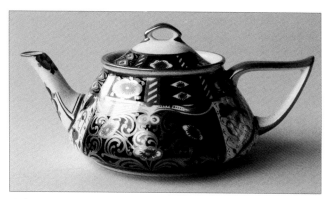

Colour Plate 100. Imari teapot, Minton Birks. 5in. (12.7cm) diameter, 3in. (7.62cm) high.

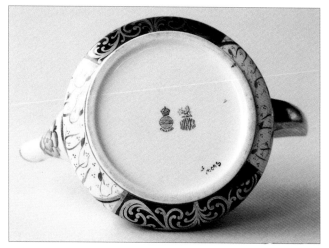

Colour Plate 101. Trade mark Minton Birks on Imari teapot, pattern 5604.

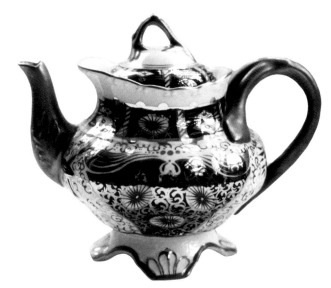

Colour Plate 102. Imari teapot. 6½in. (16.51cm) high.

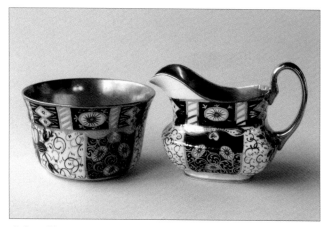

Colour Plate 103. Imari sugar and creamer, gold interiors. Crown over BR& Co. Stoke-on-Trent. Creamer Savoy bone china. 3½in. (8.89cm) high.

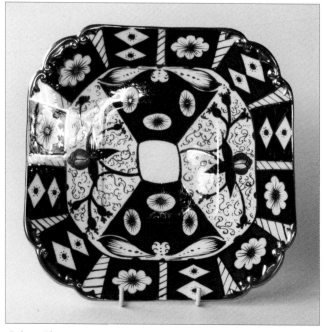

Colour Plate 104. Imari four-sided cake plate. Trade mark Savoy China, Made in England. 10in. (25.4cm) diameter.

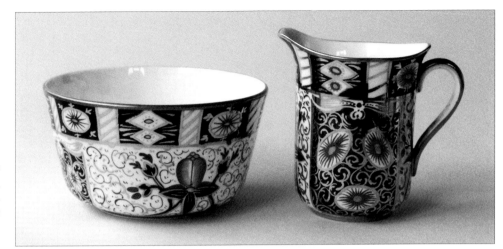

Colour Plate 105. Imari sugar bowl and creamer. Trade mark crown above BR& Co. Stoke-on-Trent. Bowl 4¾in. (12.07cm) diameter, creamer 3½in. (8.89cm) high.

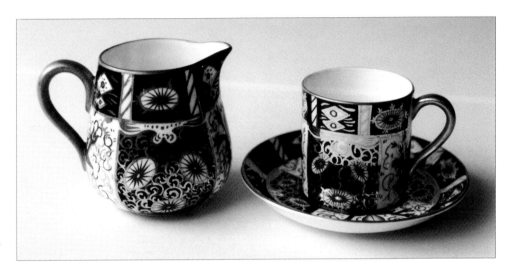

Colour Plate 106. Imari cup, saucer and milk jug. Trade mark Birks original china.

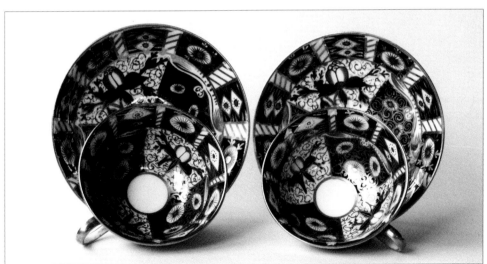

Colour Plate 107. Imari cups and saucers.

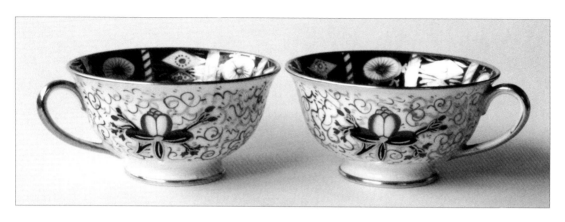

Colour Plate 108. *Imari cups. Trade mark BR&Co. Savoy China.*

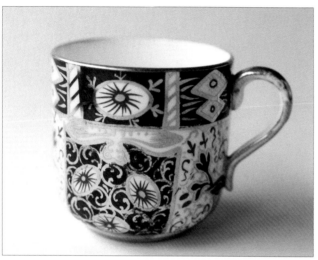

Colour Plate 109. Imari cup, pattern 4658. Trade mark Savoy China. 2½in. (6.35cm) high.

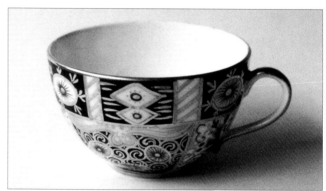

Colour Plate 110. Imari cup. Trade mark BR&Co. crown (only).

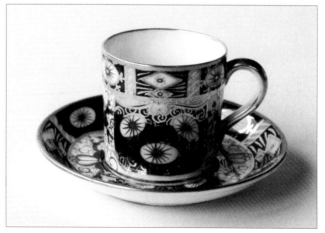

Colour Plate 111. Imari coffee can and saucer. BR&Co. Saucer 4¼in. (10.8cm) diameter, can 2in. (50.08) high.

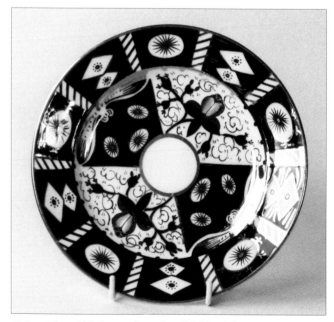

Colour Plate 112. Imari plate. 7in. (17.78cm) diameter.

Colour Plate 113. Trade mark BR&Co. grapes on vine on Imari plate.

Colour Plate 114. Imari plate. Trade mark BR&Co. with crown. 7in. (17.78cm) diameter.

Colour Plate 115. Finger bowl. Trade mark crown over BR&Co. Stoke-on-Trent.

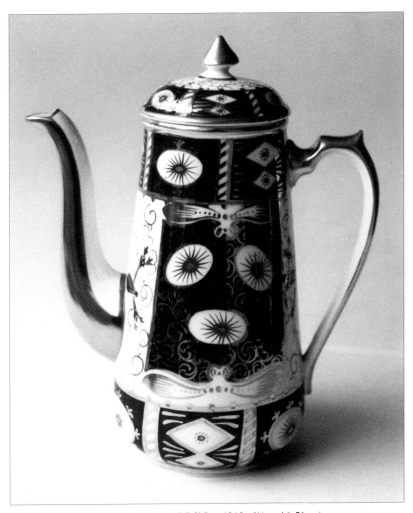

Colour Plate 116. Imari coffee pot. BR&Co. 1910. 6½in. 16.51cm),

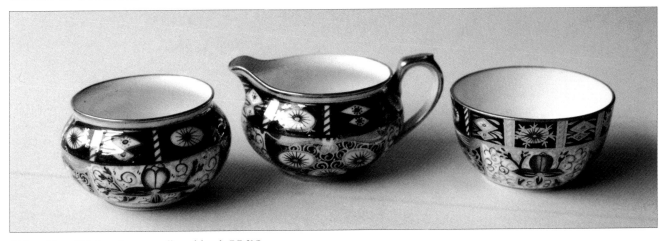

Colour Plate 117. Imari sugar, milk and bowl. BR&Co.

Samples of wares included practically all grades, from neat and moderate priced decorations up to high class richly enamelled and gilt patterns.[3] There were many new designs for the current season which, from the least expensive to the very best, were characterised by simplicity and good taste. The ornamentations that were bright in colour combinations were not gaudy. It was observed in the 1910 report that the firm's china was very good and had recently greatly improved. No doubt this was due to the influx and influence of all the artistic talent at the factory, coupled with the introduction to the staff of Lawrence Birks' old friend and colleague from Minton days, Frederick Rhead, and his two daughters Charlotte (Lotty) and Dolly.[4] All these artists were to prove particularly valuable over the next few years, when Birks Rawlins & Co. achieved great success on the international scene.

The new forms and decorations that had been introduced were attractive lines and they were very successful with their colour patterns which, produced by a process of their own, were sharp and clear. (The highly skilled sculptors, modellers and decorators used a great amount of enamelling, fired at the lower temperature within the muffle kilns.) Several of the shapes in the tea and breakfast ware were quite out of the ordinary run of taper cups, that were so plentiful. Teapots, sugars and creams, cruets, sugar sifters and other requisites could be supplied en suite in many pretty decorations. Déjeuner sets in several decorative patterns were shown, with a number of fancy pieces and a good range of coffee cups and saucers of great beauty. The *Pottery Gazette* of 1 November 1910 devoted a whole page to Birks Rawlins & Co.

3. *Pottery Gazette,* 1 November 1910, p.1247.
4. 'Lawrence Birks and the Vine Pottery' by Bernard Bumpus in *Ars Ceramica,* p.45.

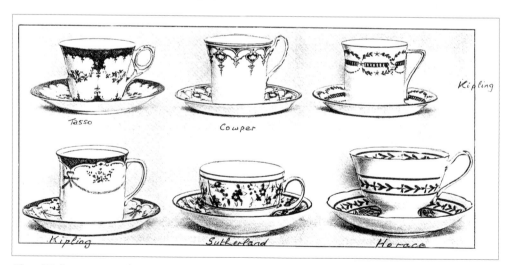

Plate 25. Six teacups and saucers. Pottery Gazette.

Plate 25, by courtesy of the *Pottery Gazette,* shows six teacups and saucers. The first one, the 'Tasso' shape, has a pretty enamelled pattern with a blue border, gold ornamentation and gold edge. Festoons of flowers are added. The 'Cowper' shape has a neat conventional pattern and gold edge. The 'Kipling' shape has a bright decoration in colours around the body of the cup and inside the saucer. This shape is shown again

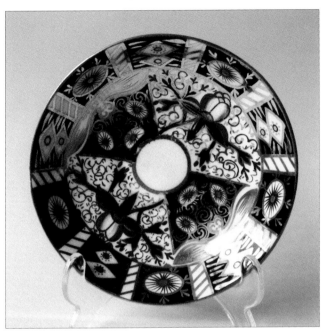

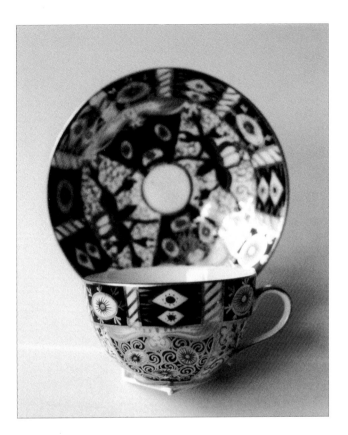

Colour Plate 118. Imari plate-saucer. Trade mark BR&Co. crown (only).

Colour Plate 119. Imari cup and saucer. Trade mark BR&Co. crown (only).

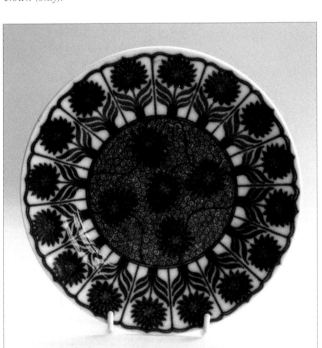

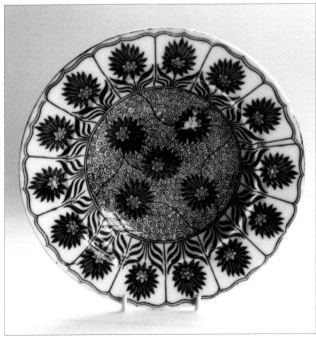

Colour Plate 120. Aster pattern large dinner plate 16 asters. 9½in. (24.13cm) diameter.

Colour Plate 121. Aster pattern large dinner plate 14 asters. 9½in. (24.13cm) diameter.

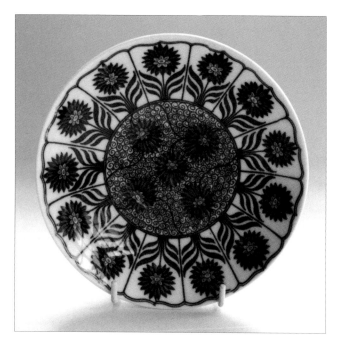

Colour Plate 122. Aster pattern large dinner plate 13 asters. 9½in. (24.13cm) diameter.

Colour Plate 123. Aster pattern cup, saucer and eggcup.

Colour Plate 124. Aster pattern sugar bowl.

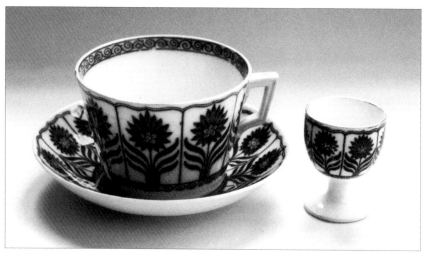

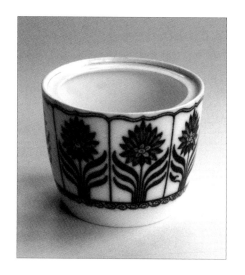

in the lower row, but with a round handle and blue and gold border, ribbon and bows in turquoise and roses. The 'Sutherland' shape has a floral pattern in Oriental style, with gilt lines on each side. The last cup and saucer, the 'Horace' shape, has festoons of flowers inside a broad band with leaves arranged featherwise, and gilt lines.

This intensive publicity resulted in a tender being accepted by the War Office for china ware in this year of 1910,[5] no doubt as a result of the exhibition and Buyers' Notes in the *Pottery Gazette*, coupled with the Holborn Viaduct display showcase in London.

Early in 1911 an exhibition of local pottery was held at a fête in Longton Park on the occasion of the visit of the Australian premier.[6] Much local pottery and porcelain was

5. *Pottery Gazette*, 1 September 1910, p.1009.
6. Ibid., 1 July 1911, p.811.

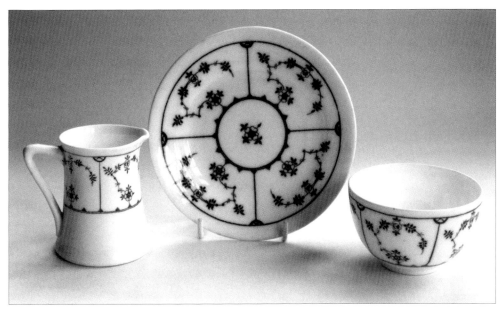

Colour Plate 125. Copenhagen style Dürer pattern milk jug, saucer and bowl.

on view and Birks Rawlins & Co. achieved a considerable boost for their export trade, making contact with the Australian Prime Minister and his staff, who must have been impressed with the wares of the firm. Much tableware was destined for Australia and the United States and consequently little of it has been seen in Britain. Shape names such as 'Melbourne' and 'Adelaide' suggest good business in Australia particularly and this is supported by the numerous times these names are recorded in the pattern books.

7. Ibid., 1 July 1913, p.807.
8. Ibid., 1 June 1915, p.654.

Production of tableware was maintained at the factory, conforming to their original philosophy. It was noted in 1913[7] that some very rich dessert plates and trays were to be viewed, having been exquisitely painted by 'Mr. [Robert] Wallace'. Déjeuner sets and tea services could be purchased, charmingly decorated in the old Sèvres and other styles. Prominence was given to imitations of the well-known blue and white Copenhagen ware, where ships, birds and flowers were depicted in dark blue on a very light blue-grey background.

A brief mention in 1915[8] further consolidated the ongoing production of tableware with a comment that the firm

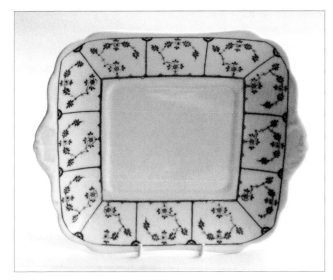

Colour Plate 126. Copenhagen style Dürer pattern rectangular plate inspired by E. Reuter. B& Co.

was showing a representative selection of useful and ornamental china, including tea, breakfast, coffee, dessert and suite ware.

A fuller description was given two years later,[9] possibly because Queen Mary visited the annual exhibition stand and made several purchases. It was noticed that on the utilitarian side there were several patterns of teaware, perhaps the most noteworthy being a decoration in the 'Derby-Imari' style, with the black element omitted from the art work. The pattern originates from the Davenport factory in Middleport near Burslem. Several old Bristol decorations were to be seen, including a fine tea service copied from a dish within the celebrated Trapnell Collection.

In 1918[10] it was observed that a pretty teaware set could be seen with a red cherry-blossom decoration, but, although emphasis was given to other wares coming out of the Vine Pottery, the writers of the day gave little exposure to tableware until 1921.[11] This could have been due to home life being disrupted by the hostilities of the Great War and the resultant massive loss of life.

There was further patronage by Queen Mary who purchased 'six or seven' small objects at the White City British Industries Fair in 1921. Tableware on show was mentioned as 'useful table articles'.

9. Ibid., 2 April 1917, p.371.
10. Ibid., 1 April 1918, p.310.
11. Ibid., 1 April 1921, p.588.
12. Ibid., 2 April 1923, p.645.

The Vine Pottery enjoyed further publicity from the *Pottery Gazette* in 1923,[12] when it was said that not only tea, breakfast and dessert services could be selected, but also other useful miscellaneous table items and fancies galore (Plate 26). Amongst the decorations, both of teasets and fancies, were treatments of Oriental inspiration, involving dainty and delightful colourings in raised enamels.

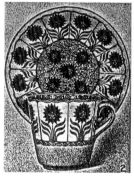

Plate 26. Illustration from 2 April 1923 Pottery Gazette, p. 645, and 'Aster' pattern ware.

1924 appeared to be quite a big year for the firm. The *Pottery Gazette* devoted a whole page to it on 1 March, including two photographs illustrating different tea and breakfast wares.[13] It was stated that the firm had become so famed for its decorative production of fancies, novelties and other wares that people might have forgotten that it produced tableware from the onset. Obviously this was tongue in cheek, as the *Gazette* were responsible for much of this belief.

13. Ibid., 1 March 1924, p.441.

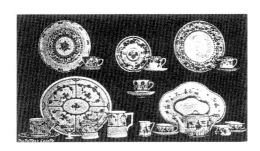

Plate 27. BR&Co. tablewares.

Plate 28. Perforated porcelain photographed by West End Studios Stoke-on-Trent, and published in Pottery Gazette 1 March 1924.

Splendid china tea and breakfast patterns in cobalt blue prints were in evidence. Also to be seen were several smart decorations with hand-painted borders, for example a simple wreath of Swansea roses with naturally coloured leafage. There were scores of dainty decorations in 'Chinese' styles, executed in beautiful enamel colours, very often of the raised variety, and again many patterns reminiscent of the older 'Copenhagen', 'Delft', 'Chelsea' and similar historic styles of sentimental interest.

Many of these wares can be seen in the photograph of the Birks Rawlins & Co. stand at the 1924 International Exhibition at Wembley (Plate 29), where the King and Queen can be seen with the agent Mr. Walton (extreme left at the rear) and Mrs. Alice Birks and son, Ronald (extreme left at the front).

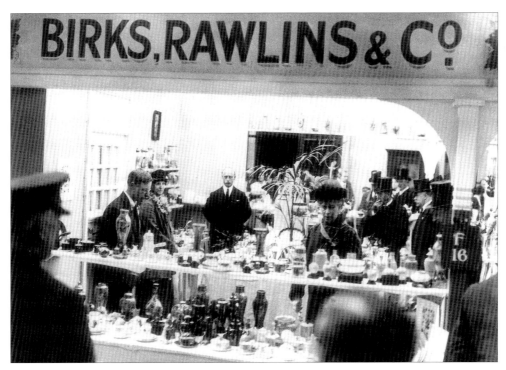

Plate 29. The Birks, Rawlins & Co. stand at the International Exhibition, Wembley, held in April 1924.

Later that year at the Potteries and Glass Exhibition within the British Industries Fair, held at White City, London from 28 April to 9 May,[14] it was recorded that within the space of a few square yards over 2,000 entirely different productions in china were displayed by the Vine manufactory. The *Pottery Gazette* correspondent expressed concern that the deluge of fancies and novelties could hinder the tableware production, implying that in the future the firm might come back to concentrate on the latter.

Vine Pottery's stand in 1925 at the British Empire Exhibition is best illustrated by the photograph of the wares and extracts from their show catalogue. The *Pottery Gazette* added little to their previous year's report, giving a mere three lines of coverage on the useful china on display.

The national strike in 1926 and the forced merger with Wiltshaw & Robinson (Carlton Ware) in 1928 brought great changes. Many artists from the Vine manufactory had moved on and Lawrence Birks, in his seventies, became a decorator. Queen Mary visited the stand at the British Industries Fair at White City between 22 February and

14. Ibid., 2 June 1924, p.1008.

(Below and opposite) Plates 30-33. Pages from catalogue, 1927.

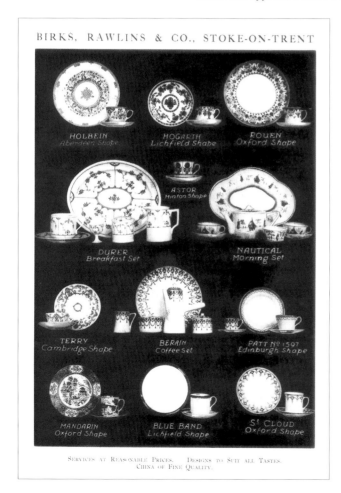

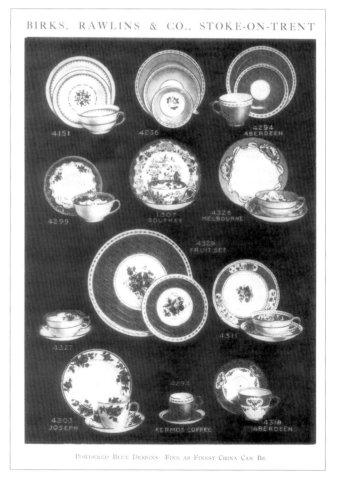

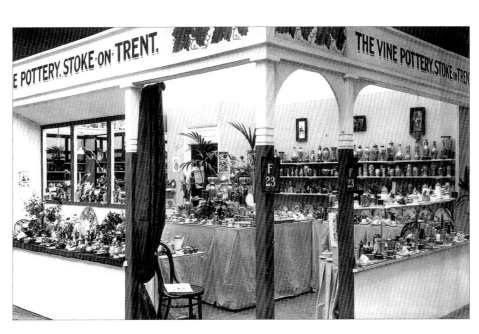

Plate 34. The Vine Pottery stand at the 1828 International Exhibition, Wembley.

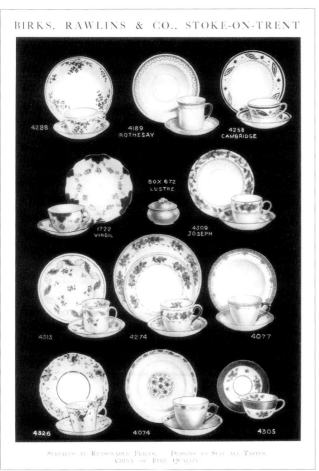

BIRKS, RAWLINS & CO., STOKE-ON-TRENT

4288

4189
ROTHESAY

4258
CAMBRIDGE

1722
VIRGIL

BOX 672
LUSTRE

4309
JOSEPH

4313

4274

4077

4326

4074

4305

SERVICES AT REASONABLE PRICES. DESIGNS TO SUIT ALL TASTES.
CHINA OF FINE QUALITY.

BIRKS RAWLINS & Cº STOKE-ON-TRENT
FINE VARIETY OF TEA WARE PATTERNS

PATT. Nº4030.
ABERDEEN SHAPE.

PATT. Nº4089.
COFFEE

PATT. Nº4164.
TASSO SHAPE.

PATT. Nº4161.

Coffee Pot
PATT. Nº1701.

PATT. Nº4057.

PATT. Nº2732.
ROTHSAY SHAPE.

COVERED SUGAR
PATT. Nº1782.

PATT. Nº2001.
CHINESE SHAPE.

COVERED BUTTER

CROWN DERBY

HONEY POT.

PATT. Nº4073.
SOUTHY SHAPE.

PATT. Nº4094.
COFFEE

PATT. Nº4032.
ABERDEEN SHAPE.

TEA BREAKFAST & COFFEE SERVICES SOLID GROUNDLAID DESIGNS
JAM POTS COVERED BUTTERS & HONEY POTS

2 March[15] and purchased a tea service groundlaid in an attractive shade of green with an over design in gold. It is thought that this action brought about more active interest in the tableware by this firm which had been registered (No. 228,880) as Birks Rawlins & Co. Ltd. by the new directors F.C. Wiltshaw (managing director) and D.E. Wiltshaw.[16]

The next event to hit the industry, and particularly B.R. & Co. Ltd., was the crash of the Wall Street Stock Exchange in the United States in 1929.[17] This meant the complete collapse of the export trade. A report commented on the joint firms 'Vine and Carlton' Potteries displaying an interesting and varied range of china teaware and earthenware.

New styles in 'Carlton' table china appeared for the Pottery and Glassware Exhibition at the British Industries Fair, held in the Empire Hall of Olympia in 1930.[18] It was announced that, under the new management, production of the china had been entirely overhauled, systemised and remodelled. This range of Carlton China opened up fresh channels and it became obvious that this was the birth of a new delicate art deco china.

Later in the year[19] it was to prove so, as it was also to be the last real reference to the name Birks, a name that had been established in the ceramic industry for almost forty years.

These remodelled shapes of cups and saucers and a thoroughly new and modern range of decorations appeared to satisfy middle-class requirements. Improvements were made to the content of the body of the china to bring the wares up to the exacting standards of the day. It was also decided to change the backstamp from 'Savoy' to 'Carlton' China.

15. Ibid., 2 April 1928, p.617.
16. Ibid., 2 April 1928, p.654.
17. Ibid., 1 April 1929, p.600.
18. Ibid., 1 April 1930, p.597.
19. Ibid., 2 June 1930, p.951.

In some cases the public were able to purchase wares with different trademarks for the same patterned cup and saucer. Most attractive designs in this new series of pedestal cup and 'q' handle shapes were 'Springtime', 'Delphinium', 'Sunshine', 'Tulips', 'Lilac posy', 'Bluebells', 'Orange tree', 'Hollyhocks', etc. This could be said to be the last series of decorations produced by that more than able sculptor, modeller and artist – Lawrence Arthur Birks.

Five years later, after the firm went into the hands of the receivers and Carlton Ware was born again under new owners, Lawrence died in 1935 at the age of seventy-seven at his home in Ashley near Market Drayton, Shropshire.

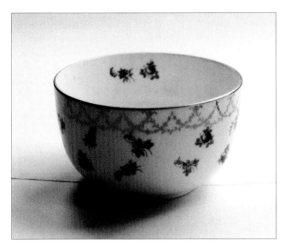

Colour Plate 127. Bowl, pattern 1841, Scattered roses, BR&Co. 5½in. (13.97cm) diameter, 3¼in. (8.26cm) high.

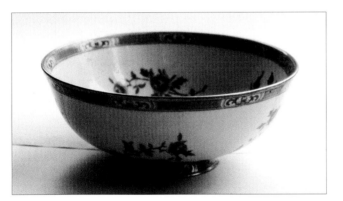

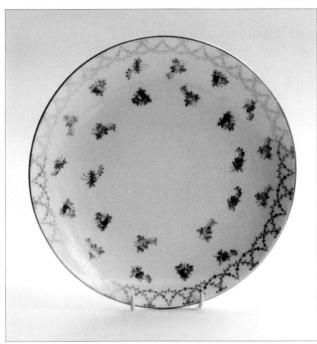

Colour Plate 128. Bowl, pattern 1841, Scattered roses, BR&Co. 9½in. diameter.

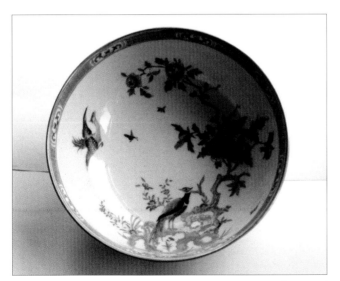

Colour Plate 129. Two views of bowl, pattern 2727, reproduction of old Chinese pattern. 8in. (20.32cm) diameter, 3in. (7.62cm) high.

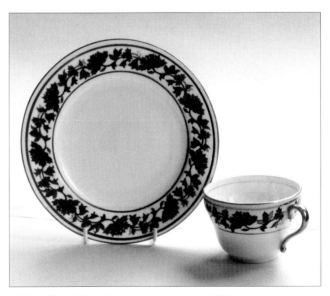

Colour Plate 130. Cup and plate, pattern 2601.

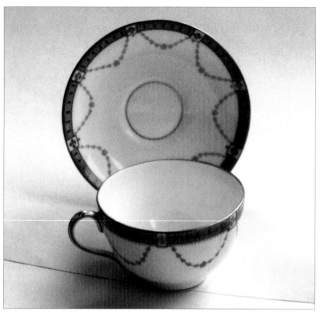

Colour Plate 131. Cup and saucer, pattern 1395, turquoise border, BR&Co., no mark.

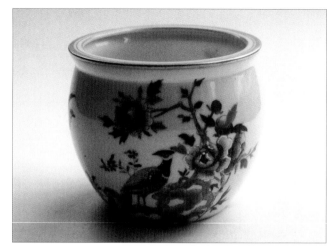

Colour Plate 132. Vase, BR&Co. 4¼in. (10.8cm) diameter, 3½in. (8.89cm) high.

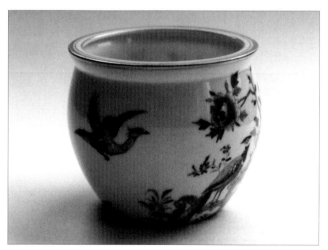

Colour Plate 133. Vase, BR&Co. 4¼in. (10.8cm) diameter, 3½in. (8.89cm) high.

Colour Plate 134. Oval plate.

Colour Plate 135. Oval plate, Japanese style.

Colour Plate 136. Two small plates and creamer.

Colour Plate 137. White patterned plate.

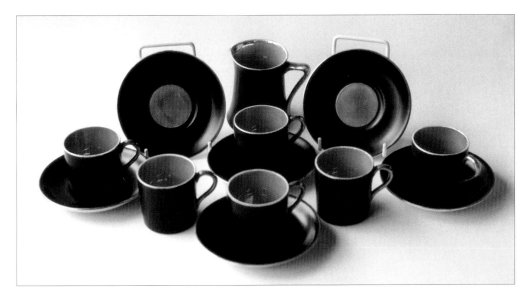

Colour Plate 138. Teaset, black/orange, six cups and saucers and creamer, BR&Co.

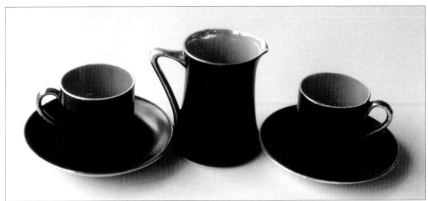

Colour Plate 139. Part teaset, black/orange, bone china Birks Rawlins & Co.

Colour Plate 140. *Coffee pot, sugar, creamer, cup and saucer. No mark.*

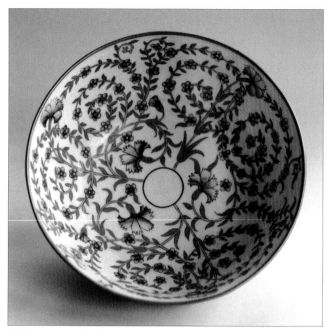

Colour Plate 141. *Plate, intricate pattern.*

Colour Plate 142. *Cup. pattern 1875.*

Colour Plate 143. *Creamer, pattern 1200, B&Co. 4½in. (11.43cm) high.*

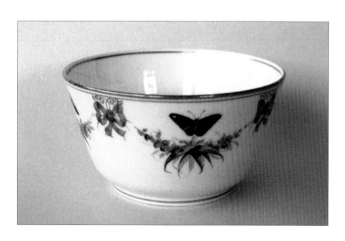

Colour Plate 144. *Bowl, 6in. (15.24cm) diameter, 3in. (7.62cm) high.*

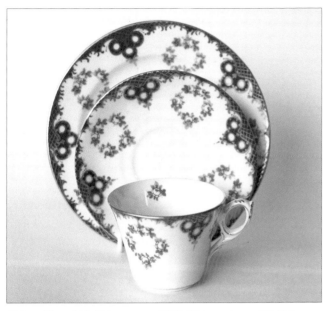

Colour Plate 145. Trio, pattern 1787, Chinese shape, BR&Co.

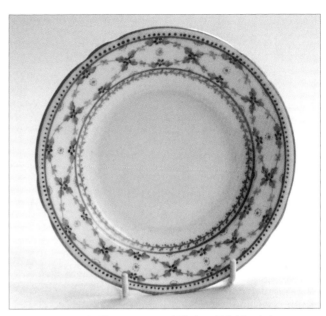

Colour Plate 146. Plate, pattern 1675. 8in. (20.32cm) diameter.

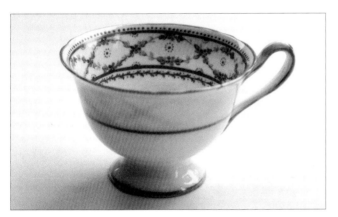

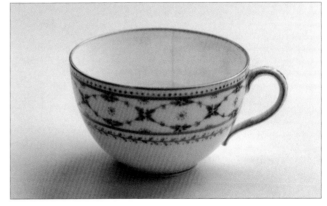

Colour Plate 147. Cup, pattern 1675.

Colour Plate 148. Cup, pattern 1675.

Colour Plate 149. Cup, sugar, small plate and creamer, pattern 2969.

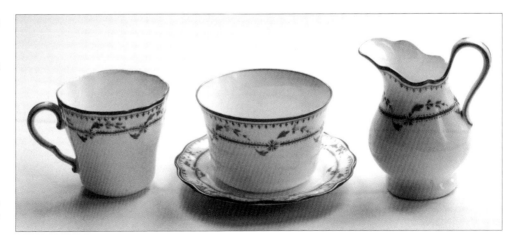

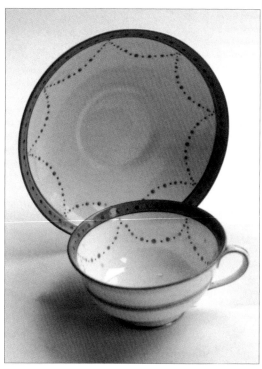

Colour Plate 150. Plate and cup, pattern 1395, turquoise blobs. B&Co.

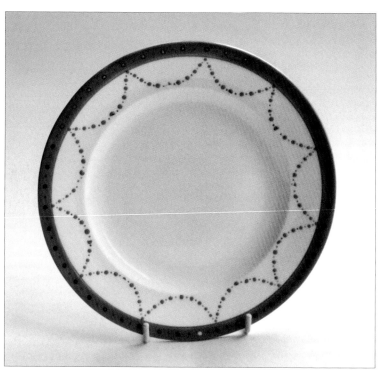

Colour Plate 151. Plate and cup, pattern 1395, turquoise blobs. B&Co. Made for T. Goode, Audley Street, London. 7in. (17.78cm) diameter.

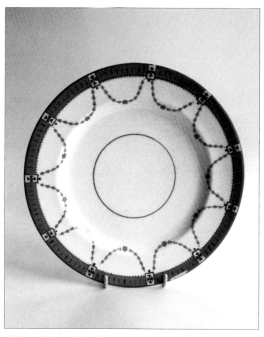

Colour Plate 152. Plate, pattern 1395, BR&Co., 9in. (22.86cm) diameter.

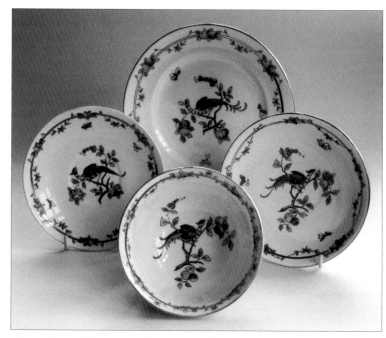

Colour Plate 153. Four small plates, bird designs.

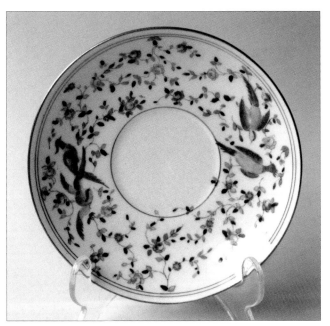

Colour Plate 154. Plate, saucer, pattern 2732.

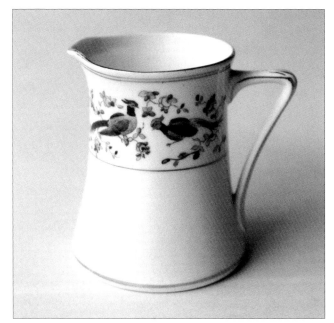

Colour Plate 155. Creamer/milk jug, pattern 2732.

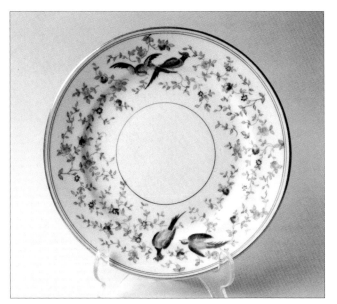

Colour Plate 157. Plate, pattern 2732.

Colour Plate 156. Trade mark on pattern 2732. BR&Co.

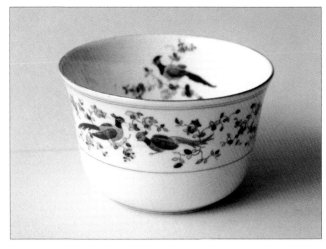

Colour Plate 158. Sugar bowl, pattern 2732.

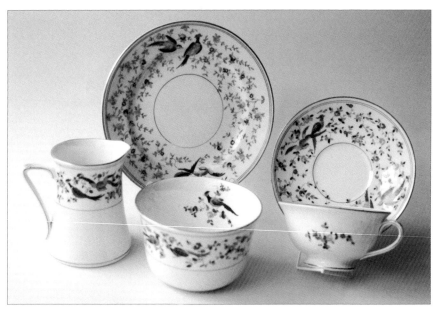

Colour Plate 159. Teaset. pattern 2732.

Colour Plate 160. Creamer, pattern 1398, B&Co. 3¾in. (9.5cm high).

Colour Plate 161. Plate, pattern 1398, B&Co. 9in. (22.86cm) diameter.

Colour Plate 162. White plate, radiating pattern.

Colour Plate 163. Two small plates, creamer and large plate.

Colour Plate 164. Two plates and creamer.

Colour Plate 165. Saucer – teaset, small plate, pattern 1898, B&Co. 6¾in. (17cm) diameter.

Colour Plate 166. Blue on white plate, Holbein pattern, B&Co. 10½in. (26.67cm) diameter.

Colour Plate 167. Blue on white plate, BR&Co. 10¼in. (26.04cm) diameter.

Colour Plate 168. Blue on white plate, BR&Co. 10¼in. (26.04cm) diameter.

Colour Plate 169. *Blue on white plate, BR&Co. 10¼in. (26.04cm) diameter.*

Colour Plate 170. *Blue border pattern on white plate, Turner pattern, B&Co. 10¼in. (26.04cm) diameter.*

Colour Plate 171. *Plate, Holbein pattern. 9½in. (24.13cm) diameter.*

Colour Plate 172. *Blue border pattern on white plate, BRCo. 10¼in. (26.04cm) diameter.*

Colour Plate 173. Blue on white plate and creamer.

Colour Plate 174. White plate, blue decoration.

Colour Plate 175. Wavy edged blue and white plate.

Colour Plate 176. *Trio, Hogarth pattern, B&Co. 1894-1900.*

Colour Plate 177. *Oval fluted plate, blue on white, Hogarth pattern, B&Co.*

Colour Plate 178. *Blue and white wavy edged plate, gold trim, pattern 1398, B&Co. 9⅝in. (24.5cm) diameter.*

Colour Plate 179. *Trade mark, blue and white plate, pattern 1398, B&Co.*

Colour Plate 180. White plate, Rim pattern.

Colour Plate 181. Blue edged pattern on plate.

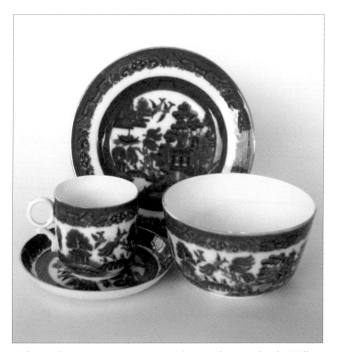

Colour Plate 182. Cup, saucer, plate and sugar bowl, Willow pattern, BR&Co.

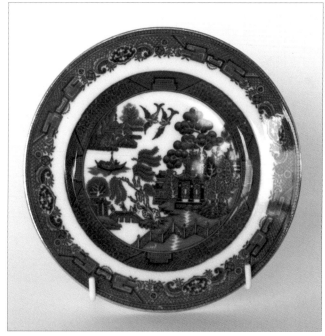

Colour Plate 183. Plate, Willow pattern, BR&Co. 7in. (17.78cm) diameter.

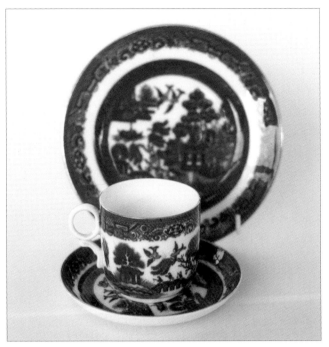

Colour Plate 184. *Trio, Willow pattern, BR&Co.*

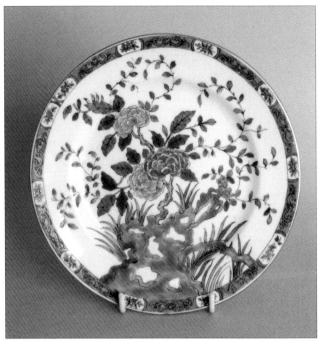

Colour Plate 185. *Plate, pattern 4030. 7¼in. (18.42cm) diameter.*

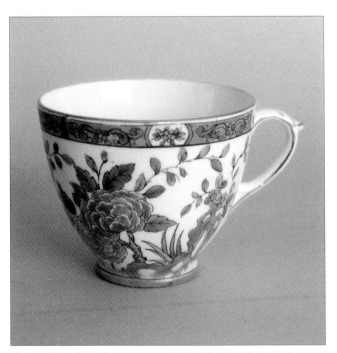

Colour Plate 186. *Cup, pattern, 4030. 2¾in. (6.99cm) high.*

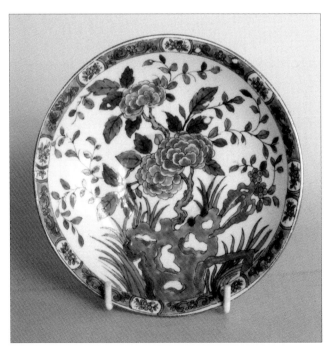

Colour Plate 187. *Saucer, pattern 4030.*

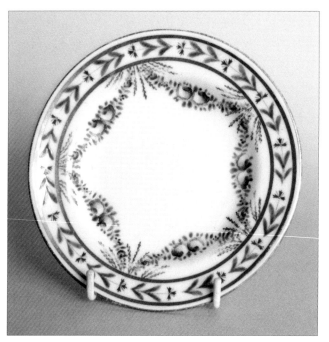

Colour Plate 188. Saucer, pattern 1674, Tivero pattern. 5¼in. (13.34cm) diameter.

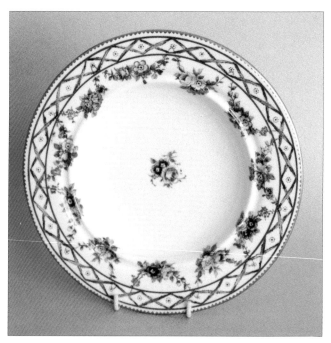

Colour Plate 189. Soup bowl, pattern 2694, BR&Co. Reproduction of old Bristol pattern from Potteries Museum for T. Goode. 9in. (22.86cm) diameter.

Colour Plate 190. Plate, pattern 2207, Southey shape, oven blue print, best gold edge, Chinese spray.

Colour Plate 191. Saucer, pattern 2092, Chinese pattern.

Colour Plate 192. White plate, six sided.

Colour Plate 193. Plate pattern 1793, Horace shape, BR&Co. 8in. (20.32cm) diameter.

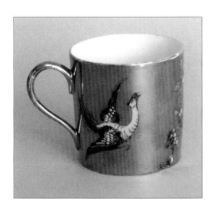

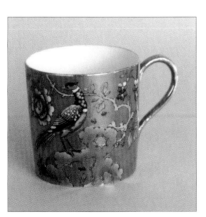

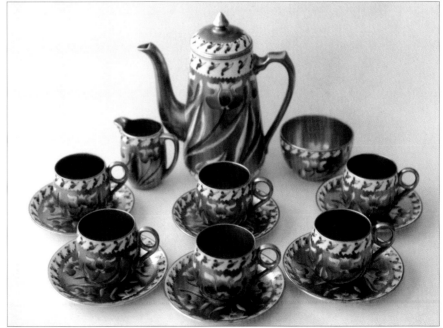

Colour Plates 194 and 195. Coffee can, pattern 2728, reproduction of old Chinese pattern. Trade mark cartouche.

Colour Plate 196. Coffee set, fifteen pieces, pattern 4235, Kermos. Trade mark Birks Rawlins & Co.

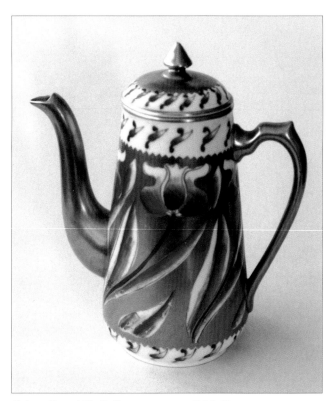

Colour Plate 197. Coffee pot, pattern 4235, Kermos.

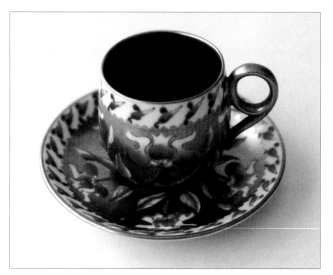

Colour Plate 198. Cup and saucer, pattern 4235, Kermos.

Colour Plate 199. Pattern name, pattern 4235, Kermos.

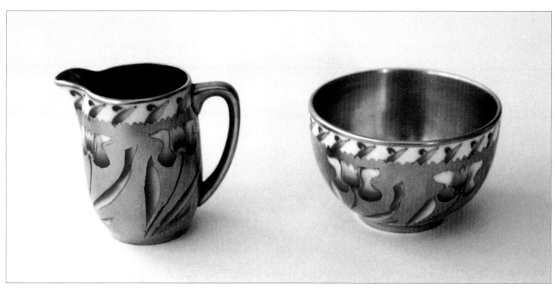

Colour Plate 200. Sugar and milk, pattern 4235, Kermos.

Tableware

Colour Plate 201. Trade mark, pattern 4235, Kermos. Bone China, Birks Rawlins & Co., Stoke-on-Trent, England.

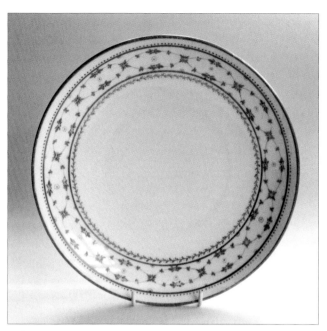

Colour Plate 202. White plate, Rim pattern.

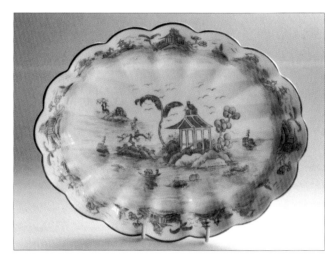

Colour Plate 203. Oval fluted plate, pink on white.

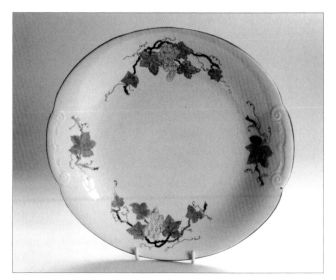

Colour Plate 204. White plate, Green leaf pattern.

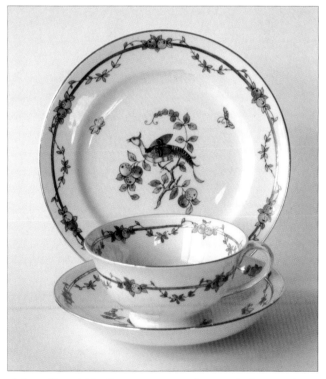

Colour Plate 205. Trio, pattern number 4335, Horace shape, BR&Co.

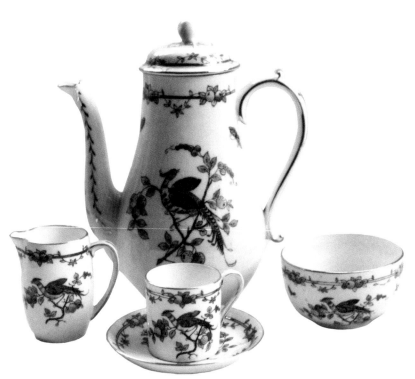

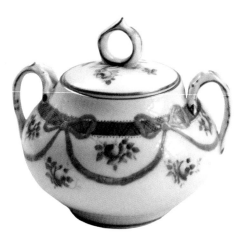

Colour Plate 206. Coffee set. Trade mark Old Birks China 1895-1928, 'The original Birks China'.

Colour Plate 207. Sugar bowl and cover, pattern 1268. 3¼in. (8.26cm) high.

Colour Plate 208. Creamer, left side.

Colour Plate 209. Creamer, right side.

Colour Plate 210. Preserve jar, pattern 2092, 'New Chinese' pattern, BR&Co. 4½in. (11.43cm) high, 4in. (10.16cm) diameter.

Colour Plate 211. Tableware, Art Deco decoration, Savoy/Carlton China.

Colour Plate 212. Pedestal style duo.

Colour Plate 213. Teaset, Kipling shape.

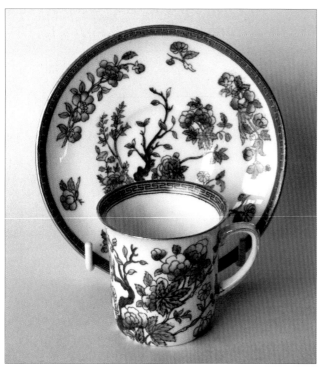

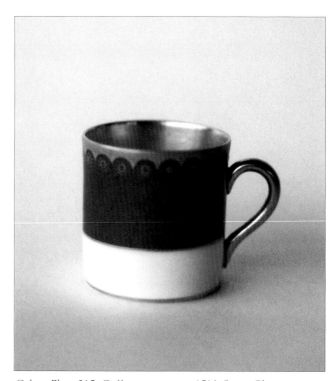

Colour Plate 214. Coffee can and saucer, Indian tree pattern. Trade mark Geo Fleet & Co. (retailer), Stoke-on-Trent.

Colour Plate 215. Coffee can, pattern 4516. Savoy China.

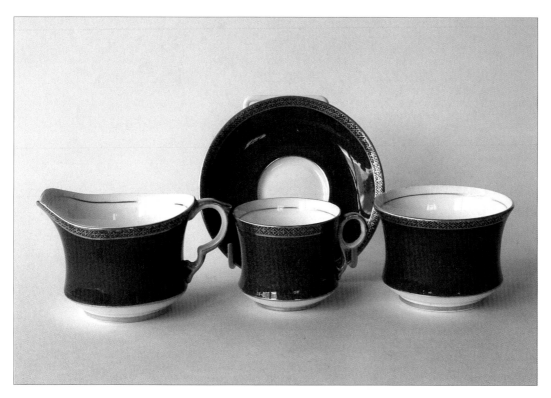

Colour Plate 216. Teaware, pattern 4514, 'Q' shape, 'Gilt crosses'. Carlton China.

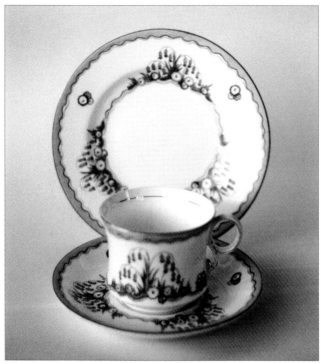

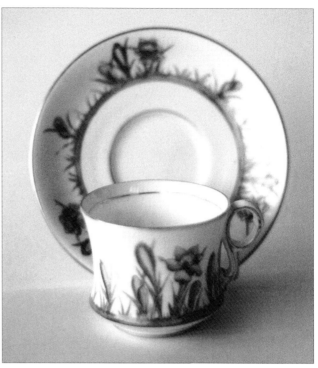

Colour Plate 217. Trio, pattern 4536, Bluebells. Art Deco for Lawleys, Regent Street.

Colour Plate 218. Cup and saucer, pattern 4526, Tulip. Savoy China.

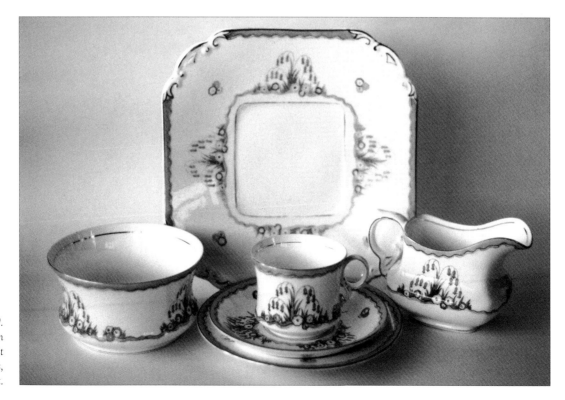

Colour Plate 219. Teaset, pattern 4536, Bluebells. Art Deco for Lawleys, Regent Street.

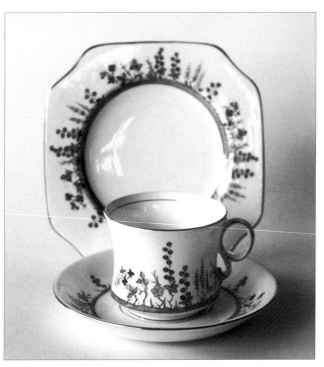

Colour Plate 220. *Teaware, pattern 4527, 'Cottage flowers', 'Q' shape. Carlton China.*

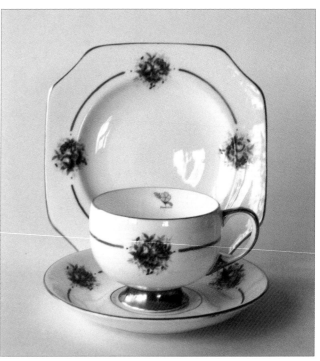

Colour Plate 221. *Teaware, pattern 4618, 'English rose', pedestal shape. Carlton China.*

Colour Plate 222. *Teaware, pattern 4639, 'Wisteria', pedestal shape. Carlton China.*

Colour Plate 223. *Plate, pattern 4655. Carlton China.*

Colour Plate 224. Teaware, pattern 4664, 'Field scabious', 'Q' shape. Carlton China.

Colour Plate 225. Miniature cup and saucer, pattern 4683, 'Butterfly, 'Q' shape. Savoy China.

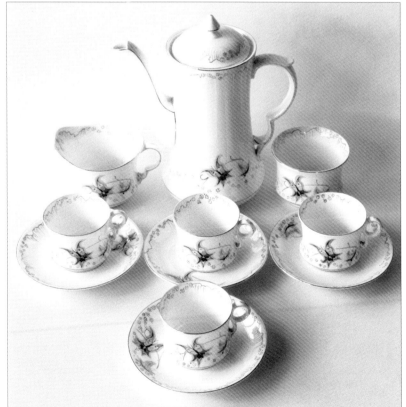

Colour Plate 226. Teaware, eleven pieces, pattern 4683, 'Butterfly, 'Q' shape. Savoy China.

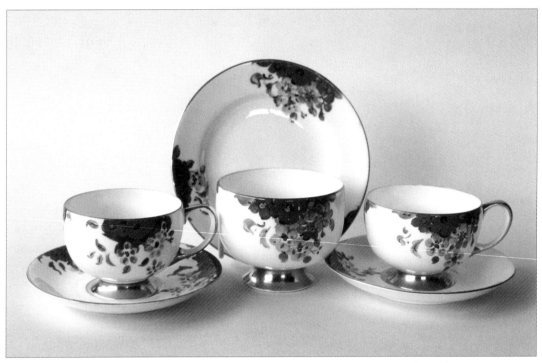

Colour Plate 227. Teaware, pattern 4693, 'Sunshine', pedestal shape. Carlton China.

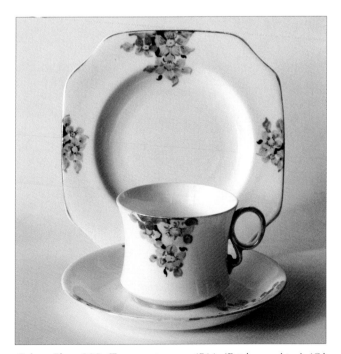

Colour Plate 228. Teaware, pattern 4744, 'Bright sunshine', 'Q' shape. Carlton China.

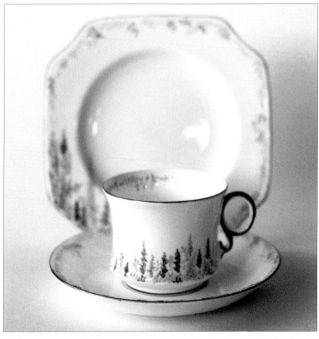

Colour Plate 229. Teaware, pattern 4753, 'Delphinium', 'Q' shape. Carlton China.

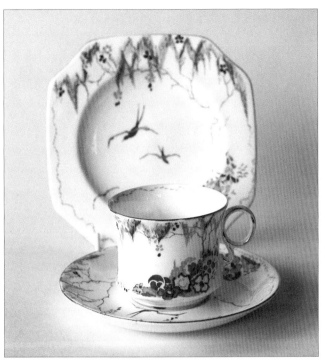

Colour Plate 230. *Teaware, pattern 4754, 'Springtime', 'Q' shape. Carlton China.*

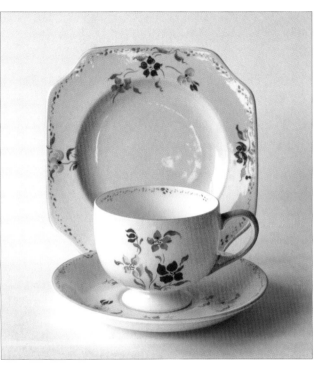

Colour Plate 231. *Teaware, pattern 4777. 'Pimpernel/Lilac posy', pedestal shape. Carlton China.*

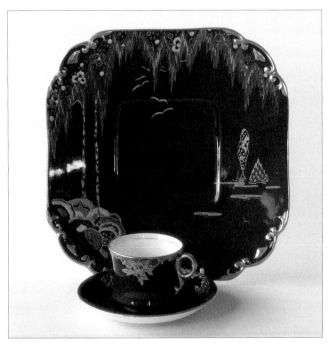

Colour Plate 232. *Teaware, pattern 4821, 'Enamelled berries', 'Q' shape, Carlton China.*

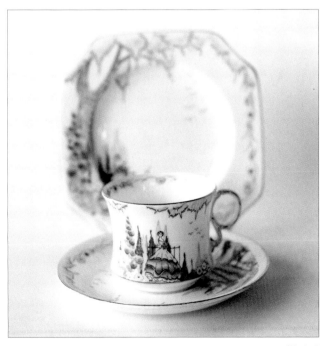

Colour Plate 233. *Teaware, pattern 4878, 'Afternoon stroll', 'Q' shape, Carlton China.*

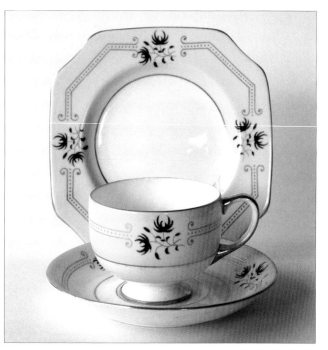

Colour Plate 234. *Teaware, pattern 4888, 'Cornflower', pedestal shape, Carlton China.*

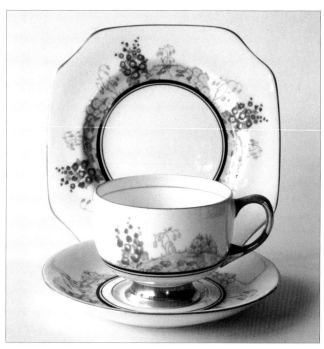

Colour Plate 235. *Teaware, pattern 4904, 'Hollyhocks', pedestal shape, Carlton China.*

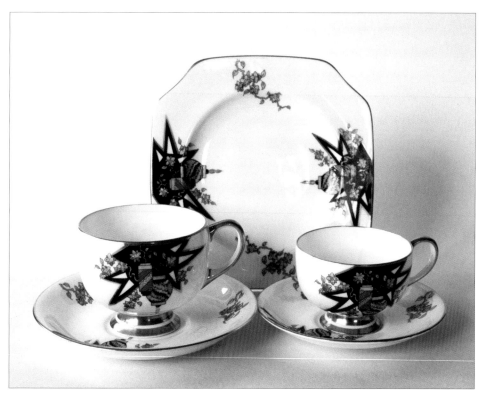

Colour Plate 236. *Teaware, pattern 4906, 'Chinese lanterns', pedestal shape, Carlton China.*

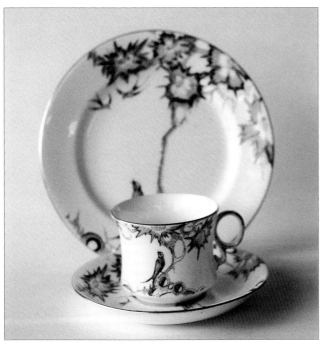

Colour Plate 237. *Teaware, pattern 4907, 'Starburst tree and birds', 'Q' shape, Carlton China.*

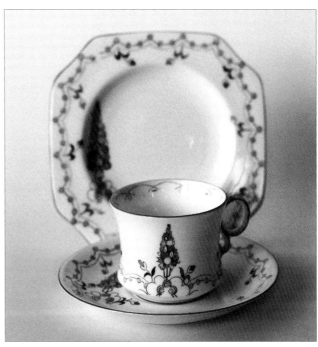

Colour Plate 238. *Teaware, pattern 4908, 'Spring flower', 'Q' shape. Carlton China.*

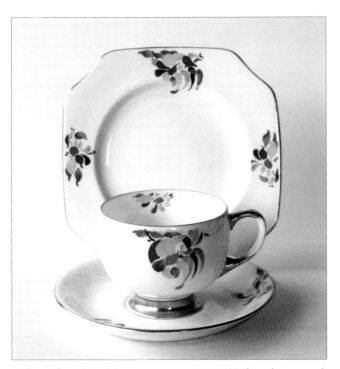

Colour Plate 239. *Teaware, pattern 4909, 'Technicolour posies', pedestal shape, Carlton China.*

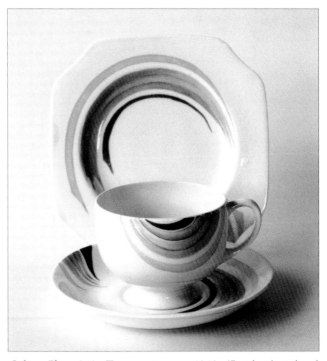

Colour Plate 240. *Teaware, pattern 4940, 'Rainbow', pedestal shape, Carlton China.*

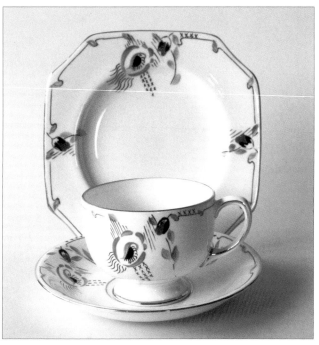

Colour Plate 241. Teaware, pattern 4948, 'Black eye', pedestal shape, Carlton China.

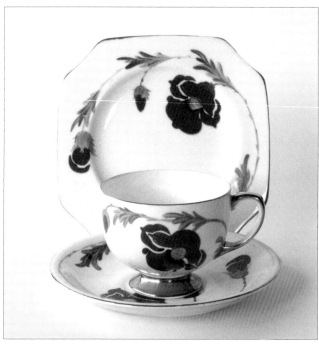

Colour Plate 242. Teaware, pattern 4977, 'Poppy', pedestal shape, Carlton China.

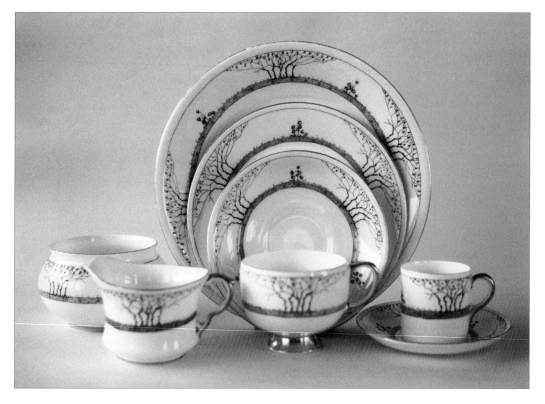

Colour Plate 243. Teaset, pattern 4979, 'Orange tree'. Savoy China. Art Deco. Rd. no. 738139.

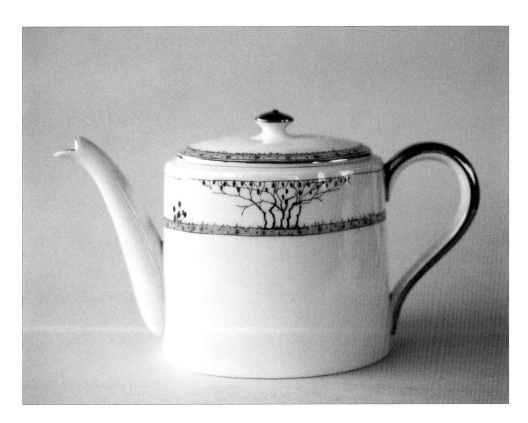

Colour Plate 244. *Tea pot, pattern 4979, 'Orange tree'. Savoy China. Art Deco.*

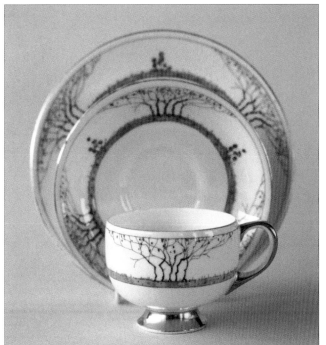

Colour Plate 245. *Trio, pattern 4979, 'Orange tree'. Savoy China. Art Deco.*

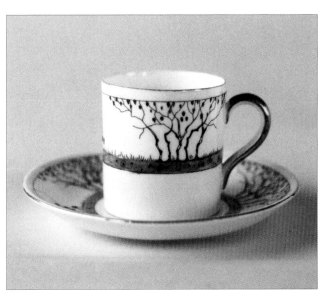

Colour Plate 246. *Coffee cup and saucer, pattern 4979, 'Orange tree'. Savoy China. Art Deco.*

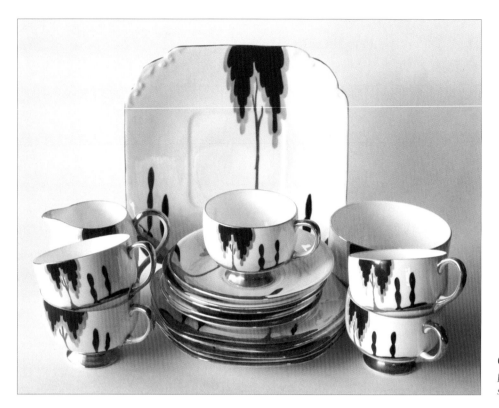

Colour Plate 247. *Teaware, eighteen pieces, pattern 4986, pedestal shape. Savoy & Carlton China.*

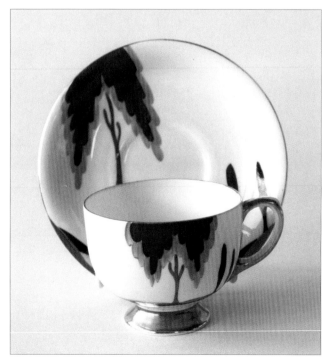

Colour Plate 248. *Teaware, pattern 4986, pedestal shape. Savoy & Carlton China.*

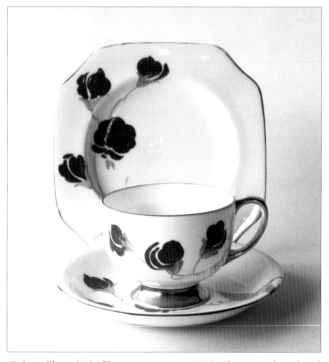

Colour Plate 249. *Teaware, pattern 4992, 'Sweet pea', pedestal shape. Carlton China.*

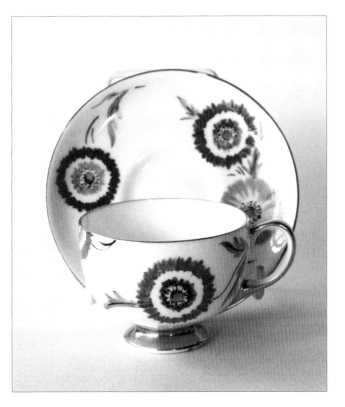

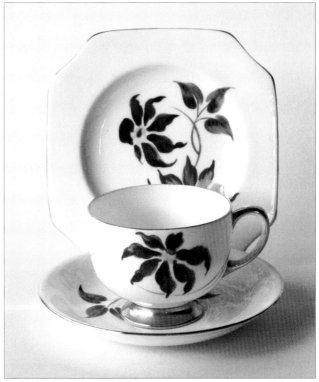

Colour Plate 250. Teaware. pattern 4990, 'Bright daisy', pedestal shape. Carlton China.

Colour Plate 251. Teaware. pattern 5000, 'Clematis', pedestal shape. Carlton China.

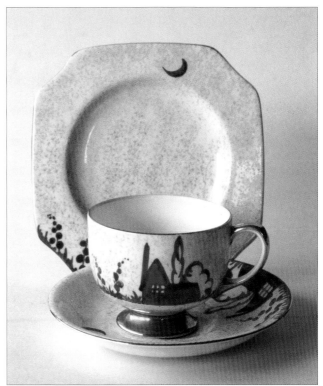

Colour Plate 252. Teaware. pattern 5001, 'Moonhouse', pedestal shape. Carlton China.

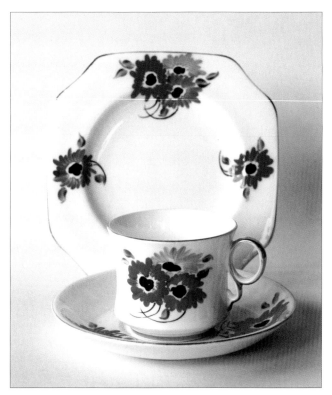

Colour Plate 253. Trio of 'Aster' pattern, 'Q' shape. Carlton China.

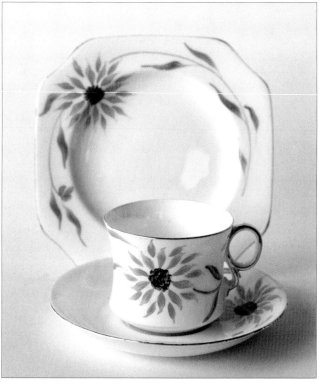

Colour Plate 254. Teaware, 'Dahlia' pattern, 'Q' shape. Carlton China.

Little has been recorded by authors of the day concerning shapes and patterns, apart from the *Pottery Gazette*, but it too laid much emphasis on other wares from the Vine manufactory. A comprehensive study of the pattern and shape books held in the Potteries Museum reserve collection in Hanley, Stoke-on-Trent reveals around twenty different shapes of cups with different handles made at the Vine factory within the 4,027 patterns. There have to be at least two books missing, unfortunately, as there is no record of the many hundreds of crested wares, grotesque figures, numerous birds, animals and cabinet wares that were modelled at the manufactory in Summer Street.

Tableware shape names were 'Aberdeen', 'Adelaide', 'Burns', 'Cambridge', 'Chinese', 'Cowper', 'Edinburgh', 'Empire', 'Horace', 'Joseph', 'Kipling', 'Lichfield', 'Melbourne', 'Minton', 'New', 'Oxford', 'Rothesay', 'Scott', 'Southey', 'Sutherland', 'Tasso' and 'Virgil'. These names suggest a leaning towards a group of poets, two very influential estates in Staffordshire and the flourishing export trade in Australia that the factory enjoyed after 1911.

The magnificent range of imagination in patterns and shapes illustrated certain Minton roots and if a piece is not trademarked appropriately it is often mistaken for that manufactory. If collecting it is advisable to question the origin and maybe the pattern number will be helpful.

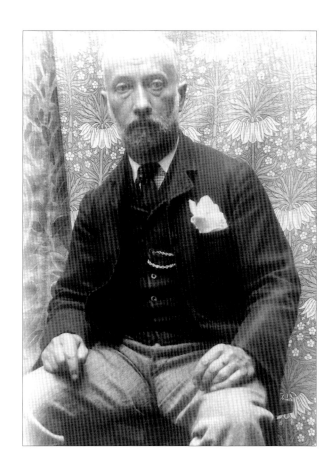

Chapter 5.

The Reuter Influence

AROUND 1901 LAWRENCE BIRKS PERSUADED HIS FRIEND AND FORMER colleague at Minton, the elderly Swiss artist Edmond G. Reuter,[1] to design for the Vine Factory. Edmond had originally come to England from Geneva in the early 1870s. He first worked at Minton's Kensington Gore Art Pottery Studio in London during 1875 and later in Stoke-on-Trent as assistant to the art director, Léon Arnoux, until the latter retired in 1895. He was an exceedingly rapid and clever craftsman, much of his best work being done on tiles. He was reputed to be an extremely silent man[2] and seldom spoke. Edmond returned to Geneva in the mid-1890s, though not before his talents had been spotted by William Morris, who employed him as a book illustrator, illuminator and calligraphist. Even after his return to Switzerland he appears to have been regarded as an honorary British citizen, as his work was shown in the British sections at the St. Louis Universal Exposition of 1904.[3]

1. Bernard Bumpus, 'Lawrence Birks and the Vine Pottery' in *Ars Ceramica*, p.44.
2. Cox's *Pottery Annual and Glass trade year book*, 1926, p.93.
3. Bernard Bumpus, 'Lawrence Birks and the Vine Pottery' in *Ars Ceramica* p.44.

Plate 35. Edmond G. Reuter.

111

4. *Pottery Gazette*, 1 November 1909, p.1223, and *Diary* p.19.
5. Bernard Bumpus, 'Lawrence Birks and the Vine Pottery' in *Ars Ceramica*, p.45 and Cox's *Pottery Annual and Glass trade year book*, 1926, p.93.

The firm gave Reuter his head and his most creative and interesting innovation was the 'Persindo Porcelain'[4] which was introduced officially during 1909. Reuter claimed that the patterns were inspired by Persian and Indian sources, but wider Middle Eastern influences were also apparent, doubtless attributable to the time he had spent in Egypt as a young man. This ivory porcelain was a form of glazed parian ware and the 'Persindo Porcelain' range was a great success, though examples are rarely seen today except in collections.[5]

Plate 36. *The Novelty of the Year – Ideal Designs ...* Pottery Gazette, *1 November 1909.*

6. *Pottery Gazette*, 1 November 1909, p.1268.

The impact of Persindo porcelain on display at J.W. Walton's Bath House showrooms in London was such that the *Pottery Gazette* reporter visited and reported on the wares in 1909.[6] The best part of a whole page of the magazine was devoted to this classic ivory

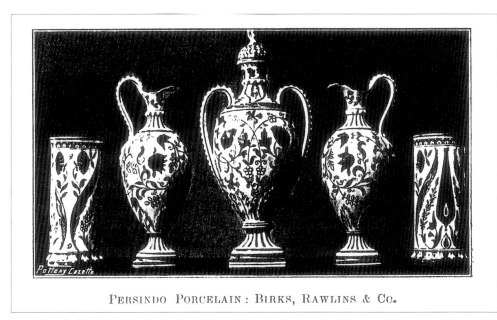

Plate 37. *Persindo Porcelain from Birks, Rawlins & Co.,* Pottery Gazette, *1 November 1909.*

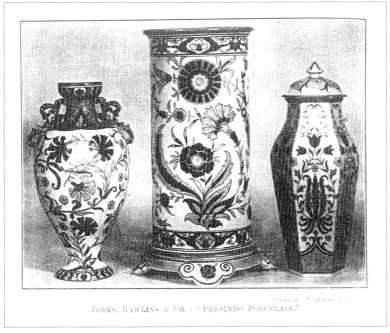

Plate 38. *Persindo Porcelain from Birks, Rawlins & Co., Pottery Gazette, 1 November 1909.*

Colour Plate 255. *Persindo vase with lid. 10¼in. (26.04cm) high. 263/35 (model number and artist's number).*

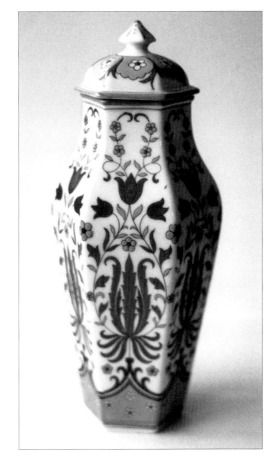

porcelain, which was presented in the form of vases and a great variety of jugs, pitchers, honey pots, fern pots, beakers, goblets and numerous other household requisites. They were all of beautiful quality and finish. All the graceful shapes have the pattern specially designed to harmonise with the size and the form of each piece, thus enhancing its individuality. Persindo porcelain is a skilful decorative treatment on the lines of 'Rhodian' ware, which was the continuation of old Persian traditions. In the older examples of Persian pottery much of the decoration is entwined, Arabesque fashion, with beautifully designed texts from the Koran, but Persindo Porcelain does not possess the religious element. Edmond Reuter had carefully assimilated the chief features of the best work and presented it in a fashion that popularised the Persian style of decoration. The variety of styles suggest floral growth more consistently, but while in 'Persindo Porcelain' the principles of conventionalism and arrangement are similar, the effect is freer, daintier and prettier. At the same time, the unaffected Persian treatment of the carnation and the rose, which is so charming, is preserved. The illustration from the *Pottery Gazette* (Plate 38) gives a good idea of its appearance.[7] The large cylindrical vase in the centre is a tall piece on four feet with the rich decorations carried out with fine

7. Ibid., 1 June 1910, p.664.

coloured effects. Another good shape shown is the vase and cover with six flat sides, narrowing from the shoulder to the neck.

These two groups taken from the *Pottery Gazette* illustrated in black and white depict a beautiful revival of an old time scheme of decoration. The 1909 scene of the two handled vase and cover and the handled pitchers on either side make an artistic set. The two cylindrical vases at the sides are good forms tastefully ornamented. These five pieces are typical of a large number of samples that were produced in abundance before the Great War. Sadly the export trade took them from these shores. Many small pieces or miniatures were also made along the same lines; all these were extremely suitable for the cabinet, drawing room and table decoration. They were very popular further afield in the United States, as they went for ivory porcelain in a big way, and eventually in Australia as export links were built up after 1911.

The advertising campaign was consistently observed each month for buyers within

Plate 39. Advertisement, Pottery Gazette Diary, *1911.*

Colour Plate 256. Vase with handles, Persindo but in lustre. 2½in. (6.35cm) high. No. 364.

114

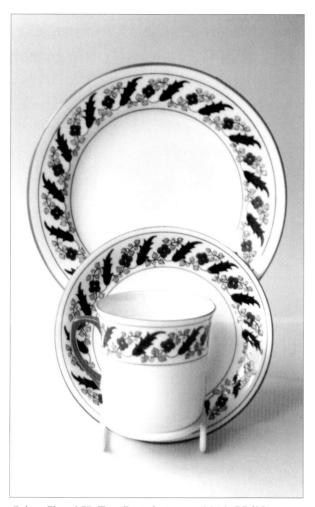

Colour Plate 258. Base of Persindo cup, pattern 2046.

Colour Plate 259. Trade mark on Persindo trio, BR&Co.

Colour Plate 257. Trio, Persindo pattern 2046, BR&Co.

Colour Plate 260. Persindo trade mark.

Colour Plate 261. Persindo trade mark.

the pages of the *Pottery Gazette* for three to four years, and it was noted that J. Dunlop[8] was an agent in Glasgow, accompanying J.W. Walton in London as previously observed (Plate 39).

The Vine Pottery experimented with certain lustre work and it has become apparent that after the Great War various miniatures were produced with the red carnation not apparent as in all previous models, but nevertheless an attractive miniature shape or product.

The pattern books illustrate the works of the gifted Swiss artist in abundance. The pattern numbers that can be attributed to the hand of Reuter are 1883, 2046, 2061, 2095, 2096, 2150, 2271, 2272, 2273, 2274, 2275, 2276, 2277, 2278, and 2681. The range of 2271 to 2278 all show a variance of a similar pattern, but a delicate change of colouring on teasets for three or four people. Many more patterns exist, as observed in

8. Ibid., advertisement, 1 October 1910, p.1089.

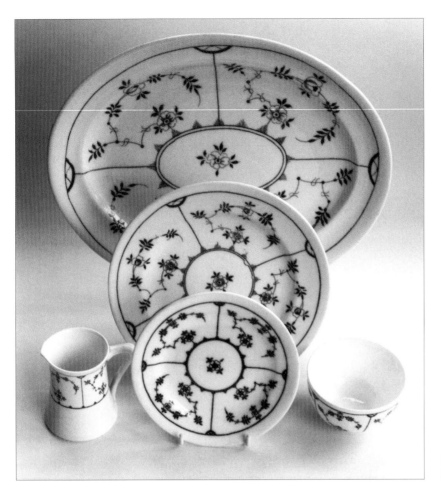

Colour Plate 262. Part service Copenhagen style, Dürer pattern.

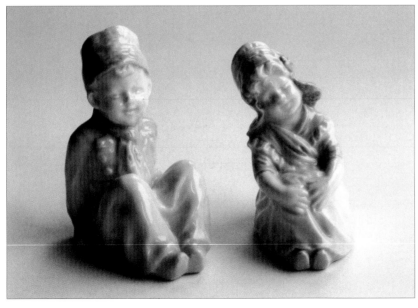

Colour Plate 263. Figures, Copenhagen style for Dutch models (Reuter influence).

a variety of collections, but unfortunately the artists hardly ever signed their work. The trio illustrated in Colour Plate 257 offers an idea of how a pattern was adapted for table use.

Edmond's influence, although not so evident, can be seen with the Copenhagen style of tableware illustrated with the 'Dürer' pattern, seen in Colour Plate 262 and in the previous chapter covering tableware. Reuter was also responsible for the production of at least two figures in 'Dutch' style and costume, but originally they were from the two Danish figures in blue/grey colouring as in Colour Plate 263. The Dutch figures may be compared in Chapter 7 covering the production of figures at the Vine Pottery.

Edmond Reuter had long been an admirer of Royal Copenhagen ware and he went to great lengths to express his feelings in a two part contribution in the *Connoisseur* of September 1905.[9] The illuminating article, with its accompanying photographs of the wares, traced the different influences on the Danish Royal factory from as early as 1760.

The Vine Pottery was always conscious of the value of artistic design and, perhaps at the suggestion of Reuter, they increased their staff by recruiting other skilled artists like Fred Ridgway, William Leak, A. Lewis, Len Rivers, who was a specialist in rose painting, and Bob Wallace.

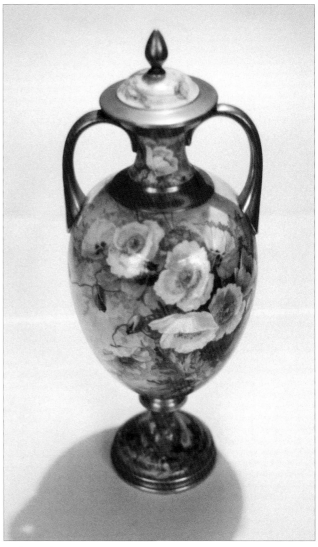

Colour Plate 264. Vase with cover, BR&Co., signed L. Rivers. 17½in. high (44.45cm).

Leonard Rivers' style was very evident with his flamboyant and individual delivery of roses and carnations. He was one of several talented artists attracted to the Vine by the proprietor and Reuter around 1901/02. He painted lavishly on a variety of tableware and cabinet display vases of grandiose proportions. Fortunately a majority representation of his work has been kept in a private collection and his signature is evident on most of the vases, dishes, jars and bowls. Probably the most magnificent of this collection is a 17½in. (44.45cm) high vase which was made in three pieces that are screwed together (Colour Plate 264). There is a fair representation of his work in the surviving pattern books for the Vine Pottery.

9. *Connoisseur,* September 1905, pp.105-111 and pp.141-150.

Persindo Porcelain

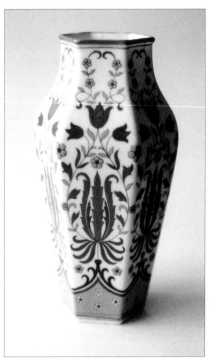

Colour Plate 265. Persindo vase. 8½in. (21.59cm) high. 263/35.

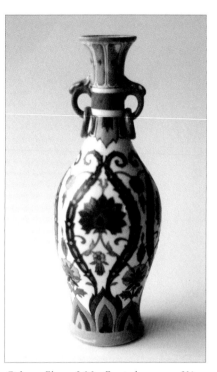

Colour Plate 266. Persindo vase. 9¾in. (19.69cm) high. 313/55.

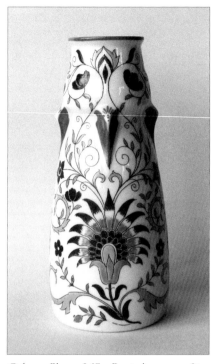

Colour Plate 267. Persindo vase. 8in. (20.32cm) high. No. 266-26.

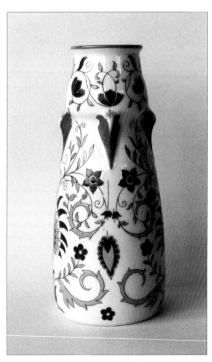

Colour Plate 268. Persindo vase. 8½in. (21.59cm) high. No. 266-26.

Colour Plates 269 and 270. Persindo bowl. 7½in. (19.05cm) diameter, 3in. (7.62cm) high.

Persindo Porcelain

Colour Plate 271. Two Persindo vases with lids, BR&Co. 10½in. (26.67cm) high.

Colour Plate 272. Persindo vase, green background, 1878/51. 7in. (17.78cm) high.

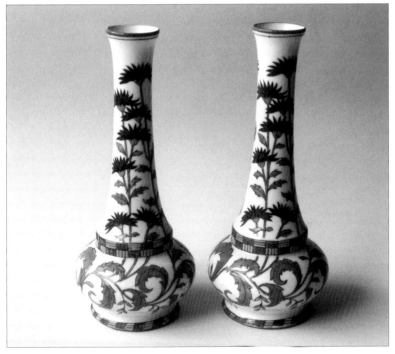

Colour Plate 273. Persindo vases, No. 278-39. 8½in. (21.59cm) high.

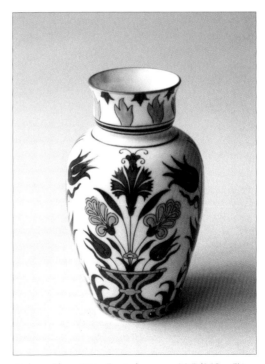

Colour Plate 274. Persindo vase, 225/28L. 5½in. (13.97cm) high.

Persindo Porcelain

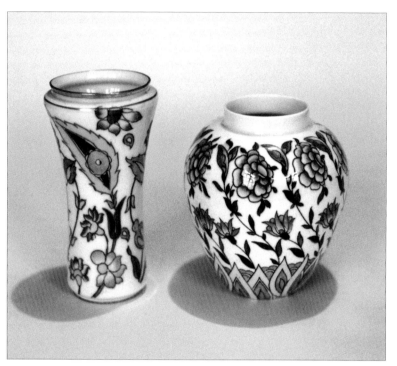

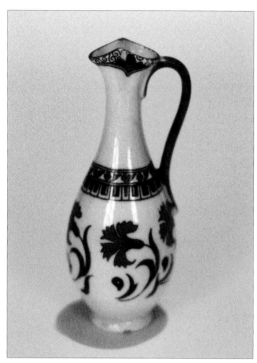

Colour Plate 275. Persindo vases, 212 over D in red, trade marked. 5in. (12.7cm) high.

Colour Plate 276. Persindo jug, 161-120. 5in. (12.7cm) high.

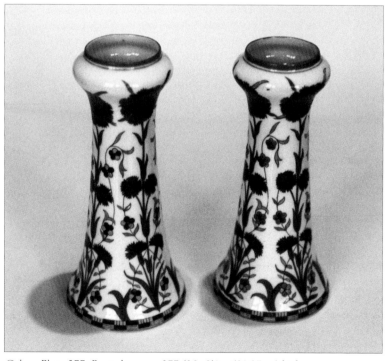

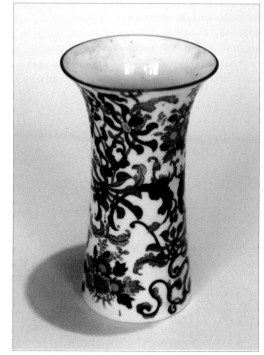

Colour Plate 277. Persindo vases, 277/38. 8⅜in. (21.27cm) high.

Colour Plate 278. Persindo vase, no mark. 4½in. (11.43cm) diameter, 7¾in. (19.69cm) high.

Persindo Porcelain

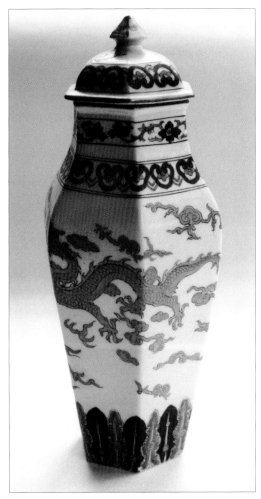

Colour Plate 279. Persindo style blue and white vase and lid, No. 453. 10¼in. (26.04cm) high.

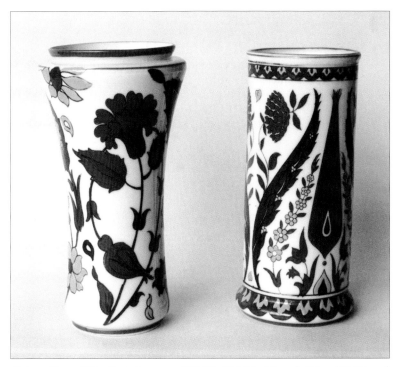

Colour Plate 280. Persindo vases, 223-24, 212-27. 5½ and 5¾in. (13.97 and 14.61cm) high.

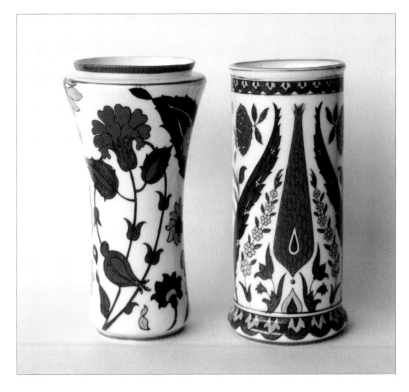

Colour Plate 281. Another view of Colour Plate 280.

Persindo Porcelain Miniatures

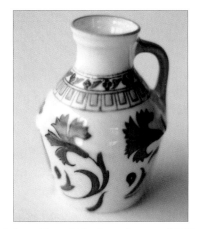

Colour Plate 282. Persindo jug, 179-12. 2½in. (6.35cm) high.

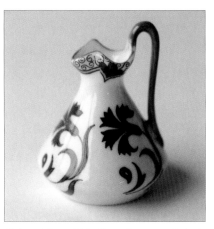

Colour Plate 283. Persindo jug with high handle, 19/12.R..

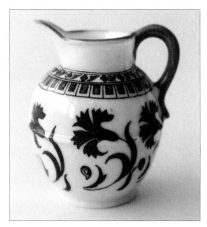

Colour Plate 284. Persindo milk jug, 160/12. 2¾in. (7cm) high.

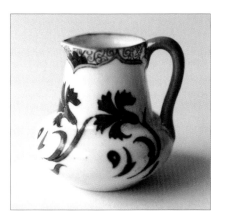

Colour Plate 285. Persindo jug, model 145-12. 2¼in. (5.7cm) high.

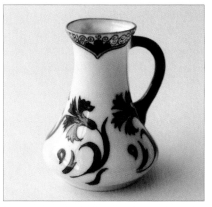

Colour Plate 286. Persindo concave jug, 89/12. 2¾in. (7cm) high.

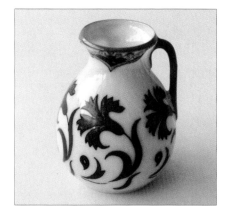

Colour Plate 287. Persindo water jug, 88/13. 2⅜in. (6cm) high.

Colour Plate 288. Persindo leather bottle, 14-12/3. 2⅜in. (6cm) high.

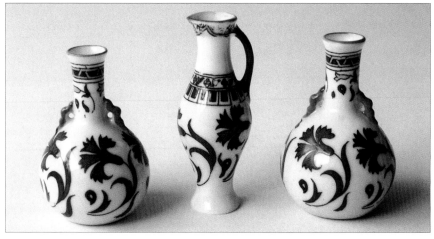

Colour Plate 289. Persindo miniatures, 158/12, 159/, 158/13. 3, 3⅜ and 3in. (7.5, 8.5 and 7.5cm) high.

Persindo Porcelain Miniatures

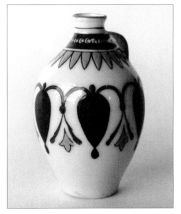

Colour Plate 290. *Persindo miniature urn with handle, No. 273/4.*

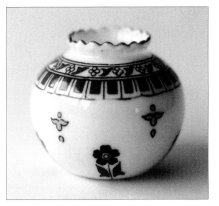

Colour Plate 291. *Globe vase model 62-11. 2in. (5cm) diameter, 1½in. (4cm) high. Savoy china.*

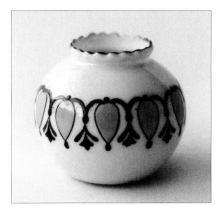

Colour Plate 292. *Model of globe vase 62-11. 2in. (5cm) diameter, 1½in. (4cm) high. Savoy china.*

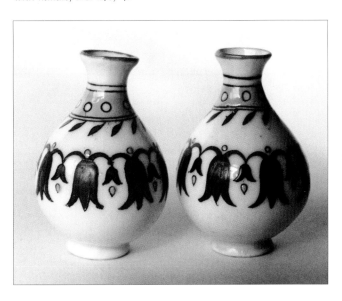

Colour Plate 293. *Pair of slim necked Persindo miniature vases, No. 82/5.*

Colour Plate 294. *Persindo jug/vase, 153-7-3 B. 2¾in. (7cm) high.*

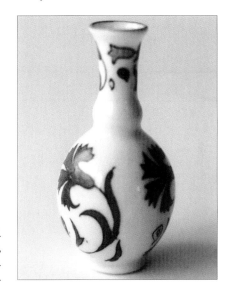

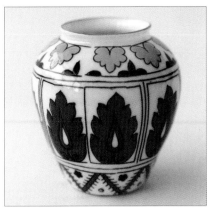

Colour Plate 295. *Model of ancient urn, 23/20. 2½in. (6.5cm) high. Savoy china.*

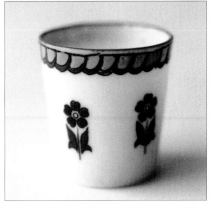

Colour Plate 296. *Bucket vase. 1½in. (4cm) high. Savoy china.*

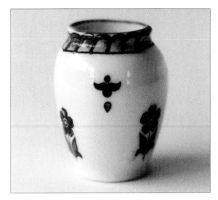

Colour Plate 297. *Ancient urn, 'Nottingham 1896' Museum, 143/1. 1½in. (4cm) high. Savoy china.*

123

Persindo Porcelain Miniatures

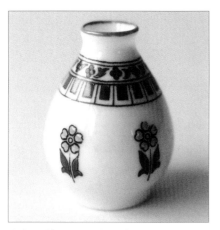

Colour Plate 298. Persindo urn, 107-1. 2in. (5cm) high.

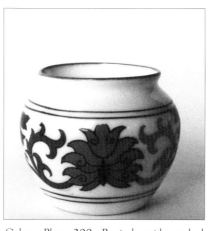

Colour Plate 299. Persindo wide necked vase, No. 1/22D.

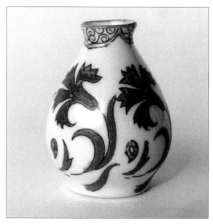

Colour Plate 300. Persindo miniature urn, No. 107/12E.

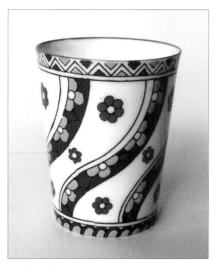

Colour Plate 301. Persindo miniature vase, BR&Co. 2⅜in. (6cm) diameter, 3in. (7.5cm) high.

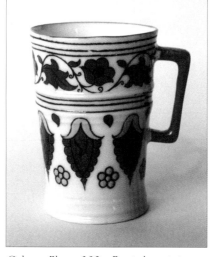

Colour Plate 302. Persindo miniature straight-sided jug, No. 183/23 B.

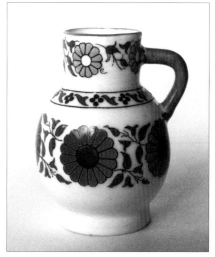

Colour Plate 303. Persindo miniature jug, No. 12/7A.

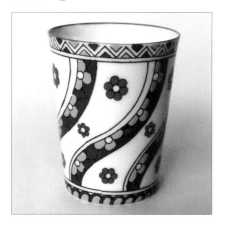

Colour Plate 304. Persindo miniature bucket vase, No. 70/14. Savoy china. 2⅞in. (7.31cm) high. (See Colour Plate 301 for a vase with the same decoration but with a BR&Co. rectangular trade mark.)

The Work of Len Rivers

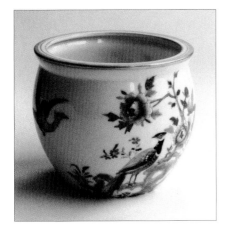

Colour Plate 305. Squat vase, 4½in. (11.43cm) diameter, 3¾in. (9.55cm) high. Pheasant/flowers painted by Len Rivers.

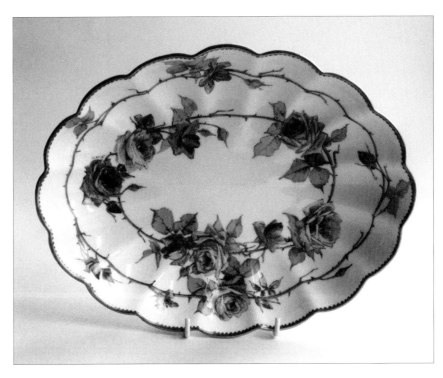

Colour Plate 306. Oval fruit dish, B&Co. L. Rivers' red signature. 10 x 8 x 1¾in. (25.4 x 20.32 x 4.45cm) high.

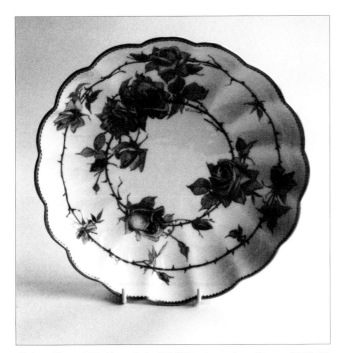

Colour Plate 307. Fruit dish, BR&Co. Artist Len Rivers, 1901-17. 8¾in. (22.23cm) diameter, 1¾in.(4.45cm) high.

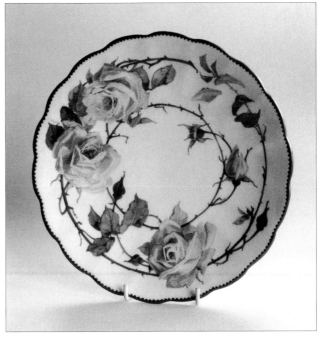

Colour Plate 308. Fruit dish, floral pattern on white. BR&Co. L. Rivers. 8½in. (21.59cm) diameter.

The Work of Len Rivers

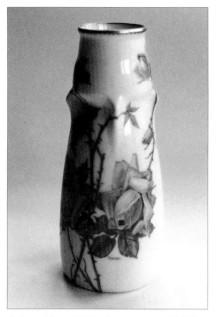

Colour Plate 309. Narrow vase, BR&Co. Signed L. Rivers. 7¼in. (19.69cm) high.

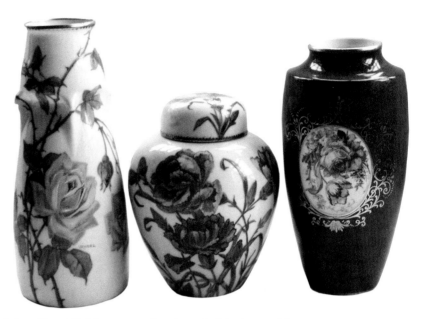

Colour Plate 310. Three vases, all trade marked BR&Co., all by L. Rivers. Left to right 7¼, 5½, 7in. (18.42, 13.97, 17.78cm) high.

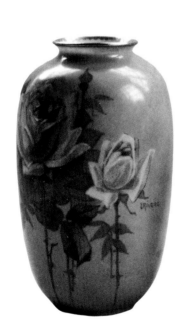

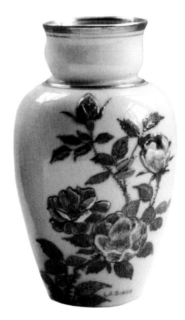

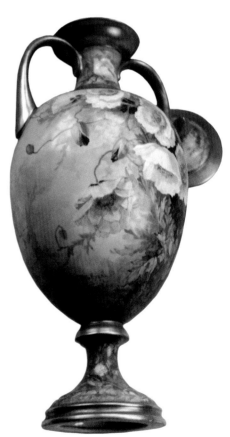

Colour Plate 311. Two vases. Left, roses, signed L. Rivers. 5in. (12.7cm) high. Right, raised flowers, signed L.A. Birks. 5¼in. (13.34cm) high.

Colour Plate 312. Large vase with handles, BR&Co. L. Rivers. 17½in. (44.45cm) high.

The Work of Len Rivers

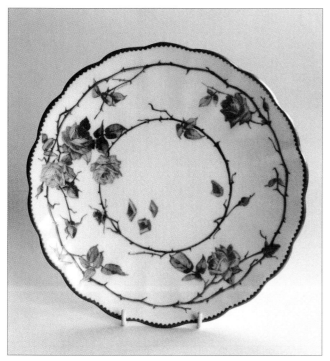

Colour Plate 313. *Wavy edged floral plate, BR&Co. L. Rivers, 8½in. (21.59cm) diameter.*

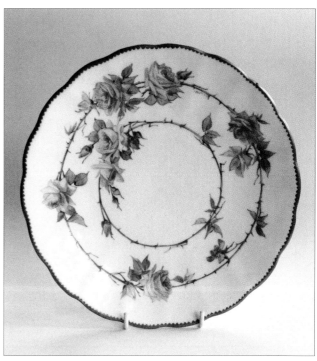

Colour Plate 314. *Wavy edged floral plate, BR&Co. L. Rivers, 8½in. (21.59cm) diameter.*

Colour Plate 315. *Floral bowl, BR&Co. Len Rivers. 2¼in. (5.72cm) deep, 6¼in. (15.88cm) diameter.*

Colour Plate 316. *Ginger jar with lid, BR&Co. L. Rivers signature. 5½in. (13.97cm) high.*

Colour Plate 317. Tube-lined scene by Charlotte Rhead. 7½ x 4¾in. (19.05 x 12.07cm).

Chapter 6.
The Rheads, Fred Ridgway and Exhibition Awards

T HE ARTISTS RECRUITED AT THE VINE POTTERY BY LAWRENCE BIRKS were so good at their work that the public and trade were made aware of their particular skills[1] during these years at the international exhibitions available to the firm. This was generally by courtesy of the medium of the monthly news from the *Pottery Gazette* magazine.

Needless to say, in this competitive world these artists were headhunted by receiving more lucrative offers to work for a neighbouring factory in one of the six towns in Stoke-on-Trent. When Frederick Rhead returned home from spending some time in the United States he joined Birks Rawlins & Co. early in 1910, but moved on after a little over two years to a more financially rewarding position as art director of Wood & Sons in Middleport, Burslem. Consequently daughters Charlotte and Dolly moved on too. There had been a great contribution with pâte-sur-pâte and tube-lining decoration from the Rheads, as demonstrated in the international exhibitions over the next two to three years. This was evident, too, in the firm's pattern books where the surname Rhead is written, although very sparingly. Reference to anyone's work in the pattern books is only by style of work. This is quite obvious in the case of works by Reuter and Rivers.

A prestigious award, a Diploma of Honour, was gained at the Turin International Exhibition[2] in 1911 by the manufactory. Lawrence Birks had decided to put on a display[3] that would show off the full range of the firm's output, which now included a wide range of table, tea, breakfast and decorative wares and high class painted goods in special porcelain pastes, matt flambé and other special glazes, and new effects in pâte-sur-pâte. Such abundance paid off as the company was awarded this Diploma, though it was inevitably the decorative wares that caught the eye. The *Pottery Gazette* reporter

1. *Pottery Gazette*, 1 July 1911, p.781.
2. Bernard Bumpus, 'Lawrence Birks and the Vine Pottery', in *Ars Ceramica*, p.45.
3. *Pottery Gazette*, 1 July 1911, p.781.

Examples of Tube-Lining

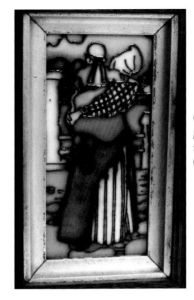

Colour Plate 319. Tube-lined plaque by Charlotte Rhead, mother and child. 5⅝ x 2¾in. (14.29 x 6.99cm).

Colour Plate 318. Tube-lined plaque by Charlotte Rhead, Jack and Jill. 11¾ x 6in. (29.89 x 15.24cm).

Colour Plate 320. Three vases with raised slip trailed contours. BR&Co., Fine bone china. 5⅝, 5¾ and 5⅝in. (14.29, 13.65 and 14.29cm) high.

Colour Plate 321. Tube-lined face plate possibly by Charlotte Rhead, 1911. 11½in. (29.21cm) diameter.

who visited the exhibition was particularly impressed by the pâte-sur-pâte work of Frederick and Charlotte Rhead. He was also enthusiastic about Lawrence Birks' own productions, William Leak's vases[4] painted in 'a most charming presentation' and some tube-lined items by Charlotte and Dolly Rhead. Finally there were a few examples of flambés and lustres that were in their experimental stage at the factory.

4. Bernard Bumpus, 'Lawrence Birks and the Vine Pottery', in *Ars Ceramica*, p.45, and *Pottery Gazette*, 1 November 1913, p.1278.

Examples of Tube-Lining

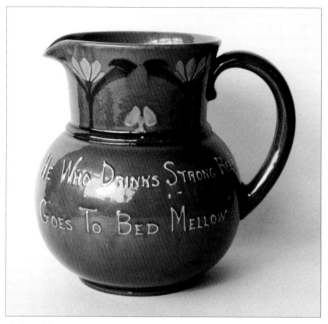

Colour Plate 322. Tube-lined earthenware body, possibly by Charlotte Rhead, 1911. A tribute to Charles Goodfellow. 6¼in. high (15.88cm).

Colour Plate 323. Reverse of the jug in Colour Plate 322.

5. Bernard Bumpus. 'Lawrence Birks and the Vine Pottery', in *Ars Ceramica*, p.46.
6. *Cox's Pottery Annual and Glass trades book*, advertisement, 1925 and 1926.
7. *Pottery Gazette*, 1 June 1915, p.654.

In 1913 Birks Rawlins & Co. were awarded the Diploma of Honour at the Ghent International Exhibition.[5] Frederick Rhead's work again contributed to the display with a cylinder vase decorated in pâte-sur-pâte. Some very rich dessert plates and trays, exquisitely painted by Bob Wallace,[6] were to be seen, and also some déjeuner sets and tea services charmingly decorated in old Sèvres and other styles. Prominence was given to imitations of the well-known blue and white Copenhagen styled ware and the artistic presentation of ships, fish, birds and flowers that were depicted in dark blue on a light blue/grey ground. This latter ware was no doubt influenced by Edmond Reuter. Fred Ridgway, another artist of extreme skill, had a vase decorated in coloured pastes, along with the subjects of birds, fish, boats, windmills etc. in coloured slips.

A multitude of vases and other ornaments and, with less appropriateness, grotesque figures of animals were seen. China baskets in the old Bow style encrusted with flowers were exciting contributions, as was a plain, square straw coloured basket.

The *British Architect*[7] was particularly full of praise for the company's work at this event, singling out the graceful designs of the pâte-sur-pâte work, Fred Ridgway's skills and the 'Persindo' examples. A great part of the exhibit consisted of small articles suitable for souvenirs, but there were also a few lines which attracted the connoisseur.

The First World War made its impression on the industry with the loss of several of the male dominated workforce, but pâte-sur-pâte work continued. Fred Ridgway was making his mark using this technique, though working in a very different style from Lawrence Birks. Consequently the journey in 1915 to the United States was rewarded with a Medal of Honour for the display of the factory's wares at San Francisco. This was

A Variety of Lustres

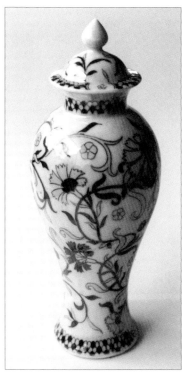

Colour Plate 324. *Lustre vase with lid, Persindo style. Trade mark. 8⅝in. (22cm) high.*

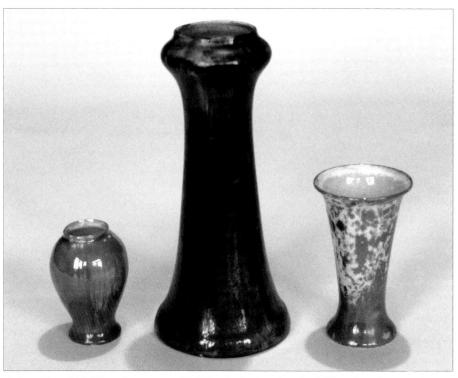

Colour Plate 325. *Three lustre vases, BR&Co. Pink 3¼in. (8.26cm), blue 8¼in. (20.96cm), pink mottled 4¼in. (10.8cm).*

Colour Plate 326. *Lustre vase signed L.A. Birks/F.A. Rhead, BR&Co. 7in. (17.78cm) high.*

Colour Plate 327. *Three vases, BR&Co. Left, lustre, 4in. (10.16cm). Centre, raised tube-lined, 5¼in. (13.34cm). Right, lustre, 4½in. (11.43cm).*

A Variety of Lustres

Colour Plate 328. Miniature of a pig, no mark. Experimental lustre, used in crested ware. 3in. (7.62cm).

Colour Plate 329. Three copper lustre green decorated vases and grotesque. 3½ to 5½in. (8.89 to 13.97cm) high.

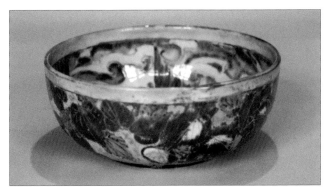

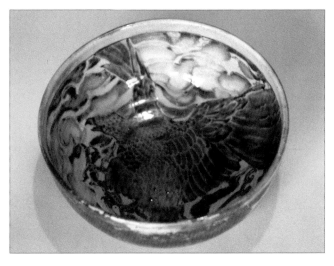

Colour Plate 330. Bowl with eagle inside, BR&Co., signed F.A. Rhead. 8¼in. (20.96cm) diameter, 3¾in. (9.53cm) high.

Colour Plate 331. Interior of the bowl in Colour Plate 330.

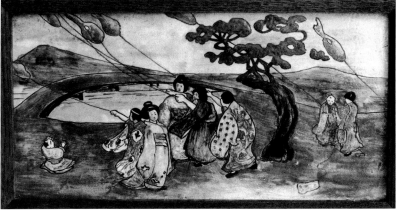

Colour Plate 332. Plaque, lustre developmental work, BR&Co., eight Oriental ladies. 11½ x 5½in. (29.21 x 13.97cm).

Examples of Fred Ridgway's skills

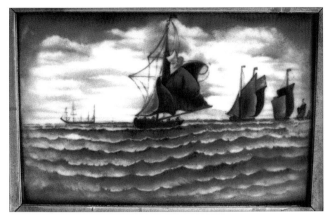

Colour Plate 333. Plaque/tile with blue sea scene of sailing boats. 7⅜ x 4¼in. (18.73 x 10.8cm).

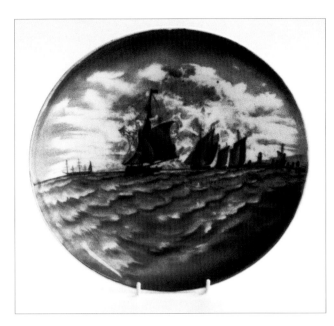

Colour Plate 334. Sailing view plate. 9½in. (24.13cm).

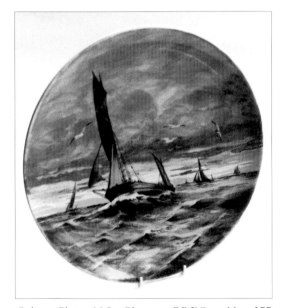

Colour Plate 335. Charger, BR&Co., No. 277 exhibition piece, signed Fred Ridgway. 13in. (33.02cm) diameter.

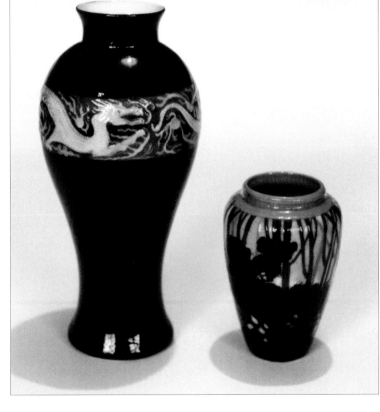

Colour Plate 336. Two lustred vases, raised contours, by Fred Ridgway. BR&Co. Left vase marked FR.7.

Examples of Fred Ridgway's skills

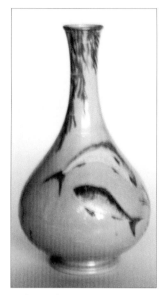

Colour Plate 337. Vase with fish scenes, signed by Fred Ridgway.

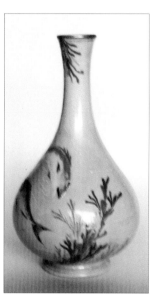

Colour Plate 338. Reverse of the vase in Colour Plate 337.

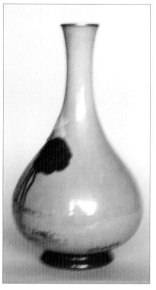

Colour Plate 339. Vase signed by Fred Ridgway.

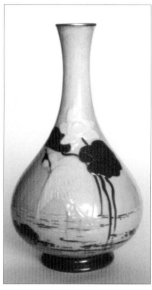

Colour Plate 340. Reverse of the vase in Colour Plate 339.

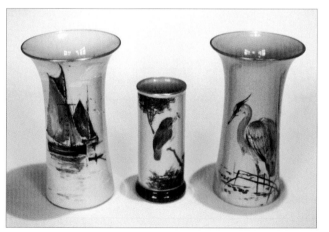

Colour Plate 341. Three Fred Ridgway vases, all signed, Birks Rawlins & Co. 7¾, 5½, 7½in. (19.69, 13.97, 19.05cm).

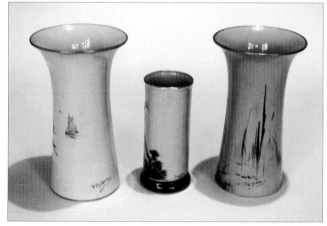

Colour Plate 342. Reverse of the three Fred Ridgway vases in Colour Plate 341.

the third international award in four years – quite astonishing for such a small firm.

Further diversification was illustrated in the selection of wares on show at the National Exhibition at the British Industries Fair in Islington between 10 and 21 May 1915, when wicker baskets were featured in a variety of shapes and sizes. Nursery wares were shown quite extensively, as well as a special range of toy teasets. The factory continued with their lines of useful and ornamental china, including tea, breakfast, coffee, dessert, suite ware and vases.

The Vine Pottery advertised their wares in many instances by virtue of their

appropriate trade mark for the particular piece of ware, for example porcelain, bone china etc.

Porcelain.

However, another ceramic body was produced from time to time, when there was a demand for a particular figure or bust. Parian ware, also known as Carrara or statuary porcelain, is a highly vitrified, often unglazed, fine grained feldspathic porcelain, which was introduced by Copeland & Garrett and by Minton in the mid-1840s. A series of parian busts were modelled with a crested bone china ware base. The artist W.H. Cooper is recorded as signing some of the pieces, whilst no doubt other sculptors or modellers, and maybe Lawrence Birks himself, contributed to the overall output of the factory. Bust models that are known to this date are as follows:

1. Edward VII, as the Prince of Wales with inscription. 5⅜in. (13.5cm) high
2. Albert, King of the Belgians, on a glazed base. 6⅛in. (15.5cm) high
3. Admiral Sir David Beatty K.C.B., with various inscriptions on a glazed base, 6in. (15cm) high
4. David Lloyd George with an inscription on the reverse, 7⅜in. (18.6cm) high
5. Lord Kitchener of Khartoum, Field Marshal K.G.-K.P., two sizes – 42⅛in. (107cm) and 47¼in. (120cm)
6. John Travers Cornwell, age sixteen, hero of the Battle of Jutland. No. 580, 42½in. (108cm) high
7. Robert Burns (1759-1796), Scottish poet, 43¼in. (110cm) high
8. Sir Walter Scott (1771-1832), Scottish novelist and poet, 41⅜in. (105cm) high

It is thought that there is a bust of William Shakespeare and other notable people but they have not yet been discovered. The words W.H. COOPER are impressed on the rear of the busts of King Albert and Admiral Sir David Beatty.

Around 1914, using the Savoy China trade mark, the factory produced the parian bust with various different crested bases of King Albert of Belgium. The plight of Belgium in 1914 mobilised many in Britain to raise funds for the country's aid. King Albert's book published by the *Daily Telegraph* in 1914 in aid of the Daily Telegraph Belgian Fund said: 'No more woeful and terrible spectacle of a country in utter desolation ever came from earthquake, eruption or other convulsion of nature in her wrath, than has been produced by the hand of man. A complete nation is in ruins. A whole country is in ashes. An entire people are destitute, homeless and on the roads. A little kingdom, dedicated to liberty, has "kept the pledge and died for it"'.

The various trade marks illustrated in this chapter will be seen on several of the photographs, but are quite difficult to find.

Cabinet Ware

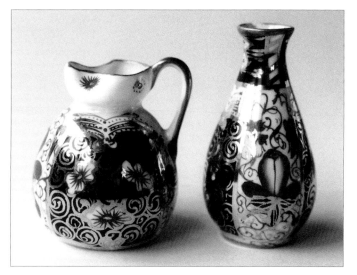

Colour Plate 343. Imari miniatures, Davenport style, BR&Co. Old Crown, AO.11.

Colour Plate 344. Imari miniatures, Davenport style, BR&Co. trade mark, Old Crown, AO.11.

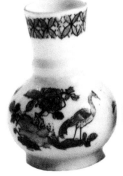

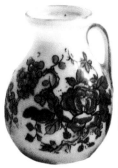

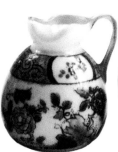

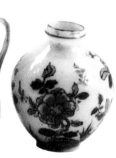

Colour Plate 345. Ginger jar and lid, Roseate porcelain, No. 415. Birks Rawlins & Co.

Colour Plate 346. Four Chinese miniatures, all trade marked BR&Co. 2¼ to 2¾in. (5.72 to 6.99cm).

Colour Plate 347. Two miniatures, Kiang-Si porcelain, BR&Co. 179/2 2½in. (6.35cm) high, 416/2 4½in. (11.43cm).

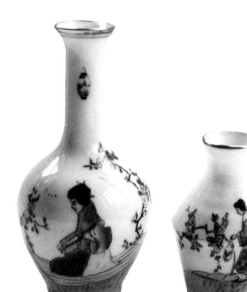

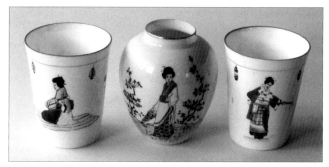

Colour Plate 348. Oriental style, Kiang-Si porcelain trade mark.

Cabinet Ware

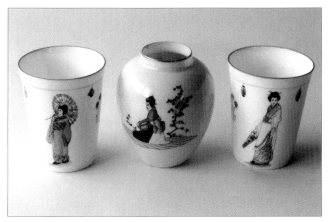

Colour Plate 349. Reverse of the oriental style pieces in Colour Plate 348.

Colour Plate 350. Three miniatures, lustre, Chinese cherry blossom. 3, 2⅜, 3in. (7.62, 6.03, 7.62cm).

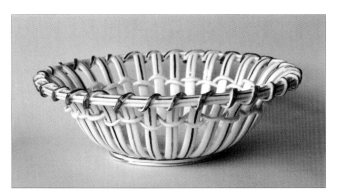

Colour Plates 351 and 352. Wicker basket. 9¾in. (24.77cm) diameter, 3in. (7.62cm) high.

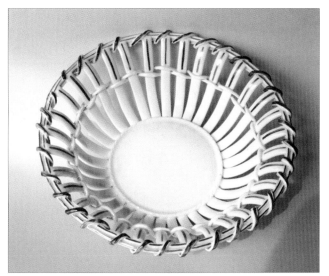

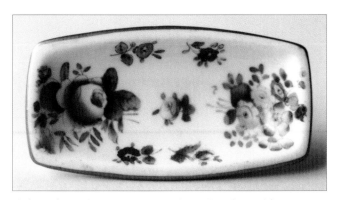

Colour Plate 353. Pintray, No. 42620. 3⅞in. (9.9cm) long.

Colour Plate 354. Minton/Birks trade mark on reverse of pintray in Colour Plate 353.

Chapter 7.

Innovations

1. *Pottery Gazette*, 1 October 1923, p.672.
2. Ibid.

B Y 1914 THE VINE FACTORY HAD BEEN IN EXISTENCE FOR SOME TWENTY years and was becoming quite famous for its new ideas and artistic design, particularly as so many talented artists had been attracted to the firm by Lawrence Birks.

Around this time M.J. Deacon came to work with Lawrence. Deacon was most experienced in the skill of executing the beautiful pierced porcelain which had been so much admired at exhibitions abroad and also by Queen Mary at the annual British Industries Fair.[1] Deacon had commenced work at Grainger's Worcester China Factory at the early age of twelve years and remained there for thirty-two years. He was afterwards with Mr. Locke (the Worcester artist famed for his reticulated and pierced ware) for seventeen years before going to Stoke-on-Trent. He had a long involvement with the industry as he was still at the Vine Pottery when he celebrated his seventieth birthday on 14 September 1923. Although by then he regarded his work as a recreation, he was most productive.[2]

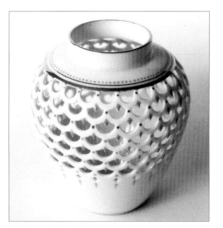

Colour Plate 355. Pierced or reticulated ginger jar by M.J. Deacon, made for the 1915 exhibition, B&R. 4¼in. (10.8cm) diameter, 5½in. (14.1cm) high.

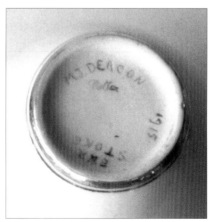

Colour Plate 356. Base of ginger jar impressed 'M.J. Deacon Potter 1915'.

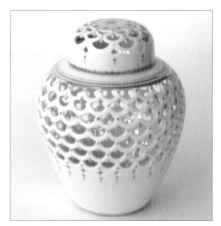

Colour Plate 357. Pierced or reticulated ginger jar by M.J. Deacon, 1915. 4in. (10.16cm), diameter, 5¼in. (13.34cm) high.

Reticulated Ware

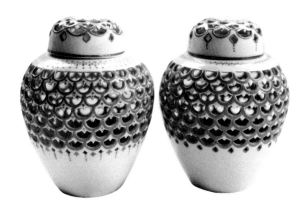

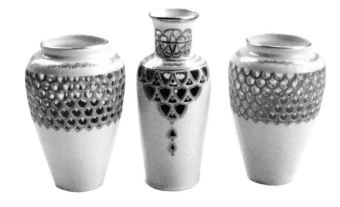

Colour Plate 358. Pierced ginger jars, with and without gold, BR&Co. 4in. (10.16cm) diameter, 5½in. (13.97cm) high.

Colour Plate 359. Pierced ware, BR&Co., Savoy. 4½, 5¼ and 4½in. (11.43, 13.34 and 11.43cm) high.

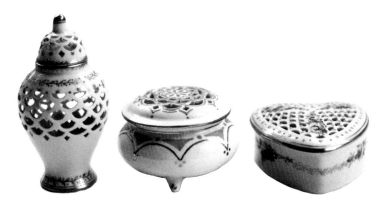

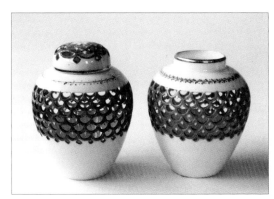

Colour Plate 360. Pierced ware. Left to right: Savoy, 3in. (7.62cm) diameter, 4in. (10.16cm) high; unmarked, 1½in. (3.8cm) high; Savoy, 1¼in. (3.18cm) high.

Colour Plate 361. Two pierced ginger jars. 3¾ and 3½in. (9.53 and 8.89cm) high.

The pierced jar illustrated in Colour Plates 355-357 was specifically made for the 1915 exhibition and one can observe on the base that Deacon had impressed the piece with his name, profession, firm and year. If marked at all, pieces would normally bear factory trade marks underneath. The reticulated or pierced method of decoration, made famous at Worcester, was a very tedious operation, often requiring several months of work on a single piece, during which time the clay had to be kept in a sufficiently moist condition to enable the fine bladed knife to be used without risk to the piece. Many attractive pieces were turned out at the Vine Factory with the B.R. & Co. and Savoy trade mark on their base. Some of these are illustrated.

Reticulated Ware

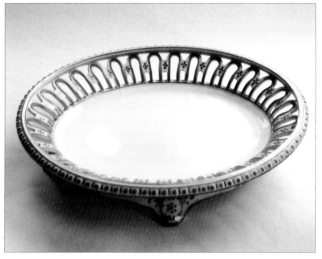

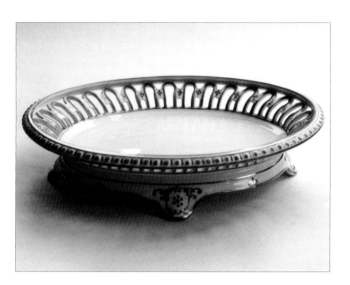

Colour Plates 362 and 363. Two views of a reticulated/pierced fruit bowl or cake dish by M. Deacon, seen in Pottery Gazette in 1902. 10¾ x 8in. (27.31 x 20.32cm) diameter.

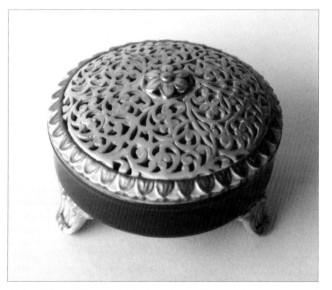

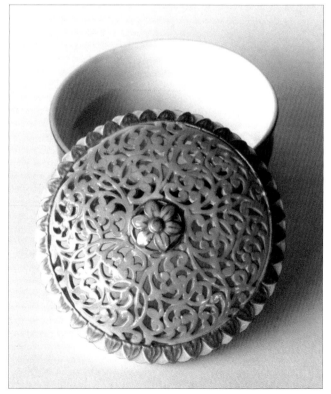

Colour Plates 364 and 365. Two views of a pierced ware pot-pourri by M.J. Deacon. 4¼in. (11cm) diameter, 2¾in. (7cm) high.

Reticulated Ware

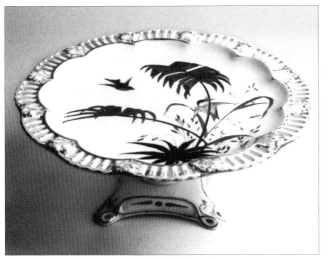

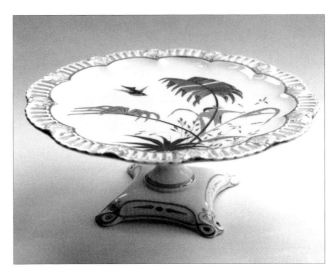

Colour Plates 366-368. Three views of a reticulated cake dish by M.J. Deacon (1915-23). 9¼in. (23.5cm) diameter, 3½in. (8.89cm) high.

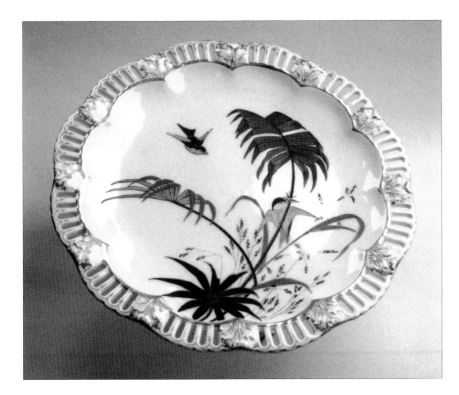

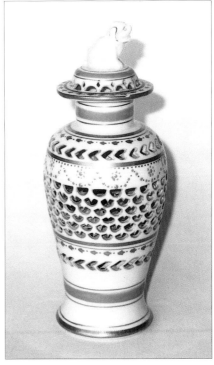

Colour Plate 369. Reticulated ware by M.J. Deacon. 7¼in. (18.42cm) high.

Many new patents were registered and these were mostly recorded by the *Pottery Gazette* after 1915. G.F. Redfern & Co., Chartered patent agents in Finsbury, London, were responsible for recording the new shapes and designs.

Number 651,545	Field Gun by Birks Rawlins & Co.	Sept. 1915
Number 651,546	Submarine E1, crested ware	Sept. 1915[3]
Number 652,617	Battleship, crested ware	Nov. 1916
Number 652,655	Red Cross Van, crested ware	Nov. 1916
Number 652,656	Armoured car, crested ware	Nov. 1916[4]
Number 659,327	Battle/Warship, crested ware	Feb. 1917
Number 659,328	Grotesque young human, sitting and produced in different coloured shirts, nicknamed 'Tweedledee or Tweedledum'. A Birks 'Grotesque'	Feb. 1917
Number 659,483.	Airship, large propeller at rear	Feb. 1917[5]
Number 660,221	Comic youth, standing, bulging eyes, coloured. Another in the Birks 'Grotesque' series.	May 1917
Number 660,222	Girl, head and shoulders, bulging eyes. Coloured Birks 'Grotesque'	May 1917
Number 660,223	Girl, Bulging or 'goo-goo' eyes and round button type mouth, another 'Grotesque'	May 1917
Number 661,446	Machine gun on stand. Crested.	Aug. 1917
Number 661,447	Young boy, standing upright wearing a red hat, blue jacket and green trousers	Aug. 1917
Number 661,740	Howitzer. Crested ware series. Sometimes referred to as a German trench mortar gun	Sept. 1917
Number 661,741	Scottish army bonnet. Crested ware	Sept. 1917[6]
Number 662,551	Fireplace model. Crested ware	Nov. 1917
Number 662,552	Winged bomb. Crested ware	Nov. 1917
Number 662,553	Torpedo Boat. Crested ware	Nov. 1917
Number 662,554	Heavy gun. Crested ware	Nov. 1917
Number 662,779	Dutch boy standing on raised block in clogs. Coloured clothing and hat	Dec. 1917
Number 662,780	Comic youth, 'goo-goo' eyes, labelled as 'Conchy', multicoloured	Dec. 1917
Number 662,781	Young man standing on crutches in hospital uniform. Coloured clothing. On rectangular block	Dec. 1917
Number 662,782	First World War Bi-plane. Crested ware	Dec. 1917[7]
Number 738,138	Savoy china table-ware pattern and shape	
Number 738,139	Savoy china table-ware pattern and shape	June 1928

3. Ibid., 1 August 1915, p.1362.
4. Ibid., 1 January 1916, pp.86 and 196.
5. Ibid., 1 May 1917, p.514.
6. Ibid., 1 June 1917, p. 706 and 1 October 1917, pp.1002, 1100 and 1196.
7. Ibid., 1 January 1918, p.158 and 1 March 1918, p.410.
8. I am most grateful to Mr. Len H. Harris for his research at the Public Record Office.

This surge of registering new patents in the war years resulted in twenty-four innovatory ideas coming out of the Vine Factory from 1915 to 1918. The evidence produced from research at the Public Record Office[8] in London has been invaluable and has confirmed various beliefs held by certain dealers and collectors, that a variety of the figures, namely

the amusing small ones, originated from the Vine Pottery. Previously people used their own observation to identify certain products and the Birks 'grotesques' proved quite a problem. If pieces of ware are not backstamped or trademarked there is much doubt and conjecture. The subject of these special little figures is dealt with separately in Chapter 8.

During the Great War period further tenders were placed for the firm's china tableware.[9] Two Government contracts for the War Office were achieved in December 1916 and June 1917.[10]

These events, coupled with the mounting of displays for the annual British Industries Fair,[11] led to immense activity within the factory. The 1917 fair, the third event of its kind under this title, was held in the Victoria and Albert Museum and the Imperial Institute from 20 February to 9 March. Despite the restrictions imposed by the Great War, it was much larger than previous fairs, both from the point of view of the number of exhibitions and the floor area covered. The Birks Rawlins & Co. ware appeared in the Art Pottery section and doubled up with a display in the Chinaware section.[12]

The factory's exhibits were visited by the Royal Family and the firm was honoured by Queen Mary selecting a choice little Chinese jar,[13] a perforated/pierced vase decorated in blue, white and gold, and a third piece of ware in the form of a winsome little maiden with a blue hood and white apron. Generally the Vine Pottery exhibited its popular lines, including the brightly coloured 'Persindo' ware, and a number of figures and statuettes which were calculated to appeal strongly to the large purchasing classes of the general public. There were shelves full of vases in the old 'Chelsea' style and a very popular adaptation of the 'Japanese' stork design. The 'Imari' pattern on the teaware omitted the black element and several 'old Bristol' style decorations were produced at the factory, including a fine tea service copied from a dish within the Trapnell Collection.

The total number of exhibitors at this particular fair increased from 350 to 440 on the previous year and they appeared well satisfied with the results achieved. Plenty of orders were placed, far more in fact in some cases than could possibly be delivered with any degree of promptitude. This was also questionable when one considers that the Great War was still raging and much of the original manpower had left for the front.

A year later it was reported that some of the pierced ware[14] was delicately coloured in turquoise, cream and gold; this was described as a 'quite recherché line'. Some 'exquisite' lustre vases appeared, yellow, green and mottled. Statuettes were being produced in pleasing Dutch and early Victorian costumes, as were silver lustre figures of soldiers, animals, bombs, battleships and children.

The factory was successful in securing the custom of the Queen Mother, Queen Alexandra, who purchased objects from the large floating flower bowl display, including the very popular butterflies, insects and swimming birds in their natural colours (see Chapter 8 on novelty wares).

Some pretty teaware with a red cherry-blossom decoration and a collection of blue and white Dutch style vases also appeared on the shelves at the 1918 British Industries Fair, which had moved to a converted dock building, presumably to gain more space than hitherto.

9. *Pottery Gazette*, 1 February 1917, p.166.
10. Ibid., 1 June 1917, p.788.
11. Ibid., 1 March 1917, p.262.
12. Ibid., 2 April 1917, p.359.
13. Ibid., 2 April 1917, p.371.
14. Ibid., 1 April 1918, p.310.

Figures

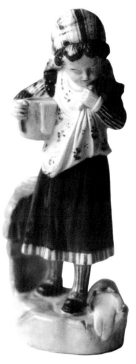

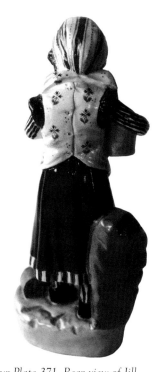

Colour Plate 370. Jill, milkmaid, Dutch. 9¼in. (23.5cm) high.

Colour Plate 371. Rear view of Jill.

Colour Plate 372. Masculine figure, BR&Co., No. 227. 6¾in. (17.15cm) high.

Colour Plate 373. Jack, young boy, Dutch. 9¼in. (23.5cm) high.

Colour Plate 374. Rear view of Jack.

Colour Plate 375. Figure, 8½in. (21.59cm) high.

Figures

Colour Plate 376. Dutch figures. Girl 7½in. (19.05cm) high., boy 7in. (17.78cm) high (cane at rear).

Colour Plate 377. Dutch boy with cane, 7in. (17.78cm) high.

Colour Plate 378. Dutch boy, BR&Co. (Savoy). 4⅛in. (10.5cm) high.

Colour Plate 379. Two Dutch girls, sitting, hands on knees, BR&Co. (Savoy). 3⅜in. (8.5cm) high.

Figures

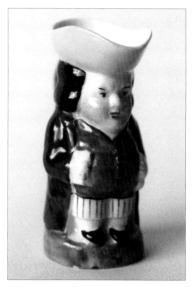

Colour Plate 380. Miniature Tobies, peppers and salt. 2⅞, 2⅗, 2½ and 2⅜in. (7.3, 6.67, 6.35 and 6.67cm) high.

Colour Plate 381. Toby jug miniature, 3in. (7.5cm) high.

Colour Plate 382. Green frog on rock. 3in. high (7.62cm), base 3½in. (8.89cm).

Colour Plate 383. Hare, green/khaki. 3in. (7.5cm) long.

Colour Plate 384. Frog, 2¾in. (7cm) high.

Edmond Reuter had died in 1917 and that must have been a blow to the company. Nevertheless, a new colouring, known as Rhodian blue, was introduced to the well-known 'Persindo porcelain' ware. This blue replaced the red in the ever popular and distinctive carnation.

The factory appeared to spend an increasing amount of its time in the production of china miniatures, artistic novelties and crested/heraldic or badge ware (see Chapter 9).[15] These fancy goods using the Savoy China ware trademark became extremely popular in the United States. Much attention was paid to these wares for nine to ten years, whilst the bread and butter tableware was relatively ignored by the writers of the day.

The latest innovation coming out of the Vine Factory was another new range of

15. Ibid., 2 June 1919, pp.580 and 581.

Figures

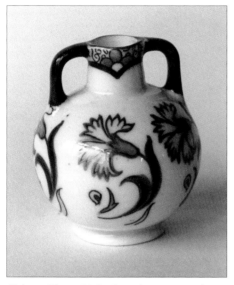

Colour Plate 385. Persindo pattern, lustre finish, Rhodian blue. No. 364. 6.2cm high.

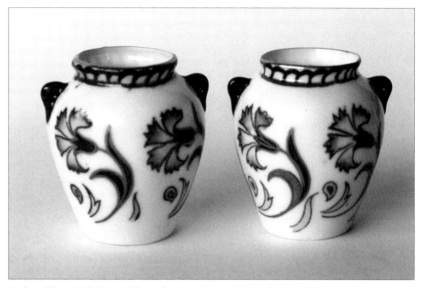

Colour Plate 386. Pair of Persindo vases, lustre finish, Rhodian blue. 2¼in. (5.72cm).

tobacco jars,[16] some round, some hexagonal, that had been recently modelled and possibly patented. Many of the models were splendidly decorated, for example, 'the pipe of peace 1920'. One of the decorations on the hexagonal tobacco jar embodied a neat yellow and turquoise border reminiscent of an inlaid pattern, which it was thought would be an extremely good seller on the market. Unfortunately the author has not seen this model and consequently it cannot be illustrated.

16. Ibid., 2 February 1920, p.183.

Colour Plate 387. Englishman, 5⁵⁄₁₆in. (13.49cm) high. Irishman, 4¾in. (12.07cm) high.

Colour Plate 388. Scotsman. 5in. (12.7cm) high.

Chapter 8.

Novelty Wares

LAWRENCE BIRKS HAD AN INTERESTING COLLECTION OF ARTISTS around at the Vine Factory in Stoke upon Trent and as early as 1910 there was a hint that the manufactory was in the business of producing novelty bone china without there being a description of a particular piece by the *Pottery Gazette* reporter.[1]

The decoration of these wares, mainly overglaze enamels, was a mixture of fat oil, turpentine and pigments. The fat oil was made using pure turpentine. Each painter had a fountain filled with turpentine and, as the turpentine evaporated,[2] the fat oil residue was left behind. The main problem for the painters was to keep the colour 'open', wet enough to manipulate. This was achieved by the addition of aniseed oil, which could be oil of fennel or lavender, to the coloured oxides. When one visited a painting studio sometimes the perfume of liquorice could be smelt. The different colours needed to be fired at different temperatures. Colours needing the highest temperatures were fired first, followed by those requiring progressively lower temperatures. Very elaborate paintings have been known to require as many as twelve firings. There was also a risk of kiln damage with each firing and consequently the cost of manufacture was quite high using this process.

The muffle kiln[3] used to fire these decorative polychrome enamels was much smaller than the other types of kiln. It was similar in construction, but the flames were led around the muffle chamber by a series of flues and did not actually enter it, thereby protecting the delicate colours. The temperature required was lower than for biscuit firing, around 750-800°C. No saggers were necessary and nor was a hovel. The lining to the muffle kiln was designed to protect the ware from the direct effect of flames. The development of the use of upper chambers to the ordinary bottle ovens led to multi-chambered ovens coming into use with the muffle kiln.

The wares were briefly described as 'fancies' in June 1915 by the *Pottery Gazette,* but one must appreciate that the Great War raging in France and Belgium was having serious consequences on manpower which was being lost in the pottery industry in general, so it was difficult to keep certain lines in production.

Towards the end of the Great War in 1918 it was recorded at the fourth British Industries Fair in the Victoria and Albert Museum and the Imperial Institute that there

1. *Pottery Gazette,* 1 November 1910, p.1247.
2. *British Ceramics Price Guide* by Victoria Bergeson.
3. *Potworks. The industrial architecture of the Staffordshire Potteries* by Diane Baker, 1991, pp.112/114.

Colour Plate 389. Floating swans, BR&Co., Savoy.

were a number of interesting figures. Among these figures[4] were a comic policeman and footballer, a 'Weary Willie' and 'Sunny Jim' with charming statuettes of girls with broken pitchers, as well as some naturally modelled animals.

Statuettes in Dutch and early Victorian costumes, and many silver lustre figures of soldiers,[5] bombs, battleships, children etc., were exhibited a year later, again at the Pottery and Glass British Industries Fair held in a converted dock building in London. The Birks Rawlins Pottery had an open stand, at the front of which was a counter upon which stood large floating bowls with perching butterflies in natural colours and swimming birds, the latter proving very successful in securing the custom of Queen Alexandra.

A year later it was documented after another exhibition[6] that the Vine Pottery launched a series of floating birds, specially made for the floating bowls, which apparently were very much in vogue in 1919. Birks Rawlins had to take out a provisional patent in order to protect the production of these charming little articles that

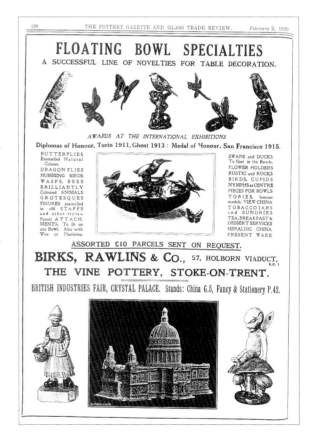

Plate 40. Floating Bowl Specialties, from The Pottery Gazette, *2 February 1920.*

4. *Pottery Gazette,* 1 April 1917, p.371.
5. Ibid., 1 April 1918, p.310.
6. Ibid., 1 June 1919, p.580

were made to swim in and out amongst the flowers in the bowls. There were ducks in a variety of colourings, based upon the natural, and a series of swans made in four sizes, which were produced in black, as well as gay and more sober colourings, all of which were extremely pleasing and really appealed to the seeker of novelties. There were also birds of

Colour Plate 390. Floating ducks, Savoy china? BR&Co.

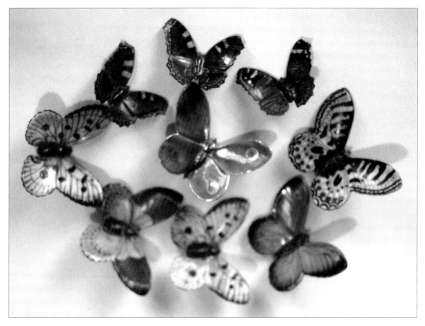

Colour Plate 391. Nine butterflies to be clipped on floating bowl, BR&Co.

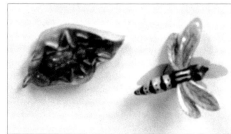

Colour Plate 392. Beetle and hornet, BR&Co.

Colour Plate 393. Black floating bowl with ducks and swans, BR&Co.

Colour Plate 394. Floating white swan, BR&Co.

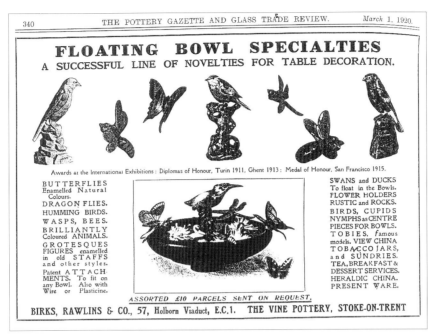

Plate 41. Floating Bowl Specialties, from The Pottery Gazette, *1 March 1920.*

different kinds on tree stumps for placing in the centre of the bowls, notably a brilliantly coloured kingfisher with outstretched wings. Another model of the same bird was made with its wings closed. Probably the brightest of our English birds, the kingfisher is always a great favourite with the collector. A pretty bird in the series was a tomtit, which was modelled with equal care; the same could be said about the robin.

The factory realised that there were probably some people who would prefer a simple flower holder as the floating bowl centre and so holes were formed in the tree trunks or branches in order to allow an arrangement of flowers to be added. This line of charming flower holders proved most successful.

A new range of Tobies and Puck on a mushroom coloured à la nature proved quite popular. Birks Rawlins & Co. even conceived a series of gaily decorated porcelain butterflies which were applied to the rim of the floating bowl by means of a little plasticine or a wire attachment. These latest developments in floating bowl accessories were aptly termed 'nature butterflies', for in their production nature had been closely followed. Some of the butterflies[7] were quite conventional in their treatment and it was the opinion that the models of the well-known peacock, red admiral, tortoiseshell, adonis and apollo could not be bettered elsewhere in the industry. The swallowtail was extremely popular and difficult to fabricate. Another quite remarkable novelty was the dragonfly, produced in such a way that the insect actually appeared to fly, and whose wings shone with a wonderful lustre. Bees, wasps, beetles etc. were likewise supplied for a similar purpose.

A floating bowl[8] decorated with any of these permutations would have had a unique effect on the centre of the dining table and was a tremendous credit to the porcelain

7. See advertisements from *Pottery Gazette*, 1 January 1920. p.54; 1 February 1920, p.188; 1 August 1920, p.1046.
8. *Pottery Gazette*, 1 February 1920, p.54 and 1 August 1920, p.1046.

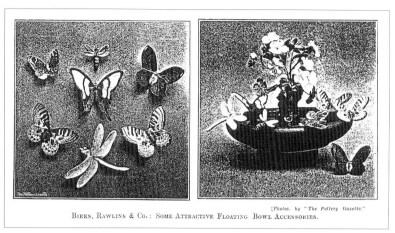

[Photos. by "The Pottery Gazette."

BIRKS, RAWLINS & CO.: SOME ATTRACTIVE FLOATING BOWL ACCESSORIES.

Plate 42. Birks, Rawlins & Co.: Some attractive floating bowl accessories. Photographs by The Pottery Gazette.

novelty trade. At this time, just after the Great War, this Stoke upon Trent factory was congratulated on its achievement by the principal connoisseurs in the trade. Glowing reports and tributes were accorded to the display at the 1920 British Exhibition, where the correspondent for the *Pottery Gazette* thought that the insects, particularly the butterflies and dragonflies, were more delicate than the previous year, An enormous demand for these novelties had developed, along with the decorated birds[9] perched on lumps of rockery. They were sold freely on all markets and Her Majesty, Queen Mary, a frequent visitor to the Birks Rawlins stand at these annual exhibitions, purchased a number of these meritorious small wares.

A new model in its preliminary stages, which was considered to be extremely good, was that of a boy carrying a pail upon his shoulder. It was a rather small model, but full of character and most attractive. There was also a new figure of a footballer, engaged in the act of throwing in the ball, wearing the club colours of town/city football team, so as to create a special interest in the game in each of the individual towns where the sport could be encouraged.

Under the general heading of 'Birks' Grotesques' was the representation of Bruce Bairnsfather's immortal 'Ole Bill', arrayed en camouflage or, if preferred, in khaki. On similar lines one could become the owner of 'Sunny Jim', 'Weary Willy', 'Artful Eliza', 'Saucy Sue', 'Peter Pan', 'Conchy', 'Blighty' and 'C 3'. All these figures were most humorous, depicting the true comic element from well-known cartoon and comic strip characters of the time.[10] The 'goo-goo' eyed models were created from the illustrations that were so popular after the cartoonist Chloe Preston had brought them to the attention of the general public during and after the period of the First World War. Patent research in the Public Record Office has confirmed the pottery origin. The 'grotesque' characters were supplied with tasteful showcards available to prospective purchasers through the dealers. The cards drew attention to the fact that all models

9. Ibid., 1 February 1920. p.183.
10. *Chloe Preston and the Peek-a-Boos* by Mary Hillier. Patent research by Len H. Harris; Mabel Lucie Attwell Collectors' Club – Rita Smith at Abbey Antiques.

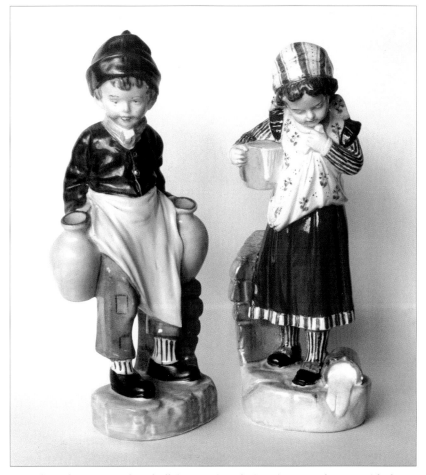

Colour Plate 395. Jack and Jill figures. 9¾ and 9½in. (24.77 and 24.13cm) high.

were something different from art or nature. Leading novelties still popular from the previous year were 'Puck on a mushroom'[11] and plump pixies sitting on toadstools.

One of the newest models, and perhaps one of the most realistic, was a frog in yellow green colouring perched on a brownish, earthy looking piece of rockery. Other models were porcelain figures, painted in polychrome enamels and gilded, of a milkmaid[12] and a young boy, each carrying pails of water, nicknamed Jack and Jill (Colour Plate 395). *The Pottery Gazette* could not give enough praise to the many and varied styles of novelties which were being produced by the Vine Pottery. A feature of the stand at this exhibition was that everyone could walk through and round the exhibits and consequently everything was open to an unhindered viewing.

The trademark or backstamp was the usual circular enclosure of vine leaves and grapes with a crown on top and B.R. & Co. in the centre. Sometimes wares had 'Savoy China, Stoke-on-Trent, England' incorporated under the mark (see above right).

11. *Pottery Gazette*, 1 February 1920, p.83.
12. *Crested China – The History of Heraldic Souvenir Ware* by Sandy Andrews.

The 'Saucy Sue' and 'Artful Eliza' figures, a little similar to miniature busts, measured an approximate 4in. (10cm) in height. One Toby jug figure of a bagpiper[13] – again painted in polychrome enamels – measured 5in. (12.5cm) in height.

Products of Lawrence Birks' factory had been in the hands of the agent J.W. Walton[14] at Holborn Viaduct in London for some fourteen years by 1920, but it was announced later that year that the agent for the firm was no longer J. Sayers.[15] It is rather difficult to assess what was happening at this time, but Mr. J.W. Walton[16] was advertising again from Bath House, 57 Holborn Viaduct, London EC6 in June 1922, offering an excellent range of wax floating flowers, suitable for use with floating flower bowls. The flowers were remarkably realistic, comprising roses, carnations, poppies, anemones and water lilies in various shapes and sizes.

A slight decline in orders was noted after the 1920 fair, but it would be unfair to blame the Board of Trade, who organised the fair in 1921.[17] The bulk of the trade in the pottery and glass industry came from the home market and order books were generally seen to be down. The Vine Pottery made a strong and decidedly varied display of their 'à la Nature' specialities, as also of useful table articles. The reporter stated that 'the range of this house is probably second to none from the aspect of novelty, and one that the average dealer can put to a variety of uses'.

So much has been said about many miscellaneous assortments of novelty, miniatures, animals, birds and an incredible amount of small crested items that you could almost forget that this factory produced tableware. Pattern books reveal a very great number of patterns over a period of almost forty years[18] and perhaps they appeared less exciting to the writers of the day. However, The *Pottery Gazette* does in 1923 wonder how the firm managed to house all the numerous moulds that must have been required in the production of such a prolific variety of models. Tea, breakfast and dessert services, as usual, were on show, accompanied by useful miscellaneous table items and fancies galore. Lawrence Birks and one of his sons were on hand at the ninth annual fair in 1923. A massive variety of wares illustrated many varied treatments of Oriental inspiration,[19] involving dainty and delightful colourings in raised enamels for both the teasets and fancies. Understandably, much was made of the ornamental lines on exhibit, such as the floating bowls with accessories, birds, butterflies, tobacco jars, ginger jars, pot-pourri jars, decorative bric-à-brac, along with the heraldic and souvenir china.

The factory had for some time now appeared to be in a roller-coaster situation of producing far too many lines for a fairly small business. There seemed to be a reluctance to drop some existing lines as new ones were introduced and it was beginning to emerge that this over-diversification would lead to a decline in interest in their wares. The *Pottery Gazette* commented rather tartly the following year that the utilitarian production of the firm was being deluged by bric-à-brac when it reported that the Birks Rawlins stand contained over two thousand different products on display at the tenth British Industries Fair.

Strangely this massive show of wares was given a whole page[20] of publicity in the

13. *British Ceramics Price Guide* by Victoria Bergeson.
14. *Pottery Gazette*, 1 February 1920, p.296.
15. Ibid., 1 November 1920, p.1568.
16. Ibid., 1 June 1922, p.871.
17. Ibid., 1 April 1921, p.588.
18. Ibid., 2 April 1923, p.645.
19. Ibid. Copy of picture in black and white.

Pottery Gazette, referring to the considerable variety of production of what was now well known under the name of 'Savoy China'. It was quite categorically stated that it would be extremely difficult to find a manufacturing house in the Potteries that produced a bigger range of articles, shapes and patterns. As the firm had made a serious effort at the novelty trade, in both China and Parian ware, and they had become so well known for the production of 'fancies', it seems feasible that many of the china dealers of that time were under the impression, quite wrongly, that Birks Rawlins & Co. were merely producers of novelties.

The warehouses at the Vine Factory in Summer Street, Stoke upon Trent revealed a completely different story for the *Pottery Gazette* reporter in 1924. The potting shops and painting rooms gave another insight into the real production of this factory.

The Vine Factory produced everything that was useful in china, such as tea and breakfast wares from ordinary stock lines upwards. Splendid china tea and breakfast patterns with cobalt blue prints were to be seen. There were many smart decorations of hand painted borders, such as a simple wreath of 'Swansea' roses with naturally coloured leafage. Scores of dainty decorations in 'Chinese' style, executed in beautiful enamel colours, very often of the raised variety, were being produced. Some patterns were reminiscent of 'Copenhagen', 'Delft', 'Old Chelsea' and other similar historic styles of sentimental interest.

There appeared to be a surprise in one of the warehouses when specimens of hand perforated porcelain china vases were discovered, no doubt the work of M.J. Deacon (see Chapter 7). These wonderfully delicate creations were featured in a photograph[21]

20. Ibid., 1 March 1924, p.441.
21. Ibid. Copy of picture in black and white.

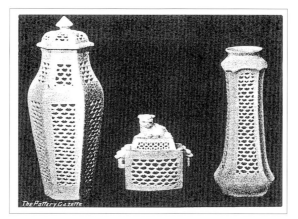

Plate 43.
Perforated porcelain photographed by West End Studios, Stoke-on-Trent, and published in Pottery Gazette, *1 March 1924.*

taken by the West End Studios of Stoke-on-Trent (Plate 43). The intrinsic work entailed in piercing these wares, coupled with the risk that was involved in the making and firing, was an obvious choice for cabinet ware.

The novelty department of the Vine Pottery was probably at its height in producing some wonderfully smart jam jars, marmalade jars and similar articles in dainty styles of modelling and painting. For example, there was an orange marmalade jar on a fixed

stand, modelled and decorated to represent the fruit itself. Also being produced were jam dishes, both tall and low, with an applied ornament in the form of a modelled and painted spray of fruit. Another piece depicted a bunch of grapes and another a spray of cherries. An apple shaped preserve pot was executed in a style true to nature. These conceptions were so remarkably realistic that they were a tremendous tribute to the skills of Lawrence Birks, who was entering his fifty-second year as a master potter.

Grotesque products are dealt with below, but at this phase in the development of the factory most of the wide variety of articles being made were useful, as well as amusing. For instance, a salt and pepper shaker and an oil and a vinegar container were executed in the form of a gaily coloured duck known as 'Winkie the glad eyed bird'. These were humorous conceptions, without a doubt, and apparently sold vigorously in the United States.

Tableware in the form of a four cup after dinner coffee set, groundlaid in a variety of pleasing tints and delicately lustred, offered as a whole set complete on an attractive wicker tray would appear to have been an appealing gift, particularly as a wedding present.

Perhaps because of the versatility of the Vine Factory's products, there was now a change of agent. The London representative was Mr. O. Davison at 254 Bank Buildings, High Holborn, London E.C. The firm were represented in Australia by F. R. Barlow & Son (Pty.) Ltd., 328 Flinders Street, Melbourne, and in New Zealand by Rawlinson & Ifwerson, Merchants and Importers, Auckland. Two travellers were looking after the provinces, Messrs. H.W. Tyler and A.C. Lewis, their task being to engage more agents to distribute the Vine Factory's wares.

Birks Rawlins exhibited over two thousand different products at the British Industries Fair at White City, London in April and May 1924.[22] (The novelty and crested range was often marked 'Savoy China'.) Many could say that this diversification would backfire in

22. *Pottery Gazette*, 1 June 1924, p.1008.*h.*

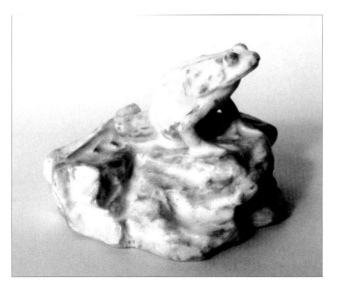

Colour Plate 396. Frog, Parian. Good condition, but discoloured by someone's attempt to paint on the body.

time, particularly at the expense of the utilitarian productions of tableware. King George V and Queen Mary again purchased several small pieces including a typical nature model of the firm, a frog on a rock (Colour Plate 396).

Whilst the majority of the novelty wares were for amusement and/or collectors, certain grotesque productions could be put to use, for example the salt and pepper shaker and oil and vinegar executed in the form of a gaily coloured duck, 'Winkie the glad eyed bird' (Colour Plates 398, 400 and 404).

A peak in production may have been reached in 1925 with a very large and varied selection of wares from the Vine

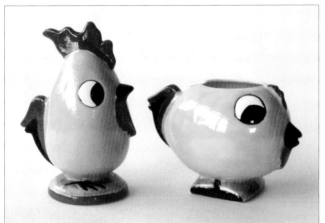

Colour Plate 397. Salt and mustard, chick and puffer fish.

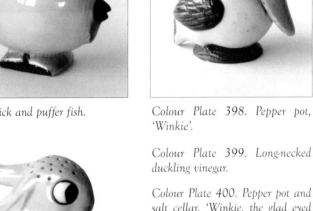

Colour Plate 398. Pepper pot, 'Winkie'.

Colour Plate 399. Long-necked duckling vinegar.

Colour Plate 400. Pepper pot and salt cellar, 'Winkie, the glad eyed bird'.

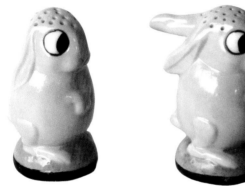

Colour Plate 401. Rabbit pepper pot.

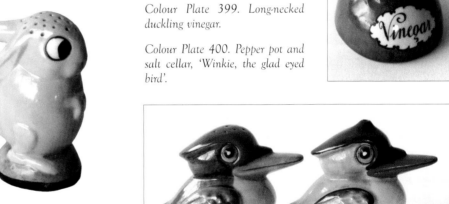

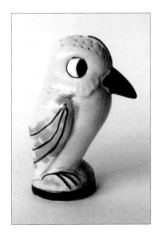

Colour Plate 402. Woodpecker pepper pot, 3⅜in. (8.57cm) hig

Colour Plate 403. Happy duckling mustard and pepper.

Colour Plate 404. Pepper pots, 'Winkie, the glad eyed bird'.

Colour Plate 405. Kingfisher, Savoy. 10in. (25.4cm) high.

Colour Plate 406. Toucan, BR&Co. 8¼in. (21cm) high.

Colour Plate 407. Budgerigar. 7¾in. (19.5cm) high.

Colour Plate 408. Kingfishers, Savoy. 6 and 4¼in. (15.24 and 10.8cm) high.

Colour Plate 409. Kingfisher, parrot and bullfinch, produced as BR&Co. 1911-21. 5½, 4¾ and 5¼in. (13.97, 12.07 and 13.34cm) high.

Colour Plate 410. Swallow, black on white. 4½in. (11.43cm) long, 4in. (10.16cm) wing span.

Colour Plate 411. Green parakeet, crested ware.

Colour Plate 412. Two red parakeets, BR&Co.

Colour Plate 413. Budgerigar, BR&Co. 7½in. (19.05cm) high.

Colour Plate 414. Two yellow canaries, Savoy China. 6⅛in. (15.5cm) high.

Colour Plate 415. Finch, BR&Co.

Colour Plate 416. Green and red budgerigars. BR&Co.

Colour Plate 417. Hornbill, Savoy China. 5in. (12.7cm) high.

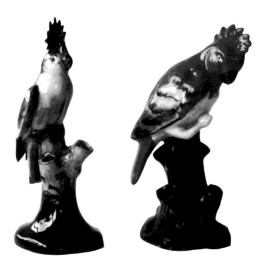

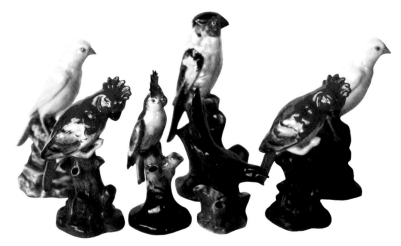

Colour Plate 418. Parakeets, BR&Co./Savoy China. 5½in.(14cm) high.

Colour Plate 419. Bird group.

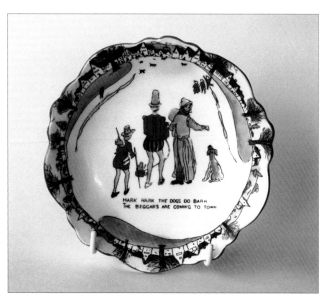

Colour Plate 420. Nursery ware saucer, 'Hark, Hark, the dogs do bark'. 4¾in. (14.61cm) diameter.

Colour Plate 421. Trade mark on nursery ware saucer.

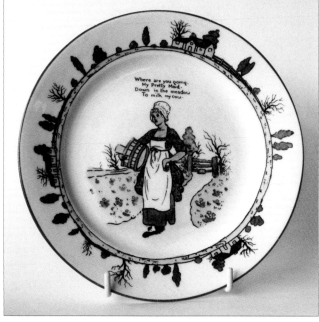

Colour Plate 422. Nursery ware plate, 'Where are you going to my pretty maid'. 7in. (17.78cm) diameter.

Colour Plate 423. Cameo with foot. 3⅜in. (8.58cm) high.

Colour Plate 424. Cameo, BR bone china. 3⅜in. (8.58cm) high.

Colour Plate 425. Cameo, BR bone china. 3⅜in. (8.58cm) high.

Colour Plate 426. Reverse view. Trademark BR Bone china.

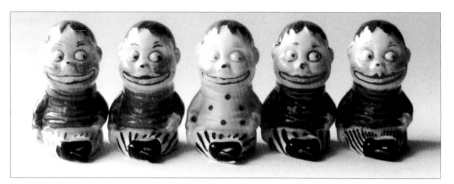

Colour Plate 427. *Cartoon character, 'Sunny Jim'.*

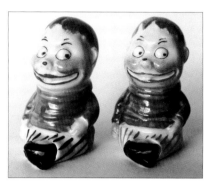

Colour Plate 428. *Grotesques. Two 'Sunny Jims'. 3in. (7.62cm) high.*

Colour Plate 429. *Pepper pot, old Dutch lady, small, Rd. No. 69445. Martha Gunn? 2½in. (6.35cm) high.*

Colour Plate 430. *Dutch boy. 3¾in. (9.53cm) high.*

Colour Plate 431. *Grotesque, 'Weary Willie'. 3¾in. (9.53cm) high.*

Colour Plate 432. *Grotesque, 'Artful Eliza'. 3¾in. (9.53cm) high.*

Colour Plate 433. *Grotesque, 'Saucy Sue'. 3⅝in. (9.21cm) high.*

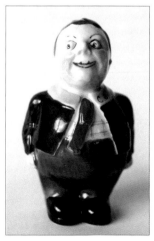

Colour Plate 434. *Grotesque, 'C 3'. 4¾in. (12.07cm) high.*

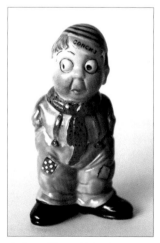

Colour Plate 435. *Grotesque, 'Conchy'. 4¾in. (12.07cm) high.*

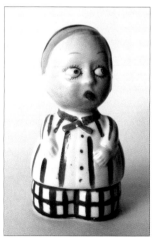

Colour Plate 436. *Grotesque, 'Blighty'.*

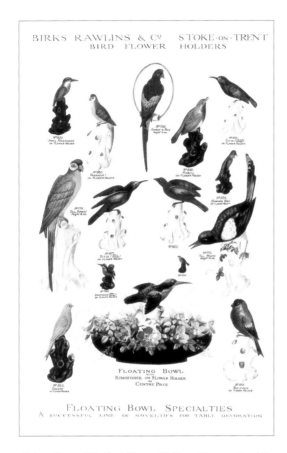

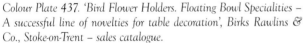

Colour Plate 437. 'Bird Flower Holders. Floating Bowl Specialities – A successful line of novelties for table decoration', Birks Rawlins & Co., Stoke-on-Trent – sales catalogue.

Colour Plate 438. 'Floating Bowl Specialities', Birks Rawlins & Co., Stoke-on-Trent – sales catalogue.

Colour Plate 439. 'Nursery Rhyme China and Dessert Ware – Finest Series in the Trade', Birks Rawlins & Co., The Vine Pottery, Stoke-on-Trent – sales catalogue.

Pottery at the British Empire Exhibition. Presumably the return of the cheaper Continental souvenirs had an impact on sales and a year later the wares seemed to have suffered from the national depression caused by the strike in 1926, which certainly caused a lack of coal and an inferior supply of clay. These occurrences contributed to subsequent erratic firing, although the merger with Wiltshaw & Robinson, the makers of Carlton Ware, offered a lifeline in 1928.

Helped to a certain degree by the merged Carlton Ware expertise, novelties continued to be made and exhibited until 1932.

Chapter 9.

Crested China

THE VINE FACTORY, AFTER SOME SIXTEEN YEARS OF PRODUCING various tablewares and other decorative ornaments, began to develop the production of china miniatures for the seasonal souvenir trade around 1910, using the newly registered trade name of Savoy China incorporating the BR & Co. inside the circle with the crown on top.

Collecting crested china or heraldic ware became a craze in Victorian and Edwardian times, when a demand for the inexpensive souvenirs developed. Holiday resorts were blossoming rapidly across the country and also abroad in more than forty countries.

The demand for a range of small white porcelain models of historic shapes decorated with coats of arms was so great that it is estimated that some ninety per cent of homes in Edwardian times contained some form of crested china. 1910 to the beginning of the Great War probably saw the craze reach its peak, but there was a surge around 1919, after the war, when the import of Continental ware was non-existent and there was a demand for souvenirs from the 1914-1919 period. Three to four years later, however, there was a sharp decline.

There was a strong demand from British troops in the Great War, billeted in France and Belgium, to provide decorative heraldic wares with the coats of arms of the various places where they were stationed. Consequently the arms of the towns in Belgium and France and possibly even Germany would relate the story of the progress of the war as the third battle of the Somme was fought in July 1916.

The Vine Factory channelled much energy into the designs of figures of soldiers, tanks, guns, grenades, ships, shells, tents and helmets, also a wealth of ammunition and buildings for their crested ware. This was sometimes referred to as 'badge ware'. In many cases the firm obtained the details from the men who were at war and in a position individually to photograph what was required. Lawrence Birks' nephew, Captain Stuart

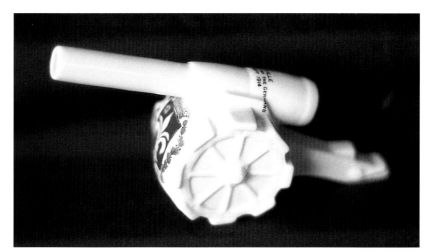

Colour Plate 440. Howitzer
field gun, No. 518, Lille. 17.
6¼in. (15cm) long.

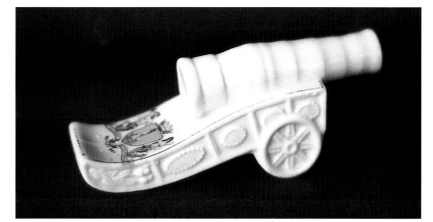

Colour Plate 441. Field gun,
No. 564, Whitley Bay. 5½in.
(13.97cm) long.

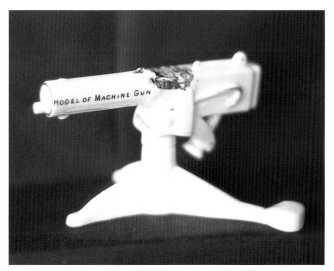

Colour Plate 442. British machine gun, No. 603, Leeds. 5⅝in.
(14.29cm) long.

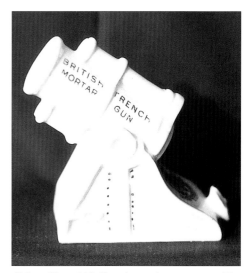

Colour Plate 443. British trench mortar gun, No.
613/10, Sunderland. 3⅞in. (9.84cm) long.

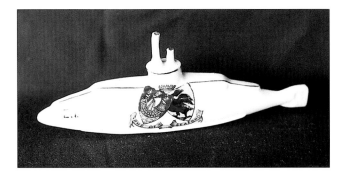

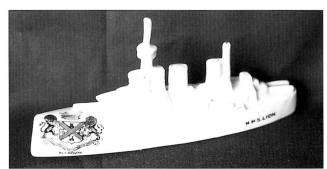

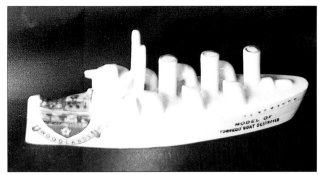

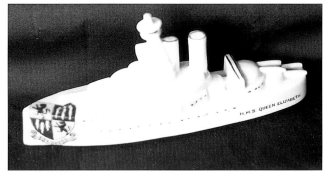

Colour Plate 444. Torpedo boat destroyer, No. 615. 5½in. (13.97cm) long. Submarine E1, No. 525, Rd.No. 651545. 6in. (15.24cm) long.

Colour Plate 445. Battleships. H.M.S. Lion, No. 624, Rd.No. 651545. H.M.S. Queen Elizabeth, No. 524, Rd.No. 652656. Both 6½in. (16.51cm) long.

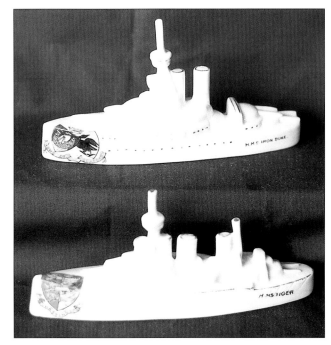

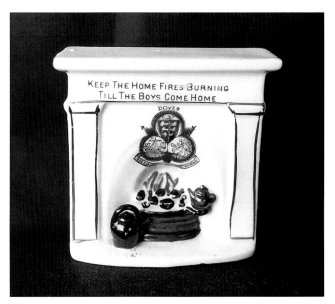

Colour Plate 446. Battleships. H.M.S. Iron Duke, No. 524, Rd.No. 652617. 6½in. (16.51cm) long. H.M.S. Tiger, No. 529. 6⅝in. (16.83cm) long.

Colour Plate 447. Fireplace inscribed 'Keep the home fires burning' etc., No. 629. 3¾in. (9.53cm) long.

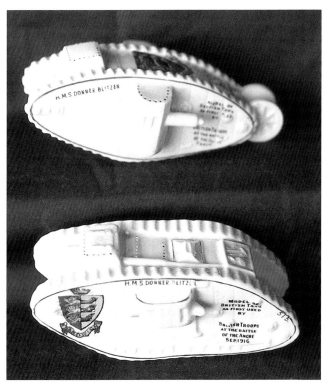

Colour Plate 448. Tanks, H.M.S. Donner Blitzen. Above, No. 663. 5⅛in. (13.02cm) long. Below No. 515. 4¼in. (10.8cm) long.

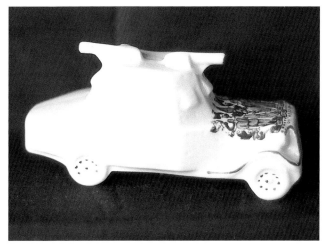

Colour Plate 449. Talbot armoured car, No. 32, Southend. 5in. (12.7cm) long.

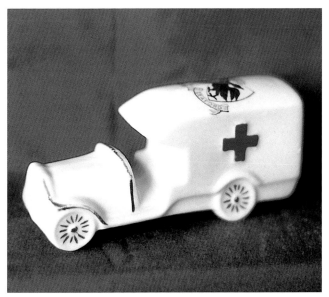

Colour Plate 450. Ambulance, red crosses moulded in relief, No. 520, Seaford. 4½in. (11.43cm) long.

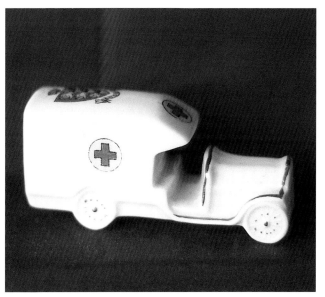

Colour Plate 451. Ambulance, red crosses in circles, No. 520, Sandwich. 4½in. (11.43cm) long.

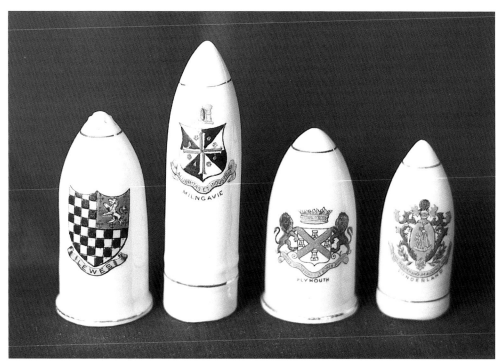

Colour Plate 452. Shells, varied sizes, 2¾in. to 4¼in. (6.9 to 11cm) long.

Colour Plate 453. Mills bomb/hand grenade, No. 574, Worthing. 3¼in. (8.4cm) long.

Colour Plate 454. Monoplane, painted wings, revolving propeller, No. 523, Southend. 5⅛in. (13cm) long.

Colour Plate 455. Monoplane, painted wings, fixed propeller, No. 523, Tavistock. 5⅛in. (13cm) long.

Colour Plate 456. Great War inscriptions, A to D.

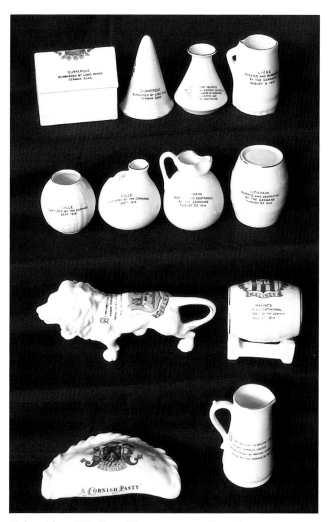

Colour Plate 457. Great War inscriptions, D to O.

Colour Plate 458. Great War inscriptions, O to Y.

Colour Plate 459.
Parian and glazed
Red Cross lady and
Scottish soldier, No.
118-163N.
Edinburgh. 6½ and
6¼in. (16.51 and
15.88cm) high.

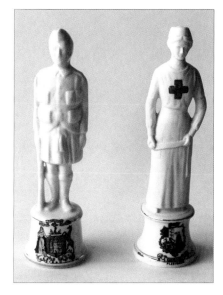

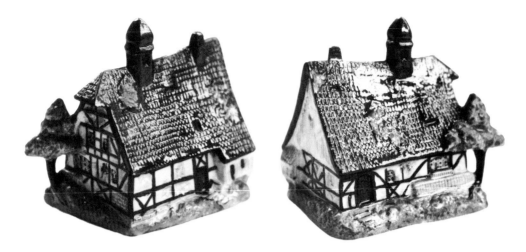

Colour Plates 460 and 461. Tumbledown Cottage, BR&Co.-Savoy.

Goodfellow, M.C., was such a person, whilst firstly serving in the Royal Engineers, then as an Observer and latterly as a pilot in the Royal Flying Corps No. 15 Squadron.

Taking advantage of the gap left in the market by the banning of goods being imported from Germany, it was reported in the *Pottery Gazette* in 1919 and 1920 that the firm was producing architectural models and could execute replicas of any well-known building to order. Aberystwyth University, King Charles Tower, Portsmouth Town Hall, Hastings Clock Tower, Exeter Cathedral, St. Paul's Cathedral, Truro Cathedral and Westminster Abbey were all recorded as being in production (see Colour Plates 462 and 463).

The demand for heraldic ware became decidedly lukewarm as tastes changed rapidly in the early twenties. The great depression thwarted manufacturers with the action of the national and coal strike in 1926, which left factories without the much needed fuel for twelve weeks, playing consequent havoc with production. The firm lacked assets to survive the loss of its business and goodwill, caused by the ovens being closed, and having little emergency funds. Some potter's millers and miller's merchants had gone out of business. Instead of the expensive felspar china clays from Devon and Cornwall cheaper inferior clays had to be used; there were many failures in firing due to the flints having been ground too finely, causing the china to crack in the ovens, so certain lines were abandoned and sales were lost.

Consequently in 1928 private arrangements were made with the earthenware firm of Wiltshaw & Robinson, makers of Carlton Ware, to merge. Lawrence Birks was bought out and embarked on the minor role of decorator and adviser for the new range of Carlton China which portrayed a certain art deco style. Many other factories in the immediate area simply went bankrupt at this depressing time. There had been massive unemployment after the Great Strike and this, coupled with the loss of coal, caused many factories to grind to a collapse in the 1930s. By 1940 production of any crested ware by rival firms had ceased altogether. Perhaps for the next thirty years many pieces of ware were thrown away before their popularity gathered pace again and certain pieces today are cherished and much admired for their designs, shapes and artistic talent.

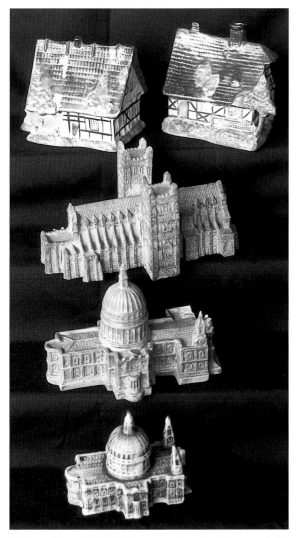

Colour Plate 462. Buildings – coloured. Exeter and St. Paul's Cathedral.

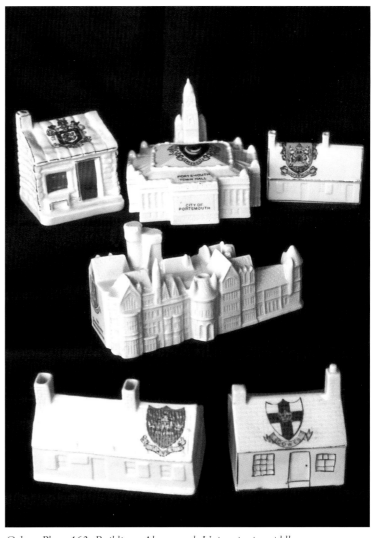

Colour Plate 463. Buildings. Aberystwyth University in middle row.

At the height of its production the Birks Rawlins factory, apart from producing their extremely popular crested wares under the name of Savoy bone china, made a conscious decision to have other outlets through the use of agents in the United Kingdom. Quite confusingly, some twenty-one outlets[1] were established over these years, these being retailers who insisted on being identified by their personal trademark on the wares that were made at the Vine Pottery. Some of these retailers shared their suppliers with other crested ware producers from the Potteries in North Staffordshire, whilst others were exclusively Birks Rawlins. Research has identified the following outlets: Aldwych China, Birks China, Bow China, B.S. & Co., Caledonia China, Caledonia Heraldic China, Diamond China, Do! Do! Crest China, Empire China, Endor China, Ivora Ware, JW & Co., Mermaid, Niagara Art China, Patriotic China, Porcelle, Queens China or Ware, C.L. Reis & Co., Rex China, Universal Series, W.R.F.S.[2]

1. *The Price Guide to Crested China* by Nicholas Pine, 2000, p.22.
2. Ibid., p.22.

Aldwych China[3]

Samuels in the Strand, London, retailed Aldwych china, specialising in so-called 'smalls', but Birks Rawlins pieces appear to be only in the form of small vases and the like with the 'Aldwych and B. R. & Co.' symbolic backstamp, identifying the ware with the factory.

Birks China[4]

Exclusively from the Vine Factory, pieces bearing this mark identified the origins of the firm stating 'established in 1895'. The trademark seen here was obviously introduced in 1928 in an attempt to trade on the old and respected name of Birks. It is well known that Birks Rawlins & Co. was in financial trouble in that particular year and it was rather an odd time to introduce a new line. Perhaps Harold Taylor Robinson of Wiltshaw & Robinson thought that this would help sales, but the venture did nothing to enhance the sales of Birks Rawlins & Co. Ltd. Most pieces recorded were domestic items with only a few models discovered to date and it has to be said that the quality is not the best compared with seventeen years before. One colour transfer view of Hampton Court Palace has been recorded on a tea plate, but known crests were from all over England. (Savoy China always carried stock numbers, but these have not all been recorded on 'Birks China'.)

Bow China[5]

Another exclusive production of Birks Rawlins, using its personalised trademark as illustrated. A small range of models with this mark have been recorded. They are mostly Great War miniatures, but a few domestic items have been found. Military badges have been recorded for regiments involved in the Great War, these being the Army Service Corps, the Gordon Highlanders, the Royal Army Medical Corps and the Seaforth Highlanders. Models can be grouped as follows:

Ancient artefacts (Carlisle salt pot, Celtic vase in the British Museum, Greek vase inscribed 'Model of Greek vase from the collection of Sir Henry Englefield, No. 66', Lincoln Jack from the original in the Museum of No. 39 and Persian vase No. 144)

Animals (elephant and howdah)

Great War (cannon shell inscribed 'Iron rations for Fritz', battleship found inscribed

3. Ibid., pp.29 and 30.
4. Ibid., pp.79-80.
5. Ibid., pp.85-85.

with H.M.S. Lion or Ramilies, No.524, submarine inscribed E1, usually found with inscription 'Commander Noel Lawrence, large German transport sunk July 30th 1915' and howitzer)
Hats (a top hat, No. 339)

Caledonia Heraldic China[6]

This ware was retailed by a Scottish wholesaler with several other leading crested china firms, including products from the Vine Factory. Most of the Birks models carry the trademark and are recognisable from the models of other firms. Where models are known to be from Birks Rawlins moulds they have, for the most part, the same stock numbers, but it has been noted that the Birks Rawlins use of stock numbers is at best perplexing. The wares can be grouped: historical/folklore; traditional/national souvenirs; seaside; animals; birds; Great War; home/nostalgic; alcohol; sport/pastimes; musical instruments; transport; hats; miniature domestic.

Diamond China[7]

Again this was a trademark used by a London wholesaler, the china being manufactured by several leading crested ware specialists including Birks Rawlins & Co. All pieces from the Vine Factory appear to be inferior or rejects, usually having bad firing flaws, in which event the value of such a piece would be reduced by 25%. They could have been wares made after the Great Strike when there was definitely inferior quality. These wares again can be grouped: ancient artefacts; historic/folklore; traditional/national souvenirs; seaside souvenirs; animals; birds; Great War; alcohol; miniature domestic.

6. Ibid., pp.92-93.
7. Ibid., pp.152-153.

Empire China[8]

The models were made for an unknown retailer, possibly William Ritchie of Edinburgh who traded mainly with the Porcelle mark. Only a few models have been identified.

Endor China[9]

The wares are thought to have been made for a retailer by the Vine Pottery. So far only three models have been recorded, a loving cup, a Welsh leek vase and a bag ware jug. The special trademark is illustrated.

Mermaid[10]

This trademark was used by William Ritchie and Sons Ltd., who retailed from Nos. 24, 26, and 28 Elder Street, Edinburgh, and mainly operated under the trademark of Porcelle. The Vine Factory possibly contributed to this ware, but there is no definite proof.

Niagara Art China[11]

This is yet another possible outlet for the Vine Factory, the trademark also being used by other pottery suppliers in the 1920s.

NIAGARA
ART
CHINA

8. Ibid., p.161.
9. Ibid., p.162.
10. Ibid., p.255.
11. Ibid., p.266.

Patriotic China[12]

This was a trademark used exclusively by the Vine Factory during the Great War. The items were marked with the illustrated trademark and mainly commemorated the Great War. There was a colour transferred teapot with the verse 'A soldier of the King' and a crest of the 11th Welsh, and certain domestic wares have also been found, namely a pot with the crest of Seaford Camp and the crest of the 13th Manchester. The pieces are generally regarded as of great interest to collectors of First World War miniature crested mementoes. There is every possibility that there are several pieces of ware still to be discovered.

Porcelle[13]

William Ritchie & Son Ltd., already mentioned in relation to the Mermaid souvenirs (and possibly Empire China), retailed much heraldic china and the Vine Factory supplied the wares with the illustrated Porcelle backstamp which was registered and recorded in the *Pottery Gazette* in October 1910. William Ritchie was an Edinburgh wholesale stationer who supplied heraldic postcards. They were also described as porcelain and earthenware manufacturers, but no record or information can be found in the standard works on the pottery industry to substantiate this rumour. Much of the ware was marketed before the Great War and seems to have ceased in the mid-twenties. The majority of the crests recorded are from Scotland, Ireland and the North of England and it appears that the concentration of sales were in this area. Most of the crested domestic wares that have been recorded are teapot stands, butter dishes and trays of various kinds, with a buff body instead of white. Porcelle china is more creamy or ivory than white and is quite fine, with the crests being of a good standard.

The range of wares is wide with a numbering system of stock numbers usually painted on the base of the models. They are listed in Nicholas Pine's *Crested China* books published in 1985, 1989, 1992 and 2000.

Generally the wares can grouped as follows: Parian/unglazed busts; ancient artefacts; buildings – white; historical/folklore; traditional/national souvenirs; seaside souvenirs; countryside; animals; birds (including eggs); Great War; home/nostalgic; comic/novelty; cartoon/comedy characters; alcohol; sport/pastimes; musical instruments; transport; modern equipment; hats; footwear; miniature domestic ware. At least 146 different pieces have been recorded to date.

12. Ibid., p.275.
13. Ibid., pp.282-285.

Queens China or Ware[14]

This trademark, as illustrated, was used by Birks Rawlins & Co. Ltd. at the Vine Factory in the late 1920s. The wares were usually seconds and had firing flaws. Only pristine pieces bore the main Savoy mark of the firm. Birks Rawlins generally advertised Queens China as a line of tableware which appeared to be of a much heavier composition, so it has to be assumed that the clay was of inferior quality compared with the usual fine bone china and was consequently a cheaper range for the market. There is no identifiable B.R. & Co. mark on any of this Queens China range which seems to indicate that the firm did not wish to tarnish the proud image presented by their main Savoy range. There is a system in the usage of stock numbers, but it does not coincide with any of the other factory products.

The wares can be listed generally as follows: ancient artefacts; traditional/national souvenirs; historical/folklore; seaside souvenirs; countryside souvenirs; birds; Great War; home/nostalgic; comic/novelty; cartoon/comedy characters; sports/pastimes; musical instruments; footwear and domestic. About one hundred different pieces have been recorded.

14. Ibid., pp.288-289.

 Queens China or Ware

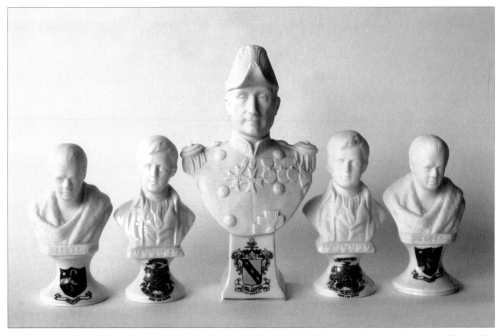

Colour Plate 464. Parian busts of, left to right, Scott, Burns (glazed), Jellicoe, Burns and Scott, all Porcelle.

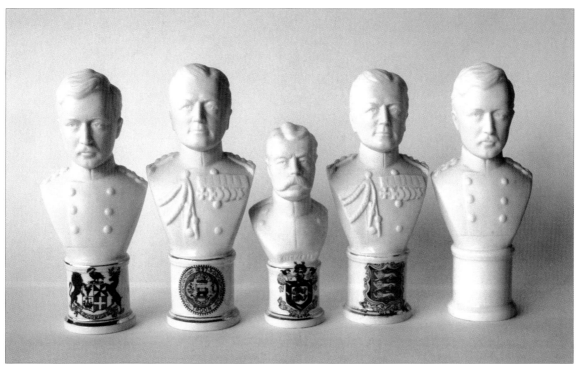

Colour Plate 465. Parian busts of, left to right, King of the Belgians, Beatty, Kitchener, Beatty and King of the Belgians, all Savoy.

Colour Plate 466. Reverse side of Parian bust. Sculptor W.H. Cooper.

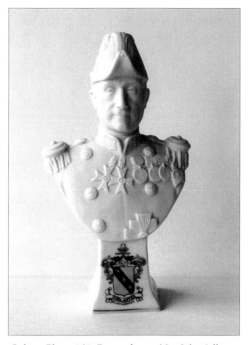

Colour Plate 467. Parian bust of Sir John Jellicoe. Sculptor W.C. Lawton, date 23-09-1914. Porcelle.

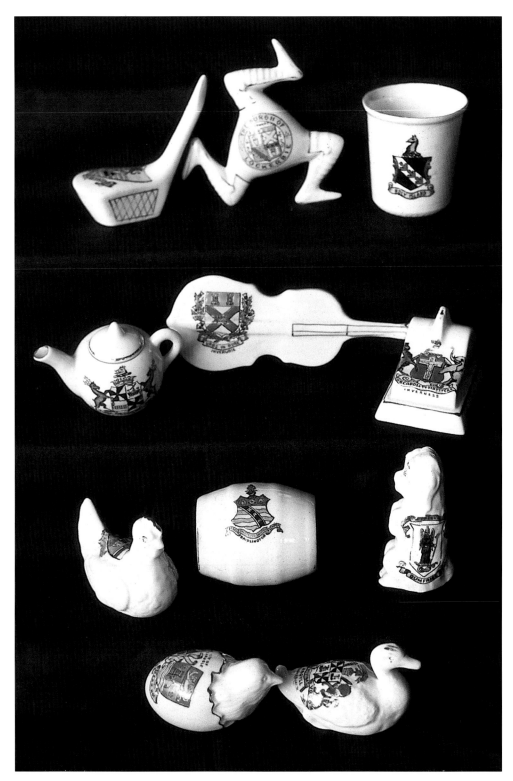

Colour Plate 468. Porcelle. Wholesaler W.R. & Son, Edinburgh.

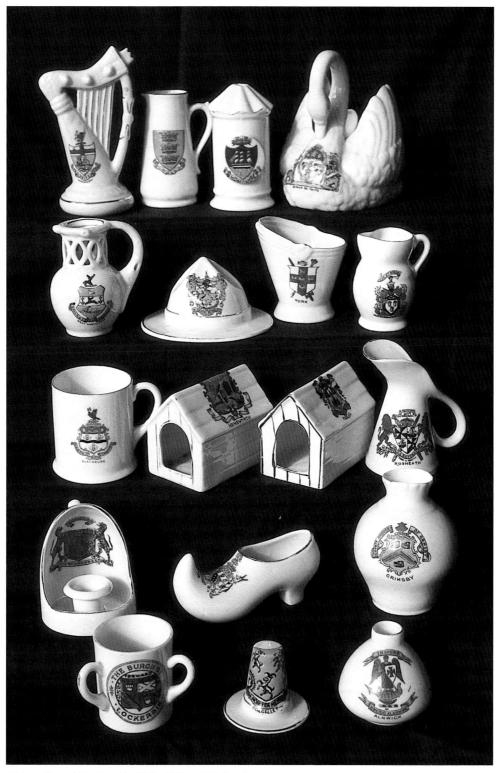

Colour Plate 469. Porcelle. W.R. & Son, Edinburgh.

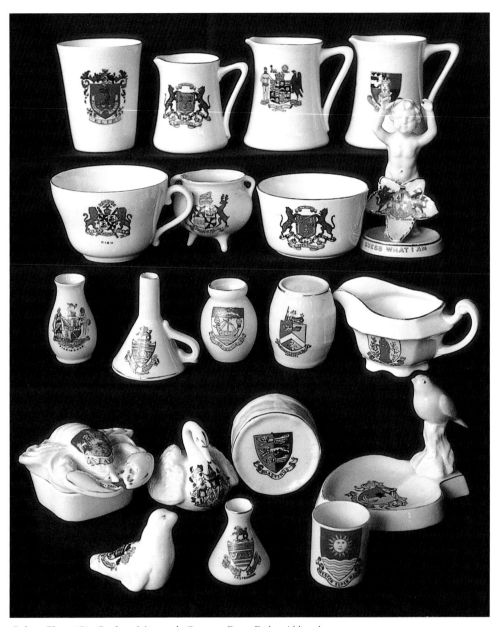

Colour Plate 471. Outlets: Mermaid; Queens; Bow; Birks; Aldwych.

Colour Plate 470. Ivora ware crinkled vase, Taunton. Trademark
W.R. & Co.

Savoy China[15]

This was a large undertaking by Birks Rawlins at their Vine Factory in Stoke upon Trent and the Savoy trademark was universally acclaimed over its years of production. The rise in popularity of the china miniatures in 1910 has already been noted, with the work being stepped up in the years at the end of the Great War to a peak of production in 1925. It was then, with the reappearance of cheap Continental souvenirs on the home market, coupled with the effect of the depression and the National Strike, that the firm went into a downward spiral. The subsequent merge with Wiltshaw & Robinson (makers of Carlton Ware) was only a temporary halt in this downward slide, because there followed the financial disaster in 1929, greatly affecting exports, and there was very limited financial capacity in the company due to one or both of the Rawlins brothers pulling out of the firm. Consequently the company was placed in the hands of the receiver, F.W. Carder, in 1932. It is thought that there was a certain influence on patterns and shapes on some of the Carlton Ware pieces, and vice versa with Birks Rawlins, during the 1928-1934 transitional period.

A most comprehensive range of Great War commemorative inscriptions was produced on many military models. These inscriptions record and describe battles, carnage and events in the war, carrying the matching crests of towns and cities in and around the concentration of hostilities.

A comprehensive method of explanation of models appears in the *Price Guide for Crested China* in 1992.[16] The wares made at the factory followed a variety of themes and this grouping helps the collector considerably.

Birks Rawlins & Co. produced a few military badges: the Argyll & Sutherland Highlanders; Army Medical Corps; Army Service Corps; Black Watch; Cameronians; Scottish Rifles; Gordon Highlanders; Highland Light Infantry; Queen's Own Cameron Highlanders; Royal Army Medical Corps; Royal Engineers; Royal Field Artillery; Royal Military College, Camberley; Royal Scots Greys; Seaforth Highlanders; Worcester Regiment; H.M.S. *Lion;* and H.M.S. *Warspite.* They appear extremely difficult to find.

Many unmarked models do exist and in a variety of price guides and journals they have been attributed to the Vine Factory. Certain shapes of models do not have enough room on the base for a factory mark, but a trained eye can generally identify which pottery or manufactory has made the majority of these unmarked pieces.

The last published *Price Guide for Crested China* does cover Savoy products in considerable detail with some thirty illustrations, but, more importantly, the models are listed in groups. It is estimated that up to 450 different models of crested ware were produced over the years at the Vine manufactory.

15. Ibid., pp.318-327.
16. Ibid., p.22.

From *The Price Guide to Crested China, 2002,*
by Nicholas Pine

The models have been grouped into types of souvenirs and have been arranged for the most part in the order in which they would have been made. The headings are as follows:

Ladies and Figures, Coloured
Unglazed/Parian
Parian busts are also found under this heading.
Ancient Artefacts
Models of historic interest
Buildings – Coloured
Buildings – White
Including bridges
Monuments (including Crosses)
Historical/Folklore
Traditional/National Souvenirs
These have been listed in the following order: Britain, England, Ireland, Scotland, Wales, other countries.
Seaside Souvenirs
These have been listed in the following order: Bathing Machines, Crafts, Fishermen/Lifeboatmen, Lighthouses, Shells, People and Punches.
Bathing Belles/Twenties Flappers
Figures
These listings include only the figures which do not belong under any other heading.
Countryside
Animals
These listings include animals which are really regional symbols as the Sussex Pig. Most collectors would include these in an animal collection.
Birds (including Eggs)
These listings also include regional or national emblems such as the Kiwi.
Great War
These models have been grouped as
follows:
Personnel, Aeroplanes/Airships/Zeppelins, Ships/Submarines, Armoured Cars, Red Cross Vans/Tanks. Guns/Mortars, Small arms, Shells, Bombs, Grenades, Mines, Torpedoes, Personal Equipment, Memorabilia and Memorials. (Florence Nightingale statues are always included in Great War collections although she died before 1914. Certainly the statue was offered for sale at the same time, so it is listed under this heading).
Home/Nostalgic
Comic/Novelty
Cartoon/Comedy Characters
Alcohol
Sport/Pastimes
This section includes card trump symbols and chess pieces. Sporting items have been listed first, then those used for pastimes.
Musical Instruments
Transport
'Modern' Equipment
'Modern', that is, at the time it was made.

Hats
Footwear
These listings also include regional or national symbols such as the Lancashire clog and Dutch sabot.
Miniature Domestic
Domestic
Miscellaneous

Under these headings models are listed alphabetically, if that is possible. All inscriptions and verses are printed in italics.
If a model is best described by its inscription this will be placed at the beginning of an entry in italics.
Sizes are height unless otherwise stated.

Great War commemorative inscriptions sometimes found on military models but more often on 'smalls'.

Albert 'British advance commenced July 1st 1916. Battle of the Somme.'
Amiens Germans defeated at Moreuil and Ovise near Amiens; August 27-29, 1914. Amiens taken by the Germans September 1 1914.'
Antwerpen 'Antwerp invaded Oct. 1st 1914. Bombarded 1914, evacuated Oct. 7th 1914. Captured Oct. 13th 1914.'
Armentiers 'Desperate Battles between British and Germans, Nov. 1914, June 1915.'
Arras 'Great Battle between French and Germans. French gain trenches June 1915.' Or '13,000 German prisoners, 160 guns captured 1917.'
Australia 'Herbertshone German Pacific Island captured by Australian Navy September 11th 1914. The German cruiser Emden attacked and burnt by H.M.S. Sydney Nov. 8th 1914.'
Advance Australia 'The Australians have made an undying name in storming the Turkish trenches April May 1915.' This inscription is in addition to the previous inscription.
La Bassee No details of inscription available.
Beaumont 'British victory German fortress of Beaumont-Hamel, Beaucourt and St. Pierre Divion, captured Nov. 13-14 1916.'
Belgium 'Belgium invaded by Germany August 4th 1914. Capital occupied August 20th 1914.'
Boulogne 'Hospital base for British wounded soldiers.'
B.E. Africa 'South Togoland seized by Great Britain August 7th 1914.'
British East Africa 'South Togoland seized by Britain August 7th 1914.'
Brugge/Bruges 'Bruges occupied by the Germans Oct. 16 1914.'
Brussels 'Occupied by the Germans August 20th 1914.'
Bucharest 'Rumania declares war on Austria-Hungary August 27th 1916.'
Calais 'German life and death advance.'
Combles Great German fortress captured by the British Sep. 26. 1916. Greatest British success of the war.'

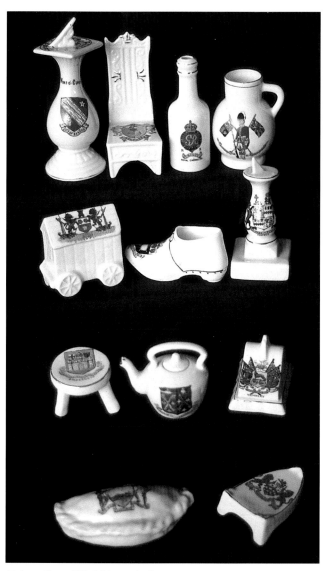

Colour Plate 472. Military badges.

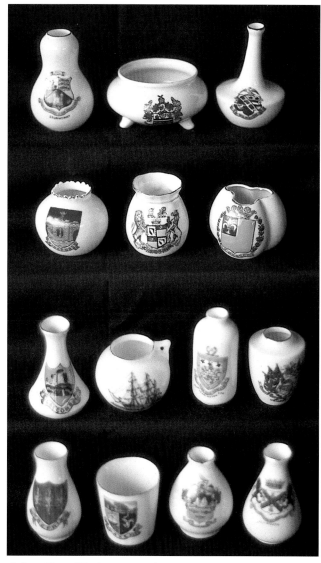

Colour Plate 473. Ancient artefacts.

Compiegne 'Battle of Compiegne Sep. 1st. 1914'
Dinant 'Sacked and burnt by the Germans August 23rd 1914.'
Dornock No details of inscription available.
Doullens No details of inscription available.
Dunkerque 'Dunkerque bombarded by long range German guns.'
Egypt 'Defended by British troops with Australian and Indian contingents.'
French Republic French Territory invaded by German troops August 2nd 1914. Battle of the Marne Sept. 8th to Sep. 12th'
Gand 'Ghent. occupied by the Germans October 13th 1914.'
Greece 'Allies land at Salonika October 5 1915.'
Hartlepool 'Bombardment of Hartlepool by the German fleet December 16th 1914'
Japan 'Declared war on Germany Aug. 23rd 1914. The fortress Kido-

Chau stormed and taken by the Japanese Nov. 7th 1914.'
Liege Invested and bombarded by the Germans August 9th 1914.
Lille 'Lille captured by the Germans Sept. 1914.'
Loos No details of inscription available.
Louvain 'Louvain burned and destroyed by the Germans, August 25th 1914.'
Luxembourg Luxembourg invaded by Germans Aug. 1914.'
Malines 'Town and cathedral bombarded by the Germans August 27th 1914.'
Messines 'Battle of Messines. Great British victory 7342 German prisoners. June 7 1917 also 47 guns captured.'
Mons 'Battle of Mons. Historic Retreat begun August 23rd 1914.'
Namur 'Namur Forts destroyed by the large German guns August 23rd 1914.'

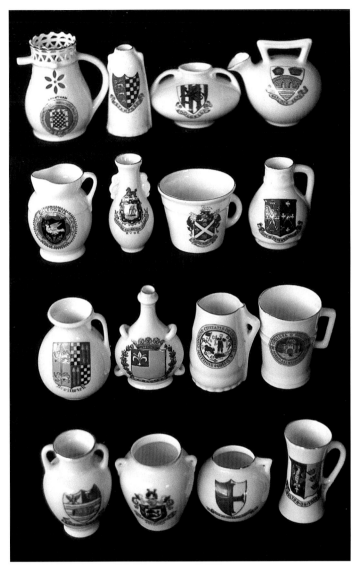

Colour Plate 474. Ancient artefacts.

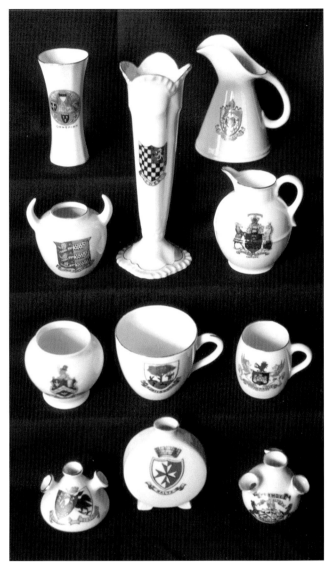

Colour Plate 475. Ancient artefacts.

Neuve Chapelle 'Brilliant British Victory over Germans at Neuve Chapelle March 10th 1915.'

Neiuport 'Bombarded January 1915.'

Ostend 'Occupied by the Germans October 16th 1914. British ships begin to take part in coast battle October 8th 1914.'

Paris 'German rush on Paris; reached 20 miles from Paris Sept 3rd 1914.'

Persia 'Persia; British defeat Turks at Kut-el-Amara Sept 28th 1915.'

Rheims 'Rheims bombarded by Germans Sept 2 1914; Cathedral destroyed Sept 19 1914.'

Russia 'Przemysl captured by the Russians 119,600 prisoners of war March 22nd 1915.'

Russia 'War declared upon Russia by Germany Aug. 1st 1914.'

Servia 'Austrians defeated by Serbians at Kolubra Dec 3-6 1914.'

Sheringham 'German air raid on Sheringham Jan. 19th 1915.'

Soissons 'Battle of Soissons.'

Union of South Africa No details of inscription available.

United States of America 'America declared war on Germany, Good Friday April 6 1917.'

Verdun 'German defeat before Fort Douardmont February 26th 1916.'

Ypres 'German push stemmed by the Valour of the British troops October 27th 1914. 2nd battle of Ypres the Canadian's gallantry saved the situation April 24th 1915.'

Some superb patriotic transfers were made including Black Watch (depicting a private), Gordon Highlanders, soldier of the King, 13th Manchester, Seaford Camp, Grenadier Guards (private), Territorial Soldier (private), and the 11th Welsh.

Commemoratives can also be found of the Scottish Exhibition,

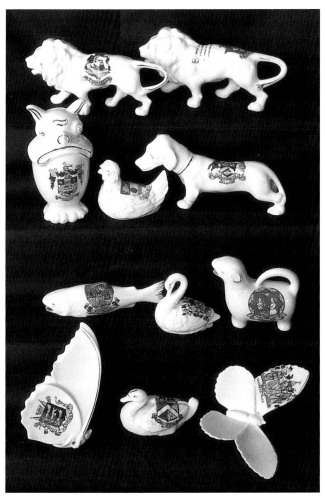

Colour Plate 476. Animals, birds, fish, butterflies.

Colour Plate 477. Animals, some amazing grotesques.

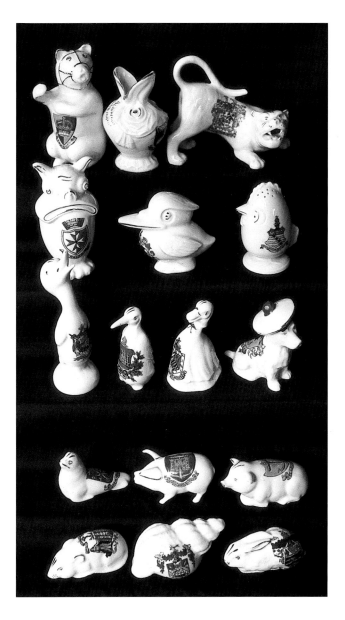

Glasgow 1911 and the Wembley British Empire Exhibition 1924/5.
Numbering System. <u>Savoy</u> models tend to be over endowed with
printed and painted numbers on their bases. Many models have a
very clear printed number which was obviously a stock number.
Unfortunately for the collector the same low numbers often appear
on different models. There are possibly one or two reasons for this,
one theory being that as models were deleted from the range new
models were given their numbers. Another theory for which there is
some evidence is that the numbers were badly printed and often only
the first or last one or two are in evidence. Sometimes where this has
happened a larger stock number is painted in black beside the
printed number. Other coloured painted numbers found near the
mark seem to be paintresses' marks, these often appearing directly
under the painted stock number also in black.

Where stock numbers have been found consistently (printed or
painted on models) they have been recorded in the following lists.

Savoy Models Parian/Unglazed

Bust of Edward VII as the Prince of Wales with inscription. 135mm.
Bust of *Albert King of the Belgians,* round glazed base. 155mm.
Bust of Admiral Sir David Beatty, found with inscription: *British
 Naval Victory, German Cruiser Blucher sunk January 24th 1915.
 England declared war on Germany August 4th 1914.* 150mm.
Bust of David Lloyd George with inscription on reverse. 186mm.
Bust of Lord Kitchener, found with inscription: *Lord Kitchener of
 Khartoum Field Marshall KG KP Secretary for war. Born 1851.
 June 15th, drowned at sea off the Orkneys 1916.* 2 sizes: 107mm
 and 120mm

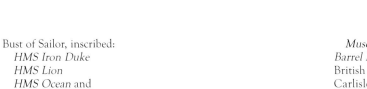

Colour Plate 478. Animals.

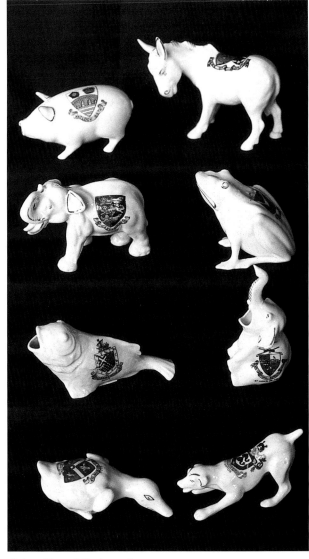

Colour Plate 479. Animals.

Bust of Sailor, inscribed:
 HMS Iron Duke
 HMS Lion
 HMS Ocean and
 HMS Warspite
 (rare), on round glazed base. No. 532. 135mm.
Bust of John Travers Cornwell, inscription: *John Travers Cornwell,*
 age 16. Faithful unto death. Hero Battle of Jutland, impressed:
 HMS Chester on cap band. No. 580. 108mm.

Ancient Artefacts
Ancient Jug. No. 87. 74mm.
Ancient Jug, Model of. Dug out of the Foundations of Lichfield

 Museum. 62mm.
Barrel Mug, Model of. No. 7. 45mm.
British Urn. 50mm.
Carlisle Elizabethan Measure, inscribed: *Model of gallon*
 Elizabethan standard measure in Carlisle museum by permission
 of Com Tullie House. No. 183. 38mm.
Carlisle Jug, *14th Century Jug found in an old tank at Carlisle gaol,*
 by permission of Com Tullie House. No. 179. 70mm.
Carlisle Salt Pot 14th Century. No. 182. 65mm.
Carlisle Vase No. 177. 70mm.
Chester Roman Vase, inscribed: *Roman Vase, original now in*
 Chester Museum. No. 134. 70mm.
China Tot, Model of. No. 33.

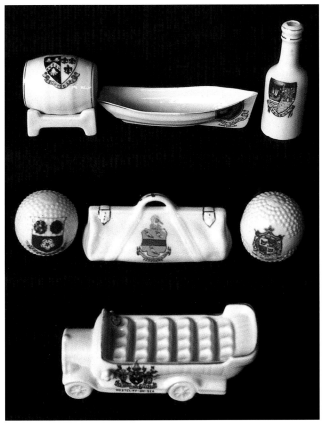

Colour Plate 480. Transport, Alcohol, Sport.

Colour Plate 481. Hats, civilian and Great War.

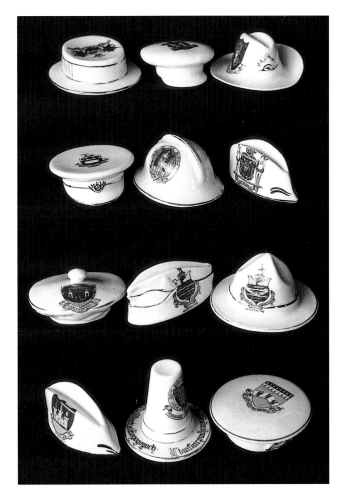

Chinese Vase in South Kensington Museum. No. 67 or 219. 70mm.

Chinese Jade Vase, inscribed: *Model of Vase of Chinese Jade.* No. 152. 68mm.

Colchester Vase. *Ancient Vase original in Colchester Museum.* No. 349. 50mm.

Colchester Roman Vase, inscribed: *Roman vase found in Cloaca, now in Colchester Castle.* No. 196. 30mm.

Exeter Vase from original in Museum.

Globe Vase. No. 62. 42mm.

Greek Vase. No. 77. 69mm.

Hastings Kettle. No. 140. 60mm.

Irish Bronze Pot. 50mm.

Italian Vase. No. 30.

Itford Urn. 44mm.

Launceston Bottle. No. 193. 65mm.

Lewes Vase, inscribed: *Model of Roman Vase in Lewes Castle.* No. 197. 35mm.

Loving Cup. *Model of Loving Cup, original by Henry of Navarre, King of France.* No. 49. 42mm.

Maltese Fire Grate. No. 39 and No. 721. 45mm.

Newbury Leather Bottle. *Model of Leather Bottle found at Newbury 1044 on battlefield now in museum.* No. 14. 63mm.

Pear Bottle. No. 17. 70mm.

Penrith Salt pot. No. 182. 60mm.

Persian Bottle. No. 68. 95mm.

Pilgrims Bottle Nevers ware. No. 172. 75mm.

Pompeian Vase. No. 161. 124mm.

Pompeian Vessel. No. 264.

Portland Vase. No. 16. 51mm.

Puzzle Jug. No. 378. 68mm.

Salt Maller, Model of. No. 106. 60mm.

Scarborough Jug. No. 454 or No. 10. 48mm.

Silchester Roman Urn No. 74. 51mm.

Shakespeare's Jug, *the jug of William Shakespeare,* with his signature. 60mm.

Shrewsbury Ewer. No. 19. 72mm.

Southwold Jar. No. 175. 90mm.

Staffordshire salt glaze tea pot, Model of with separate lid. No. 202. 75mm.

Tear Bottle. 70mm.

Teapot, copy of early 18th century stoneware (shaped as as camel). 100mm long. (Rare).

Tyg, two-handled. 62mm.

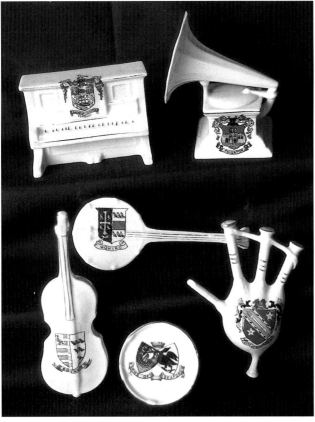

Colour Plate 482. Musical instruments.

Colour Plate 483. Buildings – lighthouses.

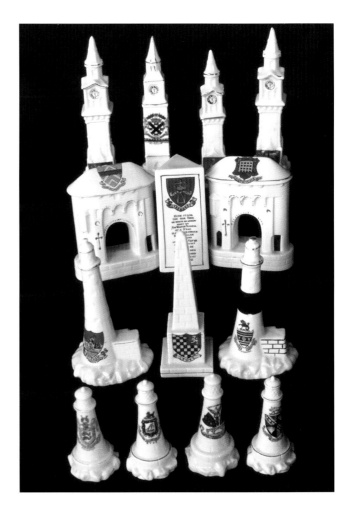

Windsor Roman *Urn Roman urn dug up at old Windsor from original now in British Museum. No. 138. 45mm.*

York Roman Ewer. *Roman Ewer from the original in Hospitium found at York. No. 20.*

Buildings – Coloured
Exeter Cathedral, brown coloured. 150mm long.
St Paul's Cathedral, brown unglazed. 125mm long, 88mm high.
Tumbledown Cottage, not named, highly coloured and glazed. Impressed 1800. 105mm long.

Buildings – White
Aberystwyth, The University. No. 68. 146mm long.
Burns Cottage. 70mm long.
Citadel Gateway. Plymouth. No. 209. 114mm.
Birmingham Town Hall. 94mm long, 62mm high.
Clifton Suspension Bridge. 132mm long.
Clock Tower. 126mm.
Cottage, not named, inscribed: *I wouldn't leave my little wooden hut for you.* 63mm long.
Derry's Clock, Plymouth. No. 17. 152mm.

First and Last Refreshment House in England. No. 301. 72mm.
Hastings Clock Tower. No. 274. 156mm.
Margate Clock Tower. 160mm.
Monnow Gate, Monmouth. 112mm.
Portsmouth Town Hall. No. 7. 80mm.
Tumbledown Cottage. 105mm long.

Monuments
Model of Lewes Martyr's Memorial. Erected in 1901 to the memory of the 16 Protestants burnt to death in front of the Star Hotel 1555-1557. 140mm. No. 791.
Rufus Stone, with usual inscriptions. 100mm.

Historical/Folklore
Burns Chair, Dumfries. 85mm.
Elizabethan Girl, full figure. 155mm.
Execution Block. 100mm long.
Gargoyle or Devils Head, open mouth, inscribed: *My word if you're not off.* No. 230. 90mm long.
Mary Queen of Scots Chair, Edinburgh Castle. 77mm.

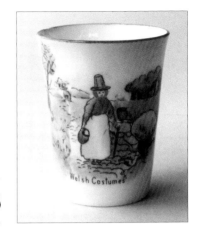

Colour Plate 484. Cup, saucer and beaker. Chillingham Castle. Cup 2¾in. (6.99cm) diameter.

Colour Plate 485. Beaker. Lady in Welsh costume, Savoy China. 3⅛in. (8cm) high.

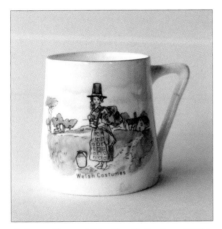

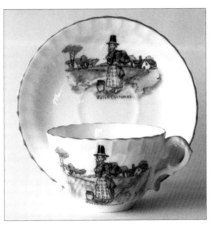

Colour Plate 486. Small beaker. Welsh costume. 2¾in. (6.99cm) high.

Colour Plate 487. Cup and saucer. Welsh costume.

Colour Plate 488. Coronation beaker, King George V and Queen Mary, 22 June 1911. Pattern 2149. Rhead.

Traditional/National Souvenirs
A Cornish Pasty. 100mm long.
Ripon Horn Blower. No. 497. 100mm.
Ye Olde Devonshire Milk Can. 78mm.
Bagpipes. 115mm long.
Monmouth Cap. 50mm,.
Tam o'shanter.
Thistle Vase. 47mm.
Welsh Hat with longest place name round brim. No. 6. 2 sizes: 35mm and 55mm.
Welsh Lady carrying a basket. 110mm.
Dutch Boy, standing coloured, salt pot. 128mm.

Seaside Souvenirs
Bathing Machine, inscribed: *Morning Dip.* 62mm.
Boat. No. 434. 128mm long.
Lifeboat. If inscribed: Zetland. No. 341. 125mm long.
Rowing Boat. No. 118. 130mm long.
Yacht. 115mm long.
Beachy Head Lighthouse. No. 377. 130mm.
Lighthouse, candlesnuffer. 95mm.

Eddystone Lighthouse. No. 136. Also found inscribed: *St. Catherines Lighthouse.* 92mm.
Lizard Lighthouse.
Lighthouse salt pot, inscribed: *salt.* 105mm.
Lighthouse pepper pot, inscribed: *pepper.* 120mm. No. 768.
Crab ashtray or dish. 52mm long.
Lobster pintray with lid. No. 426. 97mm long.
Child draped in towel, standing on a rock. 133mm.
Whelk Shell No. 451. 81mm long,

Countryside
Acorn, Model of .No. 110. 56mm. Can also be found as a pepper pot marked 'P'.

Animals
Bear inscribed: *Model of Stoneware Bear,* a performing bear on hind legs with gilded muzzle. No. 205. 106mm.
Cat, Cheshire. No. 17. 80mm.
Cat sitting, miniature, with long neck. 68mm.
Cat, angry with arched back, inscribed: *Me backs up.* No. 195. 100mm long.

Colour Plates 489 and 490. Coronation beaker, King George V and Queen Mary, 22 June 1911. Pattern 2149. Rhead.

Colour Plate 491. Trademark on coronation beaker. Savoy China, Henry Wood, Minehead.

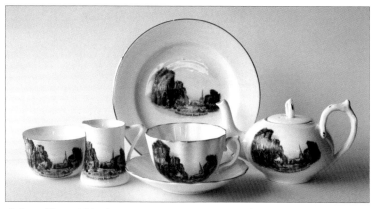 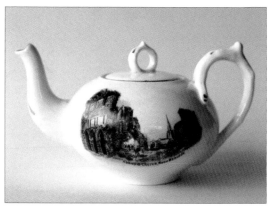

Colour Plate 492. Six piece miniature teaset. Abbey and church, Much Wenlock, Shropshire.

Colour Plate 493. Teapot. Abbey and church, Much Wenlock, Shropshire.

Cat with long neck. No. 217. 105mm.

Cat, sitting. detailed fur. 2 sizes: 56mm and 94mm. No. 245

Cat, standing with huge grin. erect bushy tail. Comic, black cartoon cat. 105mm long.

Cat. on oval lustre base. Inscribed: *Good Luck.* Cat coloured black. 90mm. (Carlton mould).

Cat, Manx, standing. 80mm long.

Dog cream jug. No. 106. 60mm.

Dog (no particular breed) sitting. 55mm.

Dog (curly tail) standing. 65mm.

Dog, Basset/Dachshund. No. 296. 132mm long.

Dog, Spaniel, sitting. No. 561. 65mm.

Bulldog, lying, inscribed: *Another Dreadnought.* 135mm long.

Bulldog, standing, with verse. *Be Briton Still to Britain True.* No 364. 130mm long.

Bulldog. standing. feet outwards. Inscribed:*Another Dreadnought.* 135mm long.

Dog. crouched and barking. No. 253. 100mm long.

Dog, Scottie, wearing glengarry. No. 477. 86mm.

Dog, Scottie, wearing a tam o'shanter. 2 sizes: 63mm and 80mm.

Dog, Scottie, looking out of kennel. Can be found with inscription: *The Black Watch.* No. 154. 80mm long.

Dog, Spaniel, begging. 65mm.

Donkey, standing. No. 308. 130mm long.

Elephant, sitting with trunk in the air. No. 218. 63mm.

Elephant, standing. No. 250. 65mm.

Elephant, standing, trunk raised. No. 253. 100mm long. Can be found coloured green.

Elephant with howdah No. 228. 66mm.

Fish. 104mm long.

Fish Jug. 70mm.

Fish Vase. No. 33. 88mm.

Frog, sitting, well detailed. No. 321. 70mm.

Frog on a rock. Green. 110mm long.

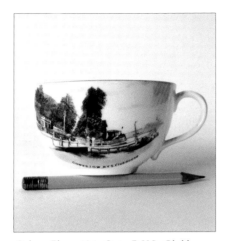

Colour Plate 494. Cup. R.Y.S. Clubhouse, Cowes, Isle of Wight.

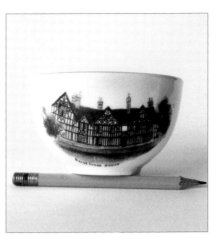

Colour Plate 495. Sugar bowl. Barnt Green House.

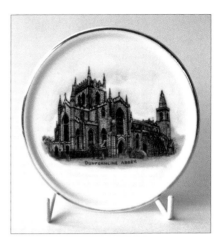

Colour Plate 496. Teapot stand. Dunfermline Abbey. 4⅜in. (11.11cm) diameter.

Colour Plate 497. Side plate. Gloucester Ancient. 7³⁄₁₆in. (19cm) diameter.

Colour Plate 498. Side plate. Borough of Eastbourne. 6⅝in. (17cm) diameter.

Colour Plate 499. Side plate. Sherbourne. 6¼in. (16cm) diameter.

Hare, crouching, No. 235. 80mm long.
Hare, sitting, ears raised. No. 245. 70mm.
Hare, looking left, upright ears. No. 253. 80mm.
Hippo, with pointed teeth. 113mm long.
Lion, sitting on square base. This was originally designed by Alfred Stevens for the British Museum. 108mm.
Lion, walking. Inscribed. 'Be Briton...' No. 123. or 'Another Dreadnought'. No. 288. 134mm long. Without inscription.
Mouse. 65mm long.
Pig, lying down. No. 544 8mm long. Can be found inscribed: Wunt be druv'.
Pig, standing and fat. No. 109. 2 sizes: 70mm and 100mm long. Large size can be found inscribed: Model of Irish Pig.
Pig, standing, open mouthed. 122mm long.
Pig, lying down. N. 859. 80mm long.
Pig, inscribed: Model of Sussex Pig. No. 198 and No. 281. 78mm long.
Pig, standing, alert ears. No. 199. 100mm long.
Pig, sitting, long nose. 110mm.

Piglet with long ears. No. 33. 65mm long.
Polar Bear. No. 236. 145mm long.
Rabbit, ears flat. 66mm long.
Rabbit, crouching. No. 247. 88mm long.
Rabbit, sitting, one ear up. No. 548. 70mm long.
Rabbit, sitting on hind legs, upright. No. 242. 104mm.
Rhino, grotesque. No. 284. 130mm long.
Seal. 2 sizes: 63mm and 80mm long.
Snail. No. 252. 84mm long.
Teddy Bear. 90mm.
Tiger, sabre toothed, or Wild Cat with inscription: My word if you're not off. 128mm long.
Toad. No. 331. 75mm.
Warthog or Wild Pig, open mouth. Grotesque. 122mm long.

Birds (including Eggs)
Bird, coloured yellow, orange and black, shaped salt pot. 90mm.

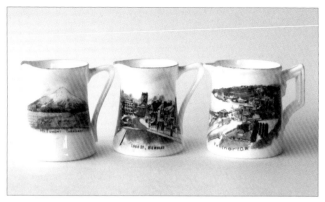

Colour Plate 500. *Creamer, Mount Egmont, Taranaki. Milk jug, Load Street, Bewdley. Beaker, Ventnor, Isle of Wight. All 2½in. (6.35cm) high.*

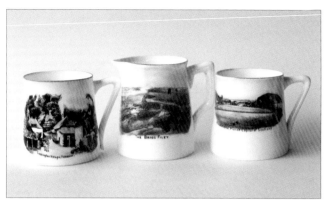

Colour Plate 501. *Beaker, Cookington Village, Torquay, 2¾in. (6.99cm) high. Milk jug, The Brigg, Filey, 3³/₁₆in. (8.1cm) high. Beaker, Benderloch, Pictish Capital of Scotland, 2¾in. (6.99cm) high.*

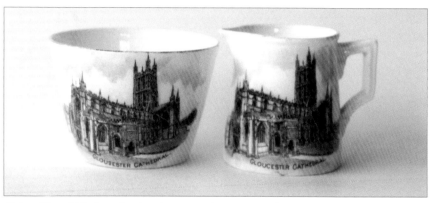

Colour Plate 502. *Sugar bowl and creamer. Gloucester Cathedral. Creamer 2³/₁₆in. (5.56cm) high, 3¼in. (8.26cm) diameter.*

Colour Plate 503. *Beaker/mug. Christchurch Priory. 3¼in. (8.26cm) high.*

Bird mustard pot. orange, yellow, red and black. 86mm long.
Bird alighting on edge of bowl. No. 248. 97mm.
Grotesque Bird. 100mm.
Clara Cluck candlesnuffer. No. 324. 87mm.
Duck, swimming. No. 562. 65mm long.
Duck, standing. 150mm.
Duck, standing on green base. Can be found coloured. 170mm.
Duckling, standing on tree trunk, colouring on trunk and beak. 186mm.
Duckling, comic, with a wasp on its beak. Also found partly coloured. 165mm
Duck, lying down, could be dead. No. 237. 105mm long.
Duck, comical, airing wings on circular base. 155mm.
Egg with Cock face, comb and tail on round base. 90mm.
Grotesque Bird jug. No. 127.
Goose in full length cloak. 72mm.
Hen, sitting, red comb. No. 23. 55mm.
Hen, sitting. 50mm.
Owl, comic.No. 33 or No. 329. 60mm.
Penguin. No. 484. 70mm.
Penguin. No. 549. 76mm.

Penguin. No. 332. 80mm.
Penguin on heart shaped ashtray. 85mm.
Swan, detailed plumage. No. 579. 50mm

Great War
Highland Infantryman, with pack, rifle and bayonet. Either glazed or parian, both on round glazed plinth. No. 530. 165mm.
Sailor, standing. arms folded, unglazed on round glazed base. (Very rare) No. 538. 160mm.
Nurse, with red cross on chest, holding bandage. Can be found inscribed: *Nurse Cavell.* No. 531. 165mm.
Biplane, with movable prop., 2 different models exist:
(a) One has open struts between the wings. (see page 60 of *Take Me Back To Dear Old Blighty* by Robert Southall).
(b) The other model is identical but has the struts filled in solid between the wings. No. 633. 140mm long.
Both models have coloured roundels and tail.
Monoplane, pointed wings and fixed prop. No. 523. 130mm long.
Monoplane, pointed wings and revolving prop. No. 527. 130mm long.
Zeppelin with revolving 2-bladed propeller, can be found with

Colour Plate 504. Cup. Whitley Bay.

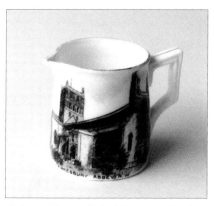

Colour Plate 505. Miniature beaker. Tewkesbury Abbey.

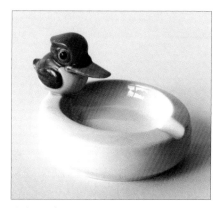

Colour Plate 506. 'Winkie glad eyed bird' ashtray.

Colour Plate 507. Leather bottle miniature with a windmill scene.

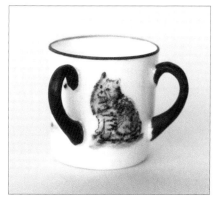

Colour Plate 508. Tyg, Savoy China. 1½in. (4cm) high, 1½in. (4cm) diameter.

Colour Plate 509. Tyg, Savoy China. 1½in. (4cm) high, 1½in. (4cm) diameter.

inscription: *Zeppelin destroyed by Lt. Robinson V.C. at Cuffley Essex Sept. 3rd 1916.* No. 567. 175mm long.

Battleship, *HMS Iron Duke*, 2 funnels. No. 524. 165mm long.

Battleship, *HMS Lion*, 3 funnels. No. 524. 168mm long.

Battleship, *HMS Queen Elizabeth*, 3 funnels. No. 615. 170mm long.

Battleship, *HMS Queen Elizabeth*. 2 funnels. No. 524. 165mm long.

Battleship, *HMS Barham*. 2 funnels. 168mm long.

Battleship, *HMS Tiger*, 2 funnels. No. 525. 168mm long.

Battleship, *HMS Warspite*, 2 funnels. 168mm long.

British Minesweeper, Model of. No. 641. 150mm long (very rare).

Torpedo Boat Destroyer, model of. Rare. No. 615. 140mm long.

Submarine, inscribed: *E1.* Usually found with inscription: *Commander Noel Lawrence. Large German Transport Sunk July 30th 1915. German Cruiser Moltke torpedoed August 19th 1915.* No. 525. 150mm long.

Ambulance with 'Rolls Royce' front and three red crosses in grey circles. No. 520. 115mm long. A similar model exists with two red crosses moulded in relief on sides of ambulance.

Armoured Car (reputedly a 'Talbot' but not named). 125mm long. Can also rarely be found named *Belgian Armoured Motor Car.*

British Motor Searchlight. No.123. 103mm long. (Rare).

Model of British Tank first used by British Troops at the Battle of Ancre, Sept. 1916 with inset steering wheels and inscribed *HMS Donner Blitzen, 515.* Long or short rear facing guns. 2 sizes: No. 597. Short guns. 138mm long. Long guns. 138mm long. No. 586. Short or long guns. 160mm long.

Tank with no trailing wheels, inscribed exactly as above. Short forward and rear facing guns protruding from side gun turrets. Also a short gun protruding from front of upper turret. 2 sizes: No. 651. 135mm long. No. 643. 155mm long.

Tank with no trailing wheels inscribed: *HMS Donner Blitzen* and *515* on side only. Has a curved exhaust pipe on roof, and one small gun protruding from front of side turrets. It differs from the other tanks and is rather flat in appearance. No. 675. 108mm long. (Rare)

Field Gun, Model of, with fish tail. No. 616. 140mm long.

Howitzer. No. 520. 140mm long.

Howitzer. No. 518. 170mm long.

Machine Gun, 2 pieces, swivels on tripod. No. 402. 153mm long.

British Trench Mortar Gun. No. 613. 98mm long.

Shell, if inscribed: *Iron rations for Fritz.* 3 sizes: No. 581 or No. 556. 75mm. No. 558 or No. 537. 110mm. No. 170. 117mm.

Colour Plate 510. Tyg, Savoy China. 1½in. (4cm) high, 1½in. (4cm) diameter.

Colour Plate 511. Medium size plate. Shanklin Old Village, Isle of Wight. 8in. (20.32cm) diameter.

Colour Plate 512. Side plate. Holy Trinity Church, Matlock Bath. 711/18in. diameter.

Colour Plate 513. Dish with crinkled edge. View of Burnham. 4⅜in. (11.11cm) diameter.

Colour Plate 514. Two-handled vase. Selsey. 2¼in. (5.72cm) high.

Colour Plate 515. Welsh lady.

(Shell 'salt' and 'pepper' pots also found. No. 663. 80mm).

Model of Stokes Bomb. No. 575. 24mm dia. at base (very rare). 105mm long.

Trench Mortar Bomb. Often found not named. No. 574. 86mm.

Hand Grenade. No. 576. 75mm. Can be found inscribed: Model of Mills Bomb. No. 326.

Anzacs Hat, Model of. No. 554. 90mm long. Unnamed.

Balmoral Bonnet, Model of. No. 611. 74mm long.

Colonial Hat. No. 554. 92mm long.

French Trench Helmet, worn by the Dauntless French Poilu. No. 569. 82mm long.

Glengarry. No. 508. 78mm long.

New Zealand Hat, Model of. No. 612. 80mm long.

Officer's Peaked Cap. No. 516. 72mm long.

German Steel Helmet. No. 566. 60mm long.

Rumanian Soldier's Steel Helmet, Model of, found with Bucharest Crest and Rumanian War declaration inscription. 82mm long.

R.F.C. Cap, Model of. Cap badge clearly moulded. No. 577. 80mm long.

Sailor's Hat, inscribed on band: *HMS Lion, HMS Queen Elizabeth* or *HMS Tiger.* Blue bow. No. 533. 71mm dia. Inscribed: *HMS*

Iron Duke.

Tommy's Steel Helmet. No. 566. 82mm long.

German Picklehaube with tall spike. 88mm long, 65mm high. (Very rare.)

Bandsman's Drum. 55mm dia.

Bell Tent. No. 118. 65mm.

Water Bottle. No. 219. 57mm.

Tommy in Dug Out, not named. No. 669. 85mm. (Very rare.)

Fireplace, inscribed: Keep the home fires burning till the boys come home.' No. 629. 94mm.

Cenotaph, inscribed *The Glorious Dead.* 130mm.

Folkestone War Memorial, May Their Deeds be held in reverence. 160mm.

Edith Cavell Memorial, Norwich, inscribed: Nurse Cavell. Red Cross on apron. No. 110. 168mm.

Home/Nostalgic

Babies Cradle on rockers. 74mm long.

Bellows. 140mm long.

Candlesnuffer. Funnel shaped. No. 437. 62mm.

Colour Plate 516. Welsh lady in bisque. 5⅝in. (14.29cm) high.

Colour Plate 517. Side view of Welsh lady in bisque.

Colour Plate 518. Stirrup cup. 4¾in. (12cm) long.

Colour Plate 519. Postcard No. 32, powder bowl. BR&Co. Ogdens – Modern British Pottery.

Colour Plate 520. Postcard No. 32, powder bowl, rear. BR&Co. Ogdens – Modern British Pottery.

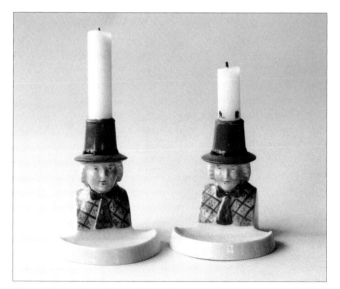

Colour Plate 521. Pair of Welsh lady candlesticks, BR&Co. 4⅜in. (11cm) high.

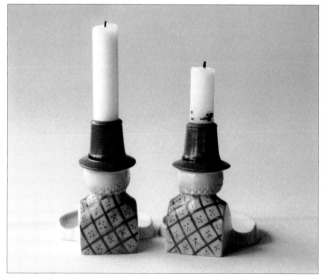

Colour Plate 522. Reverse of the candlesticks in Colour Plate 521.

Colour Plate 523. Miniature tall jug. 'A present from Kelsall'. 2⅞in. (7.3cm) high.

Colour Plate 524. Reverse of the miniature tall jug in Colour Plate 523.

Colour Plate 524. Milk can.

Colour Plate 525. Pepper pot.

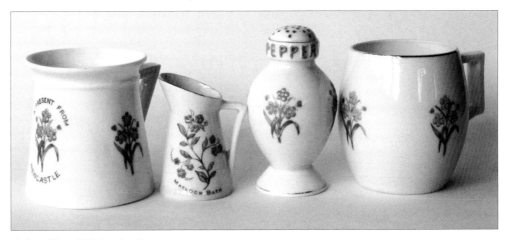

Colour Plate 526. Similar designs.

Flat Iron. 65mm.
Kennel, inscribed: *Beware of the dog*. No. 397. 53mm.
Trivet for flat iron. No. 314. 70mm long.
Grandfather Clock, inscribed: *Nae man can tether time nor tide*. No. 622 and No. 110. 150mm.
Jardiniere on stand. No. 86. 77mm.
Lantern. 82mm.
Pillar Box, miniature. 56mm.
Stool, 3 legged. No. 471. 33mm.
Suitcase with straps. No. 745. 58mm.
Sundial. 93mm.
Watering Can. No. 455. 76mm.
Wheelbarrow. 120mm long.

Comic/Novelty
Billiken. 75mm.
Boy bending down into beer barrel, *Waiting for the smacks* inscribed on his bottom. 90mm.

Boy in nightshirt, holding candle. Impressed on base *NIGHT*. Candlesnuffer. 126mm.
Candlesnuffer in form of young boy in nightwear yawning and stretching. No. 542. 85mm.
Caterpillar with human face. No. 543. 74mm. Also found coloured
Choirboy. No. 542. 85mm.
Choirboy, coloured. 104mm.
Edwardian Girl candlesnuffer wearing bonnet, coat and muff. 77mm. No. 541, and 86mm. No. 175.
Edwardian Lady, very large, huge skirt, neck frill and cap. 140mm.
Hindu god sitting on rock, blue beads. N. 28 or No. 554. 90mm.
Huntley and Palmer's Biscuit hat pin holder.
Policeman, short and fat. 103mm.
Policeman, Boy carrying truncheon, salt pot Inscribed: *SALT*. 130mm.
Tea pot in shape of man's head, spout coming out of mouth. No. 332. 60mm.

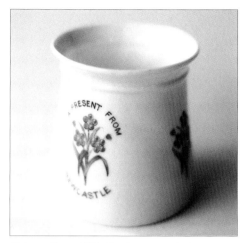

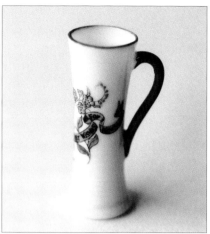

Colour Plate 527. Drinking vessel. 'A present from Newcastle.' 2¾in. (6.99cm) high.

Colour Plates 528 and 529. Vase. 'Greetings and best wishes for new year.' 2½in. (6.35cm) high.

Cartoon/Comedy Characters
Billy Bunter, fully coloured. 120mm.
Bonzo, dog (1920s cartoon character). No. 927.2 sizes: 80mm and 96mm.
Felix the Cat, crouching. Black with white face and yellow eyes. 80mm.
Tweedledum and Tweedledee, fully coloured, pair of separate sitting figures. 70mm.
Wilful Wilfred, fully coloured figure.
Winkie the Glad Eyed Bird. White. Or coloured. 80mm long.
Winkie the Glad Eyed Bird, not named, as pepper pot. Fully coloured. 70mm.
Winkie can also be found as salt or mustard pots, in colour.

Alcohol
Beer Barrel. No. 406. 55mm.
Beer Barrel with separate base. 57mm.
Old Beer Jug, Model of. No. 84 80mm.
Bottle. No. 408. 90mm.
Bottle, inscribed: Real Scotch. No. 409. 88mm.
Carboy. No. 92. 80mm.
Soda Syphon.

Sport/Pastimes
Cricket Bag. No. 745. 95mm long.
Cricket Bat. 115mm long.
Golf Ball, Model of. No. 111. 40mm.
Golf Club head. No. 442. 70mm.

Musical Instruments
Banjo. 137mm long.
Double Bass. 145mm long.
Upright Piano. No. 887. 83mm long.
Violin. 136mm long.

Transport
Charabanc (24 seater). No. 811. 134mm long.

Modern Equipment
Gramophone, square with large horn. 102mm.

Footwear
Lancashire Clog, gilded studs. No. 403. 83mm long.
Dutch Clog. No. 424. 70mm long.
Oriental Slipper. No. 312. 85mm long.

Hats
Straw Hat. 92mm long.
Top hat. 44mm.

Miniature Domestic
Barrel shaped Mug. 50mm.
Basket weave Mug. 60mm.
Cheese Dish, one piece. 40mm.
Cheese Stand, Model of, with lid. No 200. No. 45. 55mm long.
Jug. No. 102. 62mm
Jug. No. 755. 60mm.
Jug, ribbed. No. 116. 60mm.
Kettle and lid. No. 494.
Teapot with lid, diamond shaped. No. 202. 80mm.
Teapot with lid. 62mm.
Teaset on Tray. No. 401.
Tray. 106mm long.
Trinket Set on Tray. No. 436.
Vase. No. 317. 35mm.
Vase, circular on two feet No. 163. 88mm.
Vase. No. 107. 52mm.
Vase. No. 192. 56mm.
Vase. long-necked. No. 407. 65mm.

Domestic
Inkwell, square. with lid and pen rest. No. 433. 45mm.
Pins. Tray with wavy border. No. 231. 149mm long.
Pin Tray, inscribed: *Pins* in blue script in relief. 146mm long.
Tray, oval with wavy border. No. 436. 140mm long.

Miscellaneous
Bell. Model of, porcelain clapper. No. 5. 85mm.
Post and railings, posy vase. 140mm long.

Chapter 10.

Royal Patronage

ON TUESDAY 22 APRIL 1913, KING GEORGE V AND QUEEN MARY VISITED the King's Hall[1] in Stoke upon Trent for an inspection of English pottery 'of such diversity of design and make, that unquestionably had ever been gathered under a single roof'. It must have been some feat for the royal couple to tour this exhibition[2] between 12.17p.m. and 12.55pm., coupled with their many other visits during the day, travelling from Crewe Hall in South Cheshire via Newcastle under Lyme and ending at Trentham Hall for tea with the Duchess of Sutherland. Birks Rawlins & Co. prominently displayed examples of pâte-sur-pâte. Many artistic types of ware of useful and decorative pieces were shown and on 2 June the *Pottery Gazette* reported that Her Majesty recognised the floral basket which had been presented to her with several other pieces from this collection on a previous occasion. It would appear that whenever the National Exhibition took place in the capital the Queen would honour the firm with her patronage, as regularly reported in the popular press of the day. Ivory tinted bodies reproducing old Persian and Rhodian styles were much admired.

Extract from *Evening Sentinel* newspaper

Royal Visit of King George V and Queen Mary to the Kings Hall.
Stoke upon Trent. April 1913.
Birks Rawlins & Co. Vine Pottery. Savoy ware.

This firm was established in 1894 by Messrs. Birks and Rawlins for the manufacture of china. Mr. L.A. Birks had been 22 years in the atelier of Mr. Solon, where he was engaged mainly in producing pâte-sur-pâte decorations.

The firm set out to fabricate china of general utility, which should bear decorations of good design and for this purpose, they asked such eminent artists as Mr. E.G. Reuter and others to collaborate with them. Mr. Reuter's designs for ceramics and book illustrations for the late William Morris are widely known.

The products of the Vine Pottery have been mainly tea, coffee, breakfast and dessert services and general wares decorated in cobalt and other colours in various styles such as 'Chinese, Moustiers,

1. *Pottery Gazette*, 2 June 1913, pp.680-683.
2. *Evening Sentinel* newspaper, April 1913.

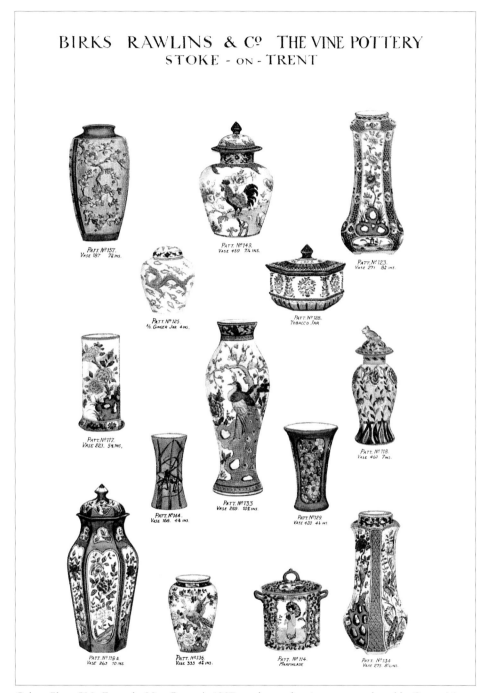

Colour Plate 530. From the Vine Pottery's 1927 catalogue, showing vases purchased by Queen Mary.

Delph &c.', also richly enamelled, painted and elaborate gilt services. They have also specialised in heraldic ivory porcelain. This ivory tinted body is further utilised for a reproduction of the old Persian and Rhodian styles of decoration, freely adapted, but full of the spirit of the fascinating style.

Naturally pâte-sur-pâte decorations occupy a prominent position in the production of this factory. The plaques exhibited and other figure subjects are designed and executed by Mr. L.A. Birks. An original treatment of this process is shown in the work of Mr. F. Ridgway, who has executed a series of wares with subjects of birds, fish, boats, windmills &c. in coloured slips.

The manufactory became a regular participant at the British Industries Fairs held annually in London and received royal patronage on each occasion, as the King and Queen sought out the company stand. In 1917 Queen Mary selected a choice little Chinese jar,[3] a perforated/pierced vase decorated in blue, white and gold, and a third piece of ware in the form of a winsome little maiden with a blue hood and white apron. The factory was also successful in securing the custom of the Queen Mother, Queen Alexandra, who purchased objects from the large floating flower bowl display, including the very popular butterflies, insects and swimming birds in their natural colours (see Chapter 8 on novelty wares).

The height of the Royal Family's patronage. however, was probably from 1920 to 1928. The sixth Annual British Industries Fair was housed at the Crystal Palace in south-east London between 23 February and 3 March in 1920.[4] This site appeared to be an eminently suitable place in which to hold such a fair compared with the previous locations of the Agricultural Hall, Islington, the Victoria and Albert Museum, and the Pennington Street Dock. The Crystal Palace ranked as the best exhibition building in the world, having a floor space of some twenty acres and estimated total frontage of over five miles.

The *Pottery Gazette* acknowledged the presence of the Vine Pottery, stating that Birks Rawlins & Co. had a prolific assortment[5] of small wares and novelties, including a notable selection of nature studies, birds, butterflies, dragonflies, dogs, swans etc. Souvenir lines in heraldic wares, model cottages, models of famous buildings, nursery rhyme wares and comical caricatures were shown in multitudinous array. There were some delightful little conceptions in decorated vases, tobacco jars and pot-pourri jars etc.

A neat little ginger jar with a Chinese 'Lotus' decoration, capitally executed, caught the eye of Queen Mary (who was accompanied by King George V and Princess Mary) as she was passing the stand, and this she purchased along with a number of other meritorious small wares. The Royal Family made an annual habit of visiting the Birks Rawlins stand whenever and wherever it was sited at these fairs for the trade. This is fairly well illustrated by the special page in the sales catalogue for 1927, when many of the pieces of ware are catalogued to illustrate the extent of the Royal Family's collection of Birks Rawlins & Co. ware accumulated, in the main, by Queen Mary.

In 1921 Birks Rawlins again were favoured by the patronage of Queen Mary who

3. *Pottery Gazette*, 2 April 1917, p. 371.
4. Ibid., April 1920, p.473.
5. Ibid., p.79.

halted at the stand as she passed through into the china and earthenware section. She expressed her delight on seeing some of the pieces and again on the return journey, purchasing in all six to seven small objects of various decorations.

Birks Rawlins exhibited a vast number of wares at the Potteries and Glass Exhibition in the British Industries Fair at White City, London over the period 28 April to 8 May 1924, where some two thousand pieces of ware could be seen.[6] (The novelty and crested range was often marked 'Savoy China'.) Many could say that this diversification would backfire in time, particularly at the expense of the utilitarian productions of tableware. The King and Queen visited the Birks Rawlins display (see Plate 29) and purchased several small pieces executed in a blue lustre with applied modelled and painted roses to form lids, as well as a typical nature model of the firm, a frog on a rock (see Colour Plate 396). This was the fifth or sixth occasion that Queen Mary had made a determined visit to Lawrence Birks' stand and, as mentioned previously, it was clear she realised that there was always something interesting to see and purchase for her ever-growing collection. King George V also expressed his approval of some of the nature models of birds, especially kingfishers and parrots.

Four years later Queen Mary was especially attracted by a tea service on view at the British Industries Fair at White City. The service was groundlaid in an attractive shade of green and bore an over printed design in gold. This was regarded as a more favourable avenue for the firm to develop, as the tableware branch of the factory had taken a back seat compared with the novelty and crested wares in the previous ten years.

The 1927 catalogue that Lawrence Birks proudly produced for exhibition purposes illustrates a selection of wares chosen by the Royal Family (Colour Plate 530). Clearly this is a very fine collection of highly decorated vases, but it was obvious that many novelties, a wicker basket and a tea service had been purchased over some sixteen years.

6. Ibid., 2 June 1924, p.1008.

Chapter 11.

The Decline of the Vine Pottery

The trade press had become rather dismissive reporting the British Empire Exhibition of 1925, curtly describing the Birks Rawlins display as very miscellaneous productions in china, useful lines and novelties.[1]

The National Strike in 1926 had a disastrous effect on the Birks Rawlins enterprise. Not only was there was an absence of coal to keep the kilns firing for several months, but the ingredients for the special parian, ivory porcelain and the ordinary bone china products suffered erratic delivery with felspar, flints and kaolin having to be obtained from different sources. Charles Frederick Goodfellow, Lawrence Birks' brother-in-law and former partner in the firm back in 1899, went bankrupt as a vital miller's merchant supplier of Potters Mills Ltd. in Stoke upon Trent. In many cases manufactories and mills required continuous firing and, once they had used up their stocks, some kilns and mills closed down completely and never started again. Certain supplies of materials were shipped by sea to Liverpool, from there to Runcorn on to the canal where they were transferred to the Middlewich branch of the Shropshire Union Canal and on to the Trent and Mersey Canal, finally arriving on the Newcastle branch of the waterway network which passed through Stoke-on-Trent to the Vine Factory doorstep (Plate 43). This canal was situated between the Bilton earthenware potworks and the Vine Factory and evidence can still be seen of a canal bridge in Corporation Street, outside the Bilton building.

Whilst the factory kept going through these difficult times, there appeared to be erratic firing with some kilns and this was coupled with somewhat inferior materials being supplied compared with the previous excellent quality. It was noticed that some wares did not quite reach the high standards of previous years and this is possibly why other outlets were negotiated and created, particularly with the crested wares (see Chapter 9). The standard of goods was certainly nothing to be proud of, Charles Goodfellow's expertise in the supplying of the various clay mixtures being sadly missed.

Competition from other European countries was now quite strong, particularly for

1. Bernard Bumpus, 'Lawrence Birks and the Vine Pottery', in *Ars Ceramica* p.47 and *Pottery Gazette*, 1 September 1925, p.1393.

Plate 43. Map of Stoke upon Trent published in the Pottery Gazette *of 1 May 1930. Birks' premises are shown as No. 15 and Wiltshaw & Robinson's as No. 6.*

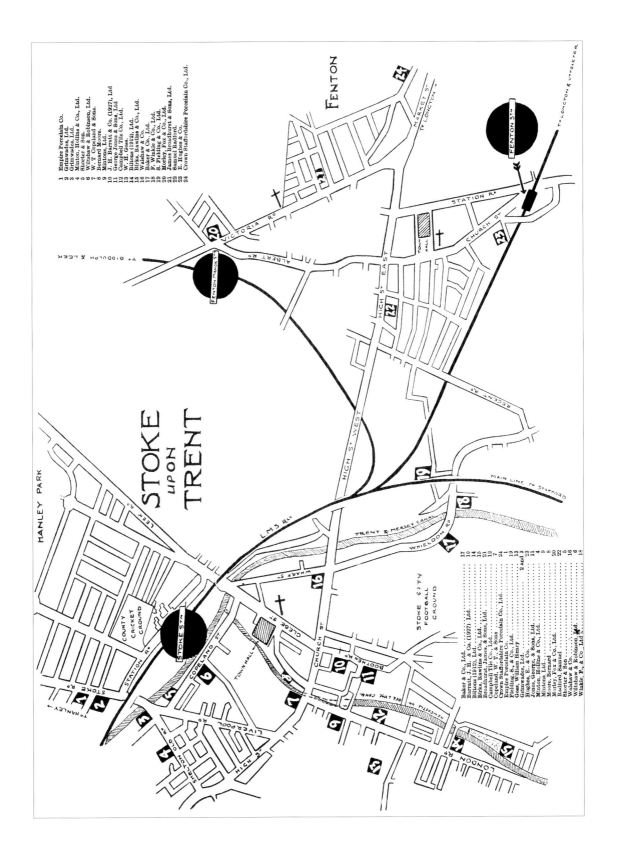

novelties and fancies, as certain countries re-established a foothold in the trade after the Great War lapse in their trading.

The late 1920s were hard times for the majority of pottery manufacturers, many of them folding or merging with supposedly stronger firms. Sadly, in 1928 Birks Rawlins & Co. at the Vine Factory announced that they had been purchased by Wiltshaw & Robinson Ltd.,[2] the proprietors of the famous Carlton earthenware pottery, also in Stoke upon Trent. Consequently a new company was registered, No. 228,880, as Birks Rawlins & Co. Ltd., a private company with a registered capital of £10,000 in £1 shares. The object of this exercise was to carry on the business of manufacturing china at the Vine Factory. The first directors were F.C. Wiltshaw (Managing Director) and D.E. Wiltshaw. There was no place for Lawrence Arthur Birks, but surely he would not have wished for one at the age of seventy-one. He did, however, appear to carry on in a decorating capacity and doubtless was responsible for the patterns and shapes of the new style Carlton/Savoy china that was produced for the five years from 1928 to 1933.

By now he was becoming rather an old man, travelling daily from his second family home at Ashley Heath, Loggerheads, near Market Drayton, Shropshire (Plates 44 and 45) to the factory in Stoke upon Trent that was no more his own. The travelling each day would have certainly taken its toll, and he must have been a depressed and rather sad person, having experienced all these events that brought the downfall. After all, he had been managing his own factory at the Vine for thirty-six years and had now been relegated to a low paid decorating job.

There was a busy presence at the Birks Rawlins & Co. Ltd. stand near the Shepherds Bush entrance to the 1928 British Industries Fair at White City, where there was a collection of the very miscellaneous productions for which the firm had become quite noted. It was evident that most objects could still be obtained from this manufactory, from grotesque and general bric-à-brac up to china teasets. The latter were on exhibit in some excellent designs, as observed by Queen Mary's purchase (see page 201).

The influence of amalgamation was shown later in the year in November by the emergence of a new trademark, registered 490,633 (see also page 172).[3]

2. *Pottery Gazette,* 2 April 1928, p.617.
3. Ibid., 1 November 1928, p.1747.

The philosophy behind the merger/takeover by earthenware manufacturers Wiltshaw & Robinson in 1928 was probably the rationale that it was sensible, in difficult times, to combine with a company that made porcelain and bone china, thus presenting the marketplace with a choice of either bone china or earthenware goods.

Nevertheless Birks Rawlins & Co. Ltd. could no longer afford to make its own shapes and was forced to become a decorating business only. The economy changed

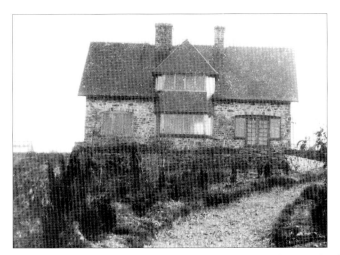
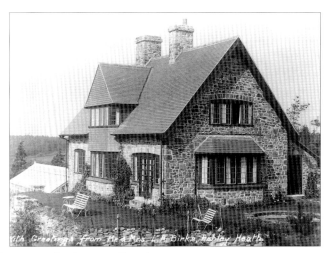

Plates 44 and 45. Lawrence Birks' home at Ashley Heath, Loggerheads, near Market Drayton, Shropshire.

dramatically with the stock exchange crash in the United States in 1929 which resulted in a complete wipe-out of the much exalted export trade that the Vine Factory had built up over the previous six to seven years.

They continued to exhibit their wares at the annual British Pottery and Glass Industries Fair at White City,[4] sharing a joint stand with partners Wiltshaw & Robinson over the next two years. An emphasis was placed again on the very varied range of china teaware, novelties and sundries. Despite all the setbacks, the trade was presented with a well-diversified range of samples in useful and gift china as wide as any factory. With the connections which now existed between the Vine and the Carlton Potteries, the one producing fine bone china and the other earthenware, dealers could be said to have a very useful source of supply, as the range of samples exhibited at the fair clearly proved.

The collection of smart new styles of tableware exhibited in 1930 were as a result of the Carlton earthenware initiative, as the productions had been entirely overhauled, systematised and remodelled.[5] Production of Carlton China now took place at the Vine Pottery, consequently Savoy ware was no longer to be seen as a trademark. Everything was to be trademarked and backstamped 'Carlton China'.

The decline proved to be terminal. It was announced in 1932 that the firm of Birks Rawlins & Co. Ltd., after four years in existence, was being wound up[6] and everything was in the hands of a receiver, F.W. Carder, on 1 March. The firm closed in 1934.

This was an extremely sad end for an enterprise which had been producing such high class and original porcelain[7] as well as quality bread and butter lines. Perhaps it will be best remembered for its occasional production of pâte-sur-pâte wares until at least 1922, at a time when other companies had long abandoned such work. This sets Birks Rawlins apart and is sufficient reason for ensuring that the firm retains a place in ceramic history, 1894 to 1934.

4. Ibid., 1 April 1929, p.600.
5. Ibid., 1 April 1930, p.597.
6. Ibid., 1 April 1932, p.526.
7. Bernard Bumpus, 'Lawrence Birks and the Vine Pottery', in *Ars Ceramica* p.47.

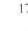

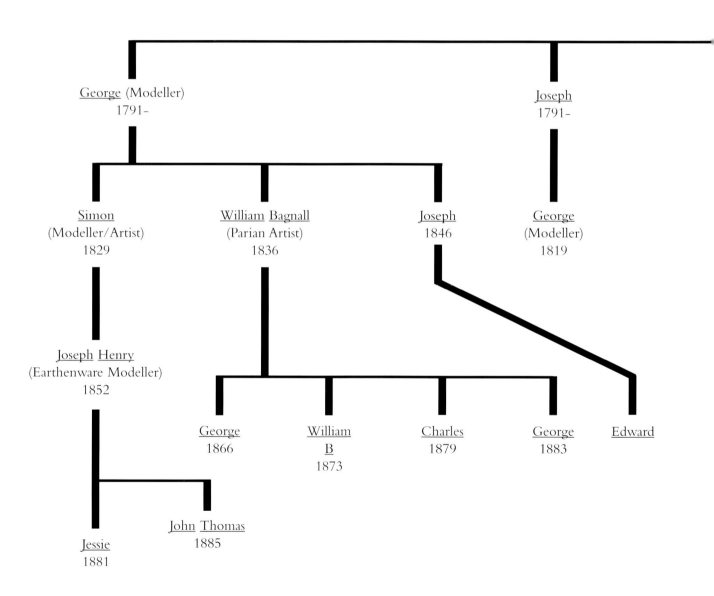

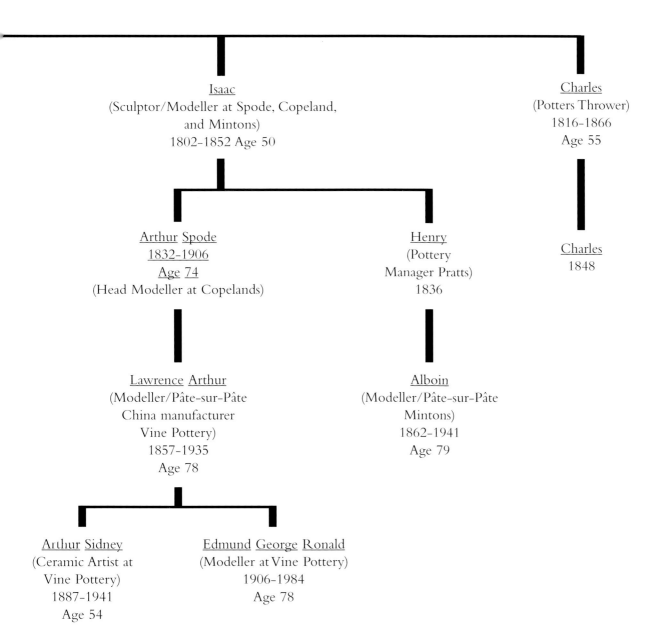

Isaac
(Sculptor/Modeller at Spode, Copeland,
and Mintons)
1802–1852 Age 50

Charles
(Potters Thrower)
1816–1866
Age 55

Arthur Spode
1832–1906
Age 74
(Head Modeller at Copelands)

Henry
(Pottery
Manager Pratts)
1836

Charles
1848

Lawrence Arthur
(Modeller/Pâte-sur-Pâte
China manufacturer
Vine Pottery)
1857–1935
Age 78

Alboin
(Modeller/Pâte-sur-Pâte
Mintons)
1862–1941
Age 79

Arthur Sidney
(Ceramic Artist at
Vine Pottery)
1887–1941
Age 54

Edmund George Ronald
(Modeller at Vine Pottery)
1906–1984
Age 78

Appendix 2

Census returns for Birks
1891

149.	High St., Hanford.	Lawrence Arthur	<u>Birks</u>.	Head.	33.	Artist in pâte-sur-pâte.	Fenton
		Alice	"	Wife.	25.		Trentham
		Dorothy M.S.	"	Dau.	8 months.		"
		Elizabeth <u>Barrett</u>		Servant	18.	Domestic servant.	Stoke~on-Trent
104.	High Street House, Fenton.	Henry	<u>Birks</u>.	Head.	55.	Pottery manager.	Fenton
		Elizabeth	"	Wife.	56.		"
90.	60 West Parade, Fenton.	Arthur	<u>Birks</u>.	Widow.Head.	58.	Ceramic modeller.	Fenton
42.	29 Ashford St., Shelton.	Alboin	<u>Birks</u>.	Head.	29.	Modeller-potter.	Fenton
		Elizabeth J.	"	Wife	26.		"
		D.K.	"	Dau.	3.		Stoke-on-Trent
		Stanley	"	Son.	2.		Shelton
		Eliza <u>Roden</u>.		Servant.	13.	Domestic servant-nurse.	Fenton
30.	4 Boothen Villa, Penkhull.	Ann	<u>Birks</u>.	Widow.Head.	45.		Stoke-on-Trent
		Lizzie	"	Dau.	28.	Potter's printer transferer.	"
		William	"	Son.	18.	Coal miner.	"
		Annie	"	Dau.	16.	Potter's printer transferer.	"
		Charles	"	Son.	12.	Scholar.	"
		George	"	Son.	8.	"	"
101.	62 Albert St., Penkhull.	Joseph	<u>Birks</u>.	Head.	38.	Warehouseman-earthenware.	"
		Mary Lingram	"	Wife.	38.		"
		Jessie	"	Dau.	10.	Scholar.	
		John Thomas	"	Son.	6.	"	"

Other Birks families in North Staffordshire

1.	Penkhull New Road.	Hannah	<u>Birks</u>.	Wid. Head.	71.	Living on own means.	Hanley
		Sarah	"	Single.dau.	41.	" " " "	Stoke-on-Trent
234	67 King Street. Fenton	Hannah	<u>Birks</u>.	Wid. Head.	58.	Grocer	Caverswall

Census returns for Birks
1881

335.	60 West Parade, Fenton.	Arthur	<u>Birks</u>.	Wid. Head.	48.	Potter's modeller. Member of the local Board of Trade.	Fenton
		Lawrence Arthur	"	Son.	23.	Artist. Pâte-sur-pâte.	"
		Gertrude	"	Dau.	21.	Dress maker.	"
		Martha Maud	"	Cousin.	34.	Unm. Housekeeper.	"
128.	111 Albert Road, Fenton.	Henry	<u>Birks</u>.	Head.	45.	Potter's fireman.	Fenton
		Elizabeth M.	"	Wife.	46.		"
		Alboin	"	Son.	19.	E. modeller's apprentice.	"
31.	4 Boothen Villa, Stoke-on-Trent.	William Bagnall	<u>Birks</u>.	Head.	45.	Potter.	Stoke-on-Trent
		Ann	"	Wife.	35.		"
		Mary E.	"	Dau.	13.	Transferer.	"
		William B.	"	Son.	8.	Scholar.	"
		Ann	"	Dau.	6.	"	"

52.	100 Whieldon Road, Fenton	Charles	"	Son.	2.		"
		Mary Ann	Birks.	Unm.Head.	37.	China paintress.	Fenton
		Elizabeth M.	"	Unm. Sister.	28.	Cook at Manufactory.	Fenton
		Emily	"	Unm. Sister/	23.	China paintress.	"
		John Frederick Green		Unm. Bdr.	33.	Accounts clerk.	Warrington
		Alfred Ernest Hill		Unm. Bdr.	29.	Potter's modeller.	Schwarzburg, Germany

Other Birks families in North Staffordshire

35.	9 Oakhill.	Charlotte	Birks.	Wid.. Head.	53		Stoke-on-Trent
		Thomas	"	Son.	19.	Potter.	"
		Leonard	"	Son.	16	Potter.	"
		Charles Stanley.		Boarder.	21.	General labourer.	Stone

Census returns for Birks
1871

141.	1 Albert Road, Fenton.	Henry	Birks.	Head.	35.	Potter's overlooker.	Fenton
		Elizabeth M.	"	Wife.	36.		"
		Alboin.	"	Son.	9.	Scholar.	"
291.	60 West Parade, Fenton.	Arthur	Birks.	Head. Widr.	38.	Potter's modeller.	Fenton
		Lawrence A.	"	Son.	13.	Scholar.	"
		Gertrude	"	Dau.	11.	"	"
		Eliza	"	Cousin.	24.	Housekeeper.	"
170.	Boothen Villas, Stoke-on-Trent.	William B.	Birks.	Head.	38.	Parian maker.	Stone-on-Trent
		Ann	"	Wife.	26.		"
		George	"	Son.	5.		"
		Mary E.	"	Dau.	3.		"
110.	7 Doncaster Lane, Stoke-on-Trent.	Simon	Birks.	Head.	41. Potter's artist.		Stoke-on-Trent
		Prudence	"	Wife.	42.		"
		Joseph	"	Son.	19.		"
		Eveline	"	Dau.	17.		"
210.	Hartshill, N.S.R.I.	Mary A.	Birks.	Patient.Wdw.	53.		Fenton

Other Birks families in North Staffordshire

223.	Next to Mr. Challinor's Works, Longton.	Joseph	Birks.	Head.	49.	Pottery manager.	Chesterton
		Jeminiah	"	Wife.	39.		Bedmington, Glouces.
		Allen	"	Son.	16.	Post Office boy.	Fenton
		Edward	"	Son.	9.	School.	"
		Frances	"	Dau.	7.	Scholar.	"
		Mary Buxton.		Servant.	13.	General domestic servant.	"
46.	Number 12. Oakhill.	Charlotte	Birks.	Head.	44.	Potter's ware cleaner.	Oakhill
		Abraham	"	Son.	18.	Potter's ovenman.	Bucknall
		William	"	Son.	14.	Potter's mould runner.	Oakhill
		Mary Ann	"	Dau.	12	Scholar.	"

Census returns for Birks
1861

167.	Temple Street, Fenton.	Frances M.	Birks.	Wid.. Head.	55.	Household duties.	Fenton
		Arthur	"	Wdr. Son.	28.	Potter's mould maker.	"
		Eliza	"	Dau.	18.	Potter's painter.	"

	Lawrence	"	G. son.	3.		"
	Gertrude	"	G. dau.	1.		"
168. Temple Street, Fenton.	Henry	Birks.	Head.	25.	Potter's figure painter.	"
	Elizabeth	"	Wife.	26.		"
133. Herbert Street, Fenton.	Charles	Birks.	Head.	45.	Potter's china turner.	Stoke-on-Trent
	Mary Ann	"	Wife.	43.		"
	Joseph	"	Son.	21.	Artist potter's modeller.	"
	Mary Ann	"	Dau.	17.	Potter's presser.	"
	Martha Jane	"	DAU.	15.	Potter's burnisher.	"
	Eliza	"	Dau.	14.		"
	Charles	"	Son.	12.		"
	Elizabeth	"	Dau..	9.		"
	Emily	"	Dau.	3.		"
	James Thomas.		Vis. Widr.	58.	Labourer-farm.	Stone
18. Penkhull/ Hartshill.	George	Birks.	Head.	42.	Potter's modeller.	Fenton
	Elizabeth	"	Wife.	41.		Stoke~on-Trent
	Albert Dudley.		Step son.	22.	Potter's ornamental press.	".
	Frederick A.	"	Step son	19.	Figure worker.	"
	Hannah	Birks.	Dau.	19.	General servant.	Fenton
	Evelyn Dudley.		Step dau	15	Potter's painter of porcelain.	Stoke-on-Trent
	Mary	Birks.	Dau.	14.	Scholar.	Fenton
183. Minshull Street, Fenton.	Simon	Birks.	Head.	31.	Potter's modeller.	Stoke-on-Trent
	Prudence	"	Wife.	31.		"
	Joseph Henry	"	Son.	8.	Scholar.	"

Census returns for Birks
1851

110. Temple Street, Fenton Culvert (Christ Church)	Isaac	Birks.	Head.	49.	Modeller.	Longton
	Frances	"	Wife.	45.		Fenton
	Julia	"	Dau.	25.	Potter's paintress.	"
	Arthur	"	Son.	19.	Modeller.	"
	Henry	"	Son.	15.	Potter.	"
	Eliza	"	Dau.	8.	Scholar.	"
65. Chapel Street, Penkhull.	Ann	Birks.	Head. Wid..	47.	Husband was George.	Checkley
	Simon	"	Son.	21.	Potter's modeller.	Fenton
	Sarah	"	Dau.	20.	Scourer of potter's liquid.	"
	Ann	"	Dau.	18.	Dress maker.	"
	Mary	"	Dau.	16.	Earthenware paintress.	Stoke-on-Trent
	Emily	"	Dau.	12.		"
	William	"	Son.	15.	Maker of potter's liquid.	"
	Julia	"	Dau.	11.	Earthenware paintress.	"
	Joseph	"	Son	5.		"
45. High Street, Fenton Culvert.	Charles	Birks.	Head.	39.	Potter's thrower.	Stoke-on-Trent
	Mary Ann	"	Wife	32.	Beer house keeper.	"
	Joseph	"	Son.	11.	Scholar	"
	Sarah	"	Dau.	9.	"	"
	Mary Ann	"	Dau.	7.		"
	Eliza	'	Dau.	6.		"
	Charles	"	Son.	3.		"
	Elizabeth	"	Dau.	6 months.		"
58. Turnpike Street, Fenton	George	Birks.	Head.	32.	Potter.	Fenton
	Ann	"	Wife.	32		Brewood
	Hannah	"	Dau.	9.	Scholar.	Fenton
	Mary	"	Dau.	4.		"

Census returns for Birks
1841

						Born in county		
Temple Street, Fenton.	Isaac	<u>Birks</u>	35.	Potter.				
	Frances	"	35.			"	"	"
	Julia	"	14.	Painter.		"	"	"
	Arthur	"	8.			"	"	"
	Henry	"	5.			"	"	"
Temple Street, Fenton.	Joseph	<u>Birks.</u>	50.	Potter.		"	"	"
	Mary	"	50.			"	"	"
	George	"	22.	Modeller		"	"	"
	Anne	"	22.			"	"	"
Temple Street, Fenton.	Charles	<u>Birks.</u>	25.	Potter.		"	"	"
	Mary Anne	"	20.			"	"	"
	Joseph	"	1.			"	"	"
Chapel Street, Penkhull.	George	<u>Birks.</u>	50.	Modeller.		"	"	"
	Ann	"	35.			"	"	"
	Simon	"	12.			"	"	"
	Sarah	"	11.			"	"	"
	Ann	"	9.			"	"	"
	Mary	"	7			"	"	"
	William	"	5.			"	"	"
	Emily	"	3.			"	"	"
	Julia	"	5 weeks			"	"	"

Other Birks families in North Staffordshire

					Born in county		
Park Street, Fenton.	William	<u>Birks</u>	25. Cratemaker.		"	"	"
	Ann	"	35.		"	"	"
	Elizabeth	"	6.		"	"	"
	William	"	3.		"	"	"
	Thomas	"	4 months.		"	"	"

Appendix 3

High profile artists employed at the Vine Pottery

The four members of the Birks family, cousins Alboin and Lawrence Arthur and the latter's sons Sidney and Ronald, are covered in Chapter 1 on the family.

William H. Cooper

A parian artist of considerable skill, signing the occasional bust that appeared as part of the crested ware scene and was produced from around 1910 onwards at the factory. A sculptor of undoubted skill, he was famous for his busts of King Albert of Belgium and Admiral Sir David Beatty, K.C.B. According to *The Dictionary of Minton* by Paul Atterbury and Maureen Batkin, William was a painter of wreaths around 1880-81.

M.J. Deacon b. 1853

Deacon worked at Grainger's Worcester China Factory from the early age of twelve, remaining there for thirty-two years. He was afterwards with Mr. Locke at Worcester for seventeen years before going to Stoke upon Trent. He was famed for his work with pierced or reticulated porcelain and bone china, which was very popular with Queen Mary. He was greatly skilled in executing this type of ware and his work was in great demand at the annual British Industries Fairs and other exhibitions abroad. The *Pottery Gazette* reported on 1 October 1923 that Deacon was hale and active on his seventieth birthday which was celebrated on 14 September at the Vine Factory. He said in the interview that, now in his ninth year at the Vine, he regarded his work as a recreation. Ginger jars, with or without lids, and pot-pourri covered bowls were typical of some of his beautiful creations. An outstanding example is a ginger jar with lid decorated very delicately with turquoise and gold, and, more importantly, impressed on the base with the words 'M.J.Deacon. Potter. 1915. B. R. Stoke' (see Colour Plates 355-357). This piece was presumably made for the British Empire Exhibition for that year. In their tribute to the artist the magazine hoped that he would continue for many more years and would continue to add more pieces of his beautiful work to the world's treasures.

A. Lewis

Quoted as a ceramic artist in the *Pottery Gazette* in 1909.

William Leak
A ceramic artist who decorated with exquisite hand painting, quoted in the *Pottery Gazette,* July 1911.

Edmond G. Reuter **1845-1917**
An outstanding ceramic designer and watercolour painter. Born in Geneva, the son of a botanist, he inherited the love of plants from his father. Edmond went to Paris in 1864 to study floral art and in 1868 visited Egypt and other eastern Mediterranean countries where he became aware of the richness of Oriental art. This influence was a source that was to influence him greatly in his later work, 'Persindo', the word being derived from Persian and Indian. Reuter arrived in London in 1870, making contact with William Morris as an illustrator, illuminator and calligrapher. He had been attracted to Minton in Stoke upon Trent and became assistant designer between 1875 and 1895, being referred to as assistant designer to Léon Arnoux, the Art Director at Minton, in the *Pottery Gazette* in 1886. He returned to his native Switzerland in 1895 and became a well-known watercolour painter, only to be attracted back to Stoke upon Trent around 1901.

Edmond Reuter introduced the 'Persindo' fine bone ivory porcelain produced from 1904 to 1917 (see Chapter 5). He stayed briefly at the houses of the brothers-in-law Charles Goodfellow and Lawrence Birks as a guest and his influence on the decor can still be seen in these houses many years after the families had left for newer pastures. Goodfellow's house, renamed Chetwynd, is now perhaps noted more for being the last dwelling of Clarice Cliff. Edmond features in *The Concise Encyclopedia of English Pottery and Porcelain* by Wolf Mankowitz and Reginald G. Haggar.

Charlotte (Lotty) Rhead **1885-1947**
Although Lotty is known world-wide for her tube-lining and art deco work, little has been attributed to her involvement at the Vine Pottery. She joined the influx of artists at this pottery with her father Frederick and sister Dolly in 1910, leaving in 1913. Lotty made a great contribution to the amount of pâte-sur-pâte and tube-lined wares produced at the factory. A series of plaques/tiles were produced in this short period depicting several local village scenes. Lotty moved on with the family exodus to Wood & Sons in Middleport, later making more of a name for herself with Burgess & Leigh, A.J. Richardson and H.J. Wood.

Dolly Rhead
Dolly joined her sister and father at the Vine Pottery, completing the same amount of time as the other members of the family. She was a ceramic artist of note in her own right and exercised many interesting tube-lined pieces between 1910 and 1913. Dolly had qualified as a midwife in the nursing profession at Addenbrooks Hospital in Cambridge, whilst her father Frederick was in the United States.

Frederick Alfred Rhead **1856-1933**

A talented ceramic designer and craftsman who studied at the Potteries and Newcastle Schools of Art and worked as an apprentice to Louis Marc Emmanuel Solon. He left Minton after a short time to join Wedgwood, where he executed a vase in pâte-sur-pâte for the Paris Exhibition in 1878. He was Art Director at Bodleys Brownfield Pottery Guild (for whom he executed the Gladstone Vase in 1888) and then moved to Wileman & Co., Longton, before having a disastrous partnership with Barkers Tiles. When in 1910 Frederick returned from the United States after visiting his sons Harry and Frederick Hurten, he and his two daughters used his friendship with his old schoolfriend, Lawrence Birks, to re-establish himself. He was at Birks Rawlins & Co. briefly till 1912 and finally went to Wood & Sons in Burslem. Frederick was joint author with his brother George Woolliscroft Rhead of *Staffordshire Pots and Potters* in 1906 (*Pottery Gazette* June 1933, p.744).

Frederick Ridgway

Ceramic artist. Developed the pâte-sur-pâte technique under the guidance of Lawrence Birks, as reported in the *Pottery Gazette,* July 1913. He became a prolific exponent of this work, signing his creations, and eventually left to join Colley Shorter's firm A.J. Wilkinson, becoming one of Clarice Cliff's bosses for a period in the 1920s.

Fred was very much into designing styles of the Victorian/Edwardian era, for example trees, streams, Chinese lanterns, waterfalls and butterflies. It was rumoured, according to Leonard Griffin in his book *The Bizarre Affair,* that he took a dislike to Clarice Cliff, although their working relationship was very productive. Clarice assisted Fred on one of his elaborate Victorian designs – pattern number 7309, dating to February 1923 – and it included the note 'C. C. does the gold'.

Leonard Rivers

An extremely highly gifted artist in the execution of roses and chrysanthemums on fine bone china. Rivers was allowed to sign his own work, which made superb cabinetware. He worked for many years at nearby Copeland and then Minton before appearing at the Vine Pottery around 1901. Many of Rivers' wares from the Vine Pottery were admired at the international exhibitions, being signed in pink/red or green.

Bob Wallace

Wallace became an apprentice at Copelands on 7 January 1864. He spent most of his working life at Copelands, becoming an artist gilder and, in the 1900s, Decorating Manager. He helped many of the artists and gilders, encouraging them to study at the local art schools, and was an example to them all. The *Pottery Gazette* in July 1913 noted his 'Exquisite painting on dessert plates and trays, also déjeuner sets and tea services charmingly decorated in old Sèvres and other styles'.

Appendix 4

Trade Marks

Vine Pottery
Trade marks.

L. A. BIRKS & CO.
1894-1900.

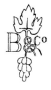

BIRKS.

China.

BIRKS

L. A. BIRKS & CO., Vine Pottery, Stoke. Staffordshire Potteries. 1894-1900. *China and Earthenwares.* Subsequently Birks, Rawlins & Co.

Impressed mark, 1896+.

G. B. & CO.

B & CO. Initial marks in various printed forms, 1894-1900.

Birks, Rawlins & Co.

BIRKS, RAWLINS, & CO.,
Vine Pottery,
Stoke-on-Trent.

BIRKS, RAWLINS & CO. (LTD.), Vine Pottery, Stoke. Staffordshire Potteries. 1900-34 *China.* Formerly L. A. Birks & Co.

BIRKS, RAWLINS, & CO.,
The Vine Pottery,
Stoke-on-Trent.

Several printed marks occur incorporating the initials B. R. & Co. or the title in full, 1900+.

 Printed marks, c. 1917+.

Savoy China

SAVOY
CHINA

CARLTON
CHINA

Trade-names and marks used, c. 1930.

Savoy

CHINA
MADE IN ENGLAND

1910-1934

Trademark used by Birks, Rawlins and Co Vine Pottery, Stoke. Merged in 19 with Wiltshaw & Robinson Ltd. (Makers of Carlton).

Trade marks.

NIAGARA
ART
CHINA

Queens China or Ware

Mainly on crested ware

Bibliography

Andrews, Sandy, *Crested China – The History of Heraldic Souvenir Ware*, Milestone Publications, 1980. Reference to different trade marks for retailing in the U.K.

Atterbury, Paul and Batkin, Maureen, *The Dictionary of Minton*, Antique Collectors' Club, 1990. Important reference to employees at the manufactory.

Atterbury, Paul, *The Parian Phenomenon*, London, 1989. With contributions from Maureen Batkin and Martin Greenwood.

Baker, Diane, *Potworks. The industrial architecture of the Staffordshire Potteries*, 1991.

Bergeson, Victoria, *British Ceramics Price Guide*, Barrie & Jenkins Ltd., London, 1992.

Bumpus, Bernard, *English Ceramics in Paris*.

Bumpus, Bernard, 'Lawrence Arthur Birks and the Vine Pottery', *Ars Ceramica*, Wedgwood Society of New York.

Bumpus, Bernard, *Pâte-sur-pâte – The Art of Ceramic Relief Decoration 1849-1992*, Barrie & Jenkins Ltd. Numerous references to the Birks cousins Lawrence and Alboin.

Eyles, Desmond, *The Doulton Burslem Wares*, Barrie & Jenkins.

Godden, Geoffrey A., *Encyclopaedia of British Pottery and Porcelain Marks*, Barrie & Jenkins Ltd., London, 1964, reprinted 1986.

Godden, Geoffrey A., *Encyclopaedia of British Porcelain Manufacturers*, Barrie & Jenkins Ltd., London, 1988.

Godden, Geoffrey A., *Victorian Porcelain*, London, 1961.

Green, Richard and Jones, Des, *The Rich Designs of Clarice Cliff*, Richard Designs Ltd., 1995.

Griffin, Leonard, *Clarice Cliff – The art of bizarre*, Pavilion, 1999.
Griffin, Leonard, Meisel, L.K. and S.P., *The Bizarre Affair*, Thames & Hudson, 1998.

Hillier, Mary, *Chloe Preston and the Peek-a-Boos,* Richard Dennis Publications, 1998.

Mankowitch, Wolf and Haggar, Reginald G., *The Concise Encyclopedia of English Pottery and Porcelain,* London, 1957.

Monkhouse, Cosmo, *A History and Description of Chinese Porcelain.* Here there is a reference to the 'Aster' pattern used by the Coalport, Minton and Vine manufactories.

Peake, Tim, *William Brownfield & Sons. 1837-1900,* Tim Peake, 1995. Special reference to the Smyrna plate.

Pine, Nicholas, *The Price Guide to Crested China,* Milestone Publications 1985, 1989, 1992 and 2000. Thirteen different outlets identified by trade marks from the Vine Pottery.

Pottery Gazette and *Pottery Gazette and Glass Trades Review.* Monthly trade publication for the period of study and research 1894-1936. Constant reference is made to the products of the Vine Pottery in the buyer's notes and elsewhere, firstly for Birks & Co., then Birks Rawlins & Co. and latterly Birks Rawlins & Co. Ltd./Carlton China.

Rhead, G.W. and F.A., *Staffordshire Pots and Potters,* London, 1906

Index to Chapters 1-11 and Appendix 3

Page numbers in bold type refer to illustrations and captions